DUCKWORTH DEBATES IN ARCHAEOLOGY
Series editor: Richard Hodges

Vessels of Influence

*China and the Birth of Porcelain
in Medieval and Early
Modern Japan*

Nicole Coolidge Rousmaniere

Bristol Classical Press

First published in 2012 by
Bristol Classical Press
an imprint of
Bloomsbury Academic
Bloomsbury Publishing Plc
50 Bedford Square
London WC1B 3DP, UK

CIP records for this book are available from the
British Library and the Library of Congress

ISBN 9780715634639

Printed and bound in Great Britain by
CPI Group (UK) Ltd, Croydon, Surrey

www.bloomsburyacademic.com

Contents

Contents

To the memory of my grandfather
Albert Hamilton Gordon
and for Lady Lisa Sainsbury

Their unswerving support has helped me in a
profound way and I am deeply grateful.

Preface

It is so uncommon a thing now-a-days for a man to examine his own taste, and habitually to do that which he really likes, that any one acting in such a manner is considered eccentric, if not absolutely insane. Such a one we are told is mad about music. Such another is mad about pictures. That man is cracked because he spends his life in going up in balloons, and this other should be put under confinement because he squanders his fortune in buying china tea-cups. It is these men who are really sane. It is these, eccentric as they are, who have really learnt the secret how to live. That crooked little blear-eyed Nestor with his tea-cups is an Emperor, nay, a Demigod, when he acquires some new wondrous prize, old as the patriarchs, transparent as amber, thinner than the holy wafer, softer in its hue than cream, covered over with those sweet, uncouth Asiatic monsters which the eye of the connoisseur can recognise at a glance. Put him in confinement! No – but put him where the world may see him, and make a study of a man who has learnt to live.

Anthony Trollope, *The New Zealanders*,

ch. X: 'Society', 154

Why people collect and what they collect have long fascinated scholars. However, while the study of collections has been a popular academic pursuit for decades in the fields of art history and cultural history, in the field of archaeology contextualised objects and material culture have been the main focus rather than the collector. It is the premise behind this study that an

in-depth analysis of the cultural practice of collecting can provide new clues to the understanding of ceramics in Japan and East Asia through the combined disciplines of archaeology and documentary research, as well as a consideration of heirloom examples as comparanda.

With the four hundredth anniversary of the origin of porcelain production in Japan fast approaching, it seems timely to reassess the role of porcelain in Japanese society. While porcelain has been fired in China for well over 1,000 years and in Korea for over 600 years, Japan did not start until the 1610s, only a century earlier than Europe. The reasons for the late start in Japan are many, and this central debate forms one of the many strands that can be seen throughout the volume.

The growing importance of porcelain can be seen as a response to the internal political consolidation of Japan and new Asian realignments in trade due to shifting market and political forces in the early to mid-seventeenth century. The domestication of the merchant economy with the new *Pax Tokugawa*, coupled with a growing leisure industry and the ever-expanding importance of pageantry and entertaining in the newly formed social order, all contributed to the creation of a porcelain industry in Japan. However, to understand porcelain's role in Japanese society as a commodity, trade goods or objects of desire, it is essential to dig back further and examine the position of the model on which ceramics were fashioned, namely Chinese ceramics in medieval Japan.

This book examines in particular the passion in Japan for Chinese ceramics in the medieval and early modern periods and its transformation into a localised industry in the Hizen area of Kyushu. The Japanese importation of Chinese ceramics is well known but has yet to be examined in an integrated fashion through the fields of archaeology, art history and cultural studies. Furthermore, the study of Chinese ceramics and that of nascent Japanese porcelain production have developed along different trajectories in Japanese and in Anglo-American scholarship. The debates about the study of Chinese ceramics in Japan and the origins of Japanese porcelain from multiple

10

points of view are brought together in single focus in this volume. It is the author's hope that this volume will prove to be a resource and a stimulus for further study in this important and yet under-researched field.

This slim volume took many years in the making and I was exceedingly fortunate to have had the support of so may people during its gestation. First and foremost, I am grateful to Richard Hodges and to Deborah Blake for their thoughtful guidance and stellar patience. Richard's willingness to listen to my ideas, read drafts and give comments helped me considerably throughout the writing process. Deborah has been very helpful and for her continued support I am truly grateful. My study of Chinese and Japanese ceramics began in graduate school at Harvard University, with my dissertation carefully guided by John M. Rosenfield and Bob Mowry. It is due to their encouragement and later to Louise Cort, a truly inspirational scholar and senior curator at the Freer and Sackler Galleries, Smithsonian Institution, that I was able to start my research on a firm footing.

My research has been nurtured at every stage by Ôhashi Kôji, presently Director Emeritus of the Kyushu Ceramic Museum. His scholarship and kindness have made the period of my studies so much richer. The Kyushu Ceramic Museum has provided a home away from home. Curators there, such as Fujiwara Tomoko and Suzuta Yukio, and the staff have always shared generously of their knowledge and resources. The Arita archaeologists, Murakami Nobuyuki and Nogami Takenori, who are the two most knowledgeable scholars on Hizen ceramics, have always gone out of their way to help and unstintingly give advice. The Kyushu Ceramic Museum patron Shibata Akihiko (who died in 2005) and the ceramic artist Imaizumi Imaemon XIV have also spared time to share their formidable knowledge, and for that I am in their debt.

Arakawa Masa'aki at Gakushuin University with his brilliant and creative approach to Chinese and Japanese ceramics has helped me to understand the complexity and interrelatedness of various disciplines in relation to the ceramic medium.

11

Sano Midori at the same institution has helped me revise my understanding of Japanese art history and challenged me to do my best to interpret the material properly. Kobayashi Tadashi, also a senior professor, and his wife Yasuko have provided support and nurture for me over many years. Horiuchi Hideki at the University of Tokyo in particular has selflessly shepherded me through countless sherds from multiple excavations and patiently explained the processes of Japanese early modern archaeology. His current research focusing on consumption in early modern archaeology has shifted the way I view ceramic assemblages from relevant sites. My studies in Japan have always been supported by Kawai Masatomo from Keio University, who continues to show me that Japanese culture is not only about ceramic study. I am very grateful for that corrective. The curatorial staff at the Idemitsu Museum of Arts carefully directed by Idemitsu Shôsuke with the help of Kuroda Taizô and many curators including Idemitsu Sachiko have made all the difference in my studies in Tokyo. Their comprehensive collection of Asian ceramics with a beautifully designed sherd study area has helped to ground my research more firmly and examples from their collection have helped to illustrate this volume. My recent base for the last three years in Tokyo was the department of Cultural Resources Studies at the University of Tokyo, for whose support I also owe a large debt of gratitude. The graduate students and the staff, in particular Shindô Tamaki, Shimo Yasuko and Fukushima Isao, helped me understand Japan and Japanese studies in a new and different fashion. Kinoshita Naoyuki, one of the senior professors in the department, has been my inspiration in understanding how creativity can work with careful scholarship, and that one needs to search in different fields for the answers.

In the United Kingdom, those associated with the Sainsbury Institute for the Study of Japanese Arts and Cultures have been consistently supportive of my research. I mention here Dame Elizabeth Esteve-Coll, Mizutori Mami, Simon Kaner, Sue Womack, Hirano Akira, Kazuko Morohashi, Nishioka

Preface

Keiko, Cassy Spearing, Matsuda Akira and Kishida Yoko. I would like to thank in particular Hirano Akira, the Lisa Sainsbury Librarian, for his careful checking and locating of reference materials, and Morohashi Kazuko, Research and Planning Officer, for help with illustrations, formatting and general advice. Dame Elizabeth kindly read a final draft and caught not a few infelicities. Sir Hugh and Lady Cortazzi have supplied wonderful encouragement throughout. Andy Crowson kindly helped with the map illustrations. Zoe Swenson-Wright helped to create the index in a clear and thorough fashion. Timon Screech and John Carpenter have consistently been sources of advice. Lucy North worked her magic with suggestions on organisation and editing. From the British Museum, where I am currently working as a Project Curator, Jan Stuart, Timothy Clark and the wonderful Uchida Hiromi along with Tsuchiya Noriko, Ishigami Aki and Alfred Haft have all helped me and acted as a support for my research direction. Uchida Hiromi helped considerably with checking the manuscript. Robert White has also been incredibly kind, and Brian L. Oldman always supportive, reading drafts and being honest with me.

Finally I would like to mention my mother, Sarah F. Gordon, who has looked at every page of this work unflinchingly and given insightful comments, and my brother Peter J. Coolidge and his wife Faith, who have been with me on this project from the dissertation stage onwards.

List of Illustrations

TIMELINE

Year	Periods	Japan	Korea	China
		Jomon period (c. 12500-300 BC)		Han Dynasties (206 BC-220)
BC	Prehistory	Yayoi period (c. 300 BC -400 AD)		Jin Dynasties (265-420)
400			Three Kingdoms (57 BC-668)	
		Kofun period (c.400 -538)	Silla (57 BC-935)	Song Dynasty (420-497)
500			Goguryeo (37 BC-668)	North and South Dynasties (386-589)
600	Classical	Asuka period (538-710)	Baekje (18 BC-660)	Sui Dynasty (581-618)
700				
		Nara period (710-794)	Silla Dynasty (668-935)	Tang Dynasty (618-907)
800		Heian period (794-1185)		

TIMELINE

Year	Periods	Japan	Korea	China
900			Silla Dynasty (668-935)	Five Dynasties (907-960)
1000	Classical	Heian period (794-1185)		Northern Song Dynasty (960-1127)
1100			Goryeo Dynasty (918-1392)	
1200	Medieval	Kamakura period (1185-1333)		Southern Song Dynasty (1127-1279)
1300				Yuan Dynasty (1279-1368)
		Nanbokuchô period (1333-1392)		
1400		Muromachi period (1392-1573)	Joseon Dynasty (1392-1810)	Ming Dynasty (1368-1644)
1500				

TIMELINE

Year	Periods	Japan	Korea	China
1600		Momoyama period (1573-1615)		
1700	Early Modern	Edo period (1615-1868)	Joseon Dynasty (1392-1910)	Qing Dynasty (1662-1911)
1800				
1900	Modern	Meiji Restoration (1868-1912)	Japanese colonial rule (1910-1945)	Republic period (1912-1949)
		Taishô period (1912-1926)		
2000		Shôwa period (1926-1989)	DPR of Korea (1945-present) / Republic of Korea (1945-present)	People's Republic of China (1949-present)
		Heisei period (1989-persent)		

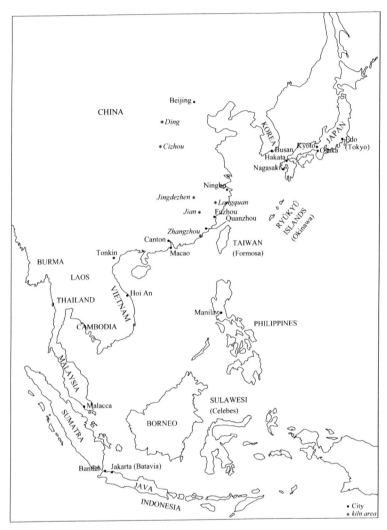

Map 1. East and Southeast Asia

20

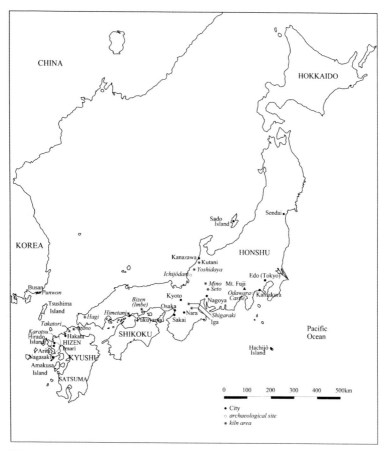

CHINA

HOKKAIDO

Sado
Island

Sendai

KOREA

HONSHU

Kanazawa
Kutani
*Yoshidaya
Ichijōdani
Edo (Tokyo)
*Mino Mt. Fuji
*Seto
Odawara
Castle Kamakura
Kyoto
Nagoya

Busan
Punwon
Tsushima
Island
Bizen
(Imbe)
Osaka
Nara
Shigaraki
Takatori
*Hagi
Himetani
Fukuyama
Sakai
Iga
Karatsu
*Kano
Hirado
Island
Hakata
SHIKOKU
Arita
HIZEN
Imari
Nagasaki
KYUSHU
Amakusa
Island
SATSUMA

Pacific
Ocean

Hachijō
Island

| 0 | 100 | 200 | 300 | 400 | 500km |

• City
○ archaeological site
* kiln area

Map 2. Japan

21

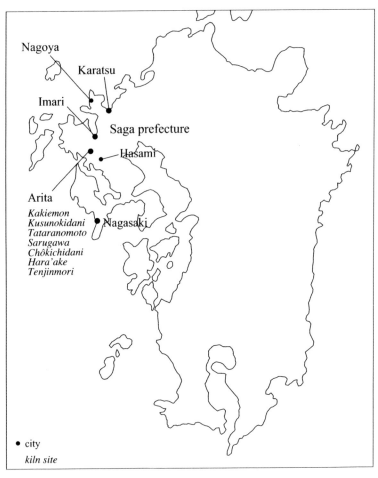

Map 3. Kyushu

Introduction

Show me the way people dine and I will tell you their rank among civilised beings.

Harper's New Monthly Magazine, September 1868

Dining and dining utensils can provide a lens through which the archaeologist or cultural historian can evaluate how the diner felt about himself or herself and the image to be projected to the community at large. In fact, utensils and the accoutrements of the rituals accompanying the necessity and pleasure of dining leave tantalising traces in archaeological, documentary and art historical records. Written records occasionally describe in detail the art of dining, but rarely dining utensils. In addition, when dining utensils survive intact, they may acquire new, additional meanings from their changing contexts. They can become 'vessels of influence' through their use in power dining or quite literally as an international trade good carried by galleons across the globe during the early modern period. Here in this volume we will be examining Chinese and Japanese porcelain as 'vessels of influence' in dining and items of trade and more tellingly also as a vehicle for the retelling of national histories.

East Asian porcelain

Owing to their sheer durability, ceramics are omnipresent in archaeological habitation sites, and are consequently often used as 'period markers' in historical studies. For example, ceramics are used for dating purposes when retrieved from

undisturbed levels, or for tracing and reconstructing trade patterns. They may even, in some cases, be used for naming entire cultural periods, as for example the Jōmon period (literally the 'cord-marked' period: 12,500-300 BC) in Japan. Yet, in Japan, while a great deal of scholarly work has been conducted on prehistoric ceramics, particularly to inquire into topics such as the dietary habits of prehistoric cultures, more scrutiny could have been given to medieval and early modern ceramics. Multiple studies do exist on individual types of ware for specific periods, together with a large amount of typological analysis, yet until recently not enough focus has been placed on the general historical and cultural significance of early modern ceramic wares, with a few notable exceptions. Other important subjects such as the role of stoneware versus porcelain in Japan have yet to be addressed.

On the other hand, individual shipwrecks have been the object of recent international research. This trend reflects the recent availability of Chinese and Southeast Asian ceramics in the general market. Trade ceramics from excavated sites in Japan are studied, and recently the Kansai Early Modern Archaeological Society (*Kankinken*) held a conference that attempted to bring together the latest findings of trade ceramics excavated in Japan (Kankinken 2009). These volumes and symposia are a welcome start, but what is called for is a more synthetic approach to Chinese trade ceramics and their role in Japanese cultural history as well as in the formulation of the Japanese porcelain industry. This book attempts to begin to bridge this gap by exploring the debates on the role of porcelain in late medieval and early modern Japan.

Porcelain ware has continued from its inception to engender admiration and interest not only from scholars but also in international trade markets. On 12 July 2005 Christie's London sold a fourteenth-century underglaze cobalt blue porcelain vase that had previously stood forlornly in the corner of a Dutch entry hall for the last hundred years, for £15.66 million – then a record price for any work of ceramic art. For the collector, and for the informed public, porcelain's allure derives

Introduction

in large part from an appreciation of the refined materials and processes needed to produce a successful vessel. In addition, the finished vessels are white of body, providing an ideal surface to paint, decorate, glaze and inscribe. Porcelain represents a unique melding of technology and style, and it spans the seemingly distinct categories of material culture, household luxury, decorative art and high art. For this reason in the West, the study of porcelain often falls between the two separate disciplines of archaeology and art history.

If we define porcelain as it is usually defined in the West, i.e. as high-fired, translucent, white ceramic ware, porcelain was invented in the eighth century in China, at the Xing kilns in southern Hebei province (Mowry 2000, 70-8). One of the earliest high technology man-made substances, porcelain is a fully vitrified ware made from kaolin, feldspar and silica (petuntse, sometimes termed 'China stone'), and fired to the extremely high temperature of 1300 degrees centigrade over a specified period of time.

Robert Mowry (Mowry 2000; see also for reference Kerr and Wood 2004; and Yabe 2002, 897) has written eloquently on the invention of porcelain in China: 'Chinese potters began to experiment with high-fired white ceramics – usually opaque white stoneware – in the Sui dynasty (581-618)', he writes. He continues:

[B]y the eighth century, they had invented porcelain, which is both white and translucent. During the Tang dynasty, the finest porcelains were made at the Xing kilns, near Neiqiu, which is in southern Hebei province, about 145 kilometers (90 miles) south of Quyang (in central Hebei province; where the Ding kilns were located). Many of the finest Xing wares were supplied to the imperial palace, then in Chang'an (near modern Xi'an, Shaanxi province). In his *Chajing* [Classic of Tea] of 760, the Tang author Lu Yu compared white porcelain to silver; in fact, the earliest Chinese taste for porcelain coincides with a surge in popularity for vessels of gold and

silver, reflecting the relationship between the ceramic and precious-metal traditions. Even if vessels of Xing porcelain were used in Tang palaces, Lu Yu remarked that celadon-glazed vessels – that is, Yue-ware vessels with pale, bluish green glazes – which he compared to jade, were still the most preferred, at least for serving tea.

China produced fine white porcelain from the eighth century onwards. Korea began to fire white porcelain in the ninth and tenth centuries (Itoh 2000, 79). Kilns located in present-day Vietnam fired semi-porcelain ware from the fifteenth century onwards. Japan, on the other hand, entered the field surprisingly late, with potters only beginning to fire porcelain in the early seventeenth century, almost a thousand years after Chinese potters had mastered the technique.

Why was Japan so late in taking up the manufacture of porcelain? Intriguingly, the question is one that is rarely asked. Indeed, perhaps as a result of the industry's late start, art historians and archaeologists alike, both Japanese and Western, either do not recognise, or significantly underplay, porcelain production in Japan as a field of inquiry. Most scholars view seventeenth- and eighteenth-century Japanese porcelain in terms of the ware that was imported to Europe and the United States of America, and not as particularly significant to the domestic market in Japan. Scholarly attention to Japanese ceramics has centred on earthenware and stoneware, which have enjoyed a long and rich history in Japan. In addition, many researchers in Japan argue that Japanese porcelain production was only initiated as a result of the invasions of the Korean Peninsula in 1592 and 1597, often referred to in Japan as the *yakimono sensô* or the 'Pottery Wars' (see Cort 1985, 331-62).

The Pottery Wars thesis holds that regional Japanese lords, who invaded the Korean Peninsula under the orders of Toyotomi Hideyoshi (1536-1598), the *de facto* ruler of the time, brought back skilled Korean craftsmen, and in particular skilled potters, in order to launch ceramic industries in their

individual domains in Japan. This is viewed as the origin of porcelain production in Japan, and it is a thesis adhered to by art historians as well as social historians and archaeologists. Indeed, it is one that is also accepted and reinforced by Korean art historians as well. However, viewing the birth of an artistic industry from the ashes of a devastating war is an unattractive and simplistic option at best. The Pottery Wars theory is accompanied by a tripartite stylistic classification of the first fifty years of Japanese porcelain as starting with a 'Korean style' in the 1610s to early 1630s, which then switched to a 'Chinese style' in the late 1630s to 1640s, and subsequently found mature expression in a 'native (i.e. genuinely Japanese) style' in the 1650s-60s.

Lately, however, new evidence has emerged that suggests the possibility of a different scenario, one that is not linear and solely based on technological factors. A new possible explanation incorporates market forces. Recently the eminent porcelain scholar Ôhashi Kôji has suggested more of a two-part breakdown that corresponds more closely to the archaeological record, starting still with a Korean style that shifts with market requirements into a long term Chinese style in the 1650s.

Historical archaeologists have uncovered large amounts of underglaze cobalt blue decorated Chinese porcelain in numerous medieval and early modern sites throughout Japan. As a result some scholars have begun to elaborate alternative views on the history of porcelain and its use in Japan. Few scholars have chosen to examine and 'fill out' the thesis surrounding the Korean connection to Japanese porcelain. This is mostly because of political sensitivities on both sides, especially after the additional insult of Japan's occupation of Korea in the first half of the twentieth century. Some Japanese archaeologists, however, have recently pointed out that a significant appetite for porcelain is evidenced in Japan certainly from the late fifteenth century onwards (Ôhashi 2004). Clearly this appetite continued to grow, as found in archaeological excavations that reveal the ever-increasing amount of Chinese porcelain imported into the Japanese archipelago up to the fourth decade of the seven-

teenth century. The Japanese nascent porcelain industry can simply be seen from its very beginning as a substitution for imported Chinese wares. But this explanation leaves us with questions about the initial 'Korean style' and its meaning for the formation of the Japanese porcelain industry.

Ceramic study in Japan

Academic studies on ceramics in Japan are divided into three distinct disciplines: art history, archaeology and maritime trade history. Japanese art historians, as a rule, have focused ceramic research on objects that fall into one of four classifications: heirloom objects (*denseihin*); ceramics currently housed in museums or private collections; vessels depicted in painted images or prints; and ceramics described in historical documents.

Important heirloom ceramics often have their own individual histories, or 'biographies', recorded on the boxes that house each piece, with letters of authentication or appreciation by personages from various periods nestled next to the object in its box. If important, and especially if it was used in tea gatherings or on a particular, famous occasion, the object may acquire multiple special cloth covers (*shifuku*), perhaps of Chinese or Indian material, tied with silken cord, adding new chapters to its biography.

These objects and their containers have survived the vicissitudes of earthquakes, floods and fires, personal or familial calamities, shifts in the economic market, as well as changes in taste. Almost by definition, therefore, they do not reflect the average or even the standard high-end production of the period in which they were first fired. Rather, because of their connection to famous tea gatherings, specific historical personages, famous families, shifting fads, or accidents of fate, heirloom ceramics represent the unusual, the rare or even the exotic in Japanese ceramic history. For example, a large Kakiemon style bowl notably missing its lid (which would have been the main feature), that currently would be viewed as only broadly within

28

Introduction

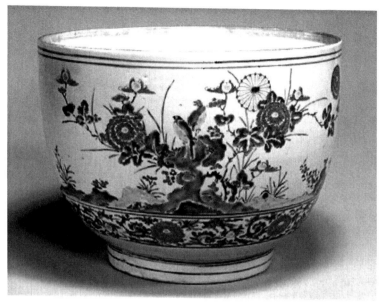

Fig. 1. Large bowl, Kakiemon style, Hizen ware, *c.* 1660-1680s.
Porcelain with design of birds and flowers in overglaze polychrome
enamels. H. 21.4 x D. 30.3. Tokyo National Museum, G5101.
Important Cultural Property.

the Kakiemon style definition, was designated an Important
Cultural Property in 1952 (Fig. 1). This happened because, as
Kakiemon style large lidded bowls were originally export goods
and thus exported, not many existed in Japan at the time and
as a result it appeared unusual. Consequently, however, it is
illustrated as a classic example and often displayed in exhibi-
tions. It can prove somewhat problematic that it is these very
objects that form the basis of the Japanese ceramic art history
canon.

Extant written records can also prove challenging in under-
standing ceramics, for two interconnected reasons. First,
original documents were often destroyed in the fires that fre-
quently ravaged Japanese towns and cities in pre-modern
times. Secondly, such documents often exist only in copies
made at a later period, sometimes several centuries later. This

29

is particularly true of the records held by the present-day potting families who trace their ancestry back over numerous generations, who in many cases lost their original records held in family archives or in ancestral temples during local wars or natural disasters. These families, at least for the last century, have had a strong professional interest in preserving and propagating narratives about their family history.

Archaeologists face multiple challenges in tackling the question of porcelain production in Japan. The large numbers of archaeological excavations that take place in Japan each year have unearthed great quantities of early modern ceramics. While over the last decade the economy has taken a downturn and the number of excavations per annum has decreased, every year still sees a tremendous number being conducted at any point (Seino 2009). A large percentage of these excavations are rescue archaeology. Matsuda Akira writes that in the financial year of 2006-7, 9,600 excavations took place of which only 500 were research excavations (Watanabe 2008, 39); approximately 95% of all excavations in Japan are rescue archaeology. Many excavations are handled at a local level, whether municipal or prefectural, and are therefore not automatically integrated into a nationwide data-based network, though real efforts are being made to address this issue. In addition, site reports, while dutiful, and for the most part comprehensive and produced to time, are not widely distributed in Japan, much less to researchers or libraries in other countries. Until recently, all site reports were collected by the Archaeological Association of Japan, but the Association can no longer house the collection and is looking for a new home for it. These factors all exacerbate the difficulty of assembling the large quantities of excavated porcelain into a coherent and meaningful distribution pattern for the Japanese archipelago. As stated earlier, for the most part excavated historic ceramics are used simply to date archaeological levels, or to determine if the level is intact chronologically, or to examine the level of international or regional contact in a given site and period.

Discussions involving issues such as rapid shifts in ceramic

style, high- versus low-end production, distribution systems, the impact of consumer demand on vessel design, the relationship between foreign and domestic ceramics, excavated examples as compared to heirloom works, and the impact of the East Asian market on the Japanese porcelain industry, are for the most part left unexplored. Instead researchers focus on the well-trodden topoi of ceramic and kiln typologies, settlement strategies, studies on subsistence and dietary patterns, and analyses of deposits and the finds contained within them. Ceramics in private and public collections in Japan are well documented, but studied as a group often on the completely artificial rationale of their current location. Porcelain with painted images on the surface naturally acquires special consideration due to a general emphasis among art historians on painterly concerns.

This book attempts to examine differing approaches to ceramics in medieval and early modern Japan through a single lens by examining the archaeological records and historical materials in the hope that these studies will bring new clarity and coherence to the issues underlying these studies.

Ceramic production and the geography of Japan

The history of ceramic production, and international trade and internal distribution patterns in medieval and early modern Japan, has been conditioned by the geographical position and topology of the Japanese archipelago. Japan is an archipelago composed of four main and many hundreds of smaller islands. The climate ranges greatly from sub-tropical in Okinawa Prefecture in the south to subarctic in the north. Much of the country is covered by mountain ranges, with only approximately 13% of the land arable. Since prehistoric times the coastline of the islands has changed considerably, submerging sites and shifting land-based and sea-based resources. In addition, some of the mountains were and still are volcanic, and this, coupled with frequent earthquakes, creates a shifting landscape. The southern island of Kyushu is geographically

quite close to the Korean Peninsula, and a swift current links southern China and Taiwan to western Kyushu. The smaller southern islands that compose current Okinawa Prefecture (formerly the Ryukyu Kingdom) were annexed as part of the Satsuma domain after a successful invasion in 1609.

Interestingly, some of the earliest examples of ceramic production in the world have been excavated in Japan, dating to around 12,000 BC (Kaner 2003, Kobayashi 2004). The Jômon period (12,500-300 BC) in the archipelago witnessed rich earthenware ceramic-producing cultures (in particular, the above-mentioned Jômon, or 'cord marked' culture, after the distinct rope-imprinted patterns found on many vessels). During the last century BC and the beginning of the first century AD, with the gradual introduction of agriculture, and in particular sericulture, ceramic forms based on new continental technologies and forms appeared, particularly from the Baekje Kingdom (18 BC-660 AD) on the Korean Peninsula.

Stoneware technology (*sueki*, or Sue ware) was introduced from the Continent, most likely from the Silla Kingdom (again on the Korean Peninsula, 57 BC-935 AD) in the fifth century. Ceramic production in Japan was dispersed throughout the three main islands of Honshu, Shikoku and Kyushu, but was centred in the Yamato area near present-day Nara Prefecture and surrounding districts (current Kyoto and Osaka Prefectures). Stoneware industries gradually grew with localised styles developing throughout the islands. Intentionally glazed earthenware was produced in limited quantities during the Nara period (710-794) and in the beginning of the Heian period (794-1185), in imitation of the three-coloured ware (*sansai*) of Tang China. During the subsequent Kamakura period (1185-1333), intentionally glazed stoneware in imitation of the more sophisticated Chinese stoneware imported at the time was produced exclusively in the Seto area (in current Aichi Prefecture). Stoneware vessels fired in other areas were for the most part high fired, with occasional stamped or incised designs ornamenting the surface or with simple ash glaze designs, again in imitation of Chinese styles. Surprisingly, however,

Introduction

painted underglaze decoration does not appear on ceramics produced in Japan until the later sixteenth century, nearly 11,500 years after ceramics were first fired in the archipelago, and just prior to the advent of porcelain. In what is now known to Japanese scholars as the Momoyama period (1573-1615), a rapid diversification of ceramic shapes and designs suddenly started to take place in the 1570s-80s. Some of the main production centres that witnessed this ceramic renaissance included the Seto and Mino area (in present Aichi and Gifu Prefectures), the Shigaraki and Iga kilns (in current Shiga and Mie Prefectures), the Bizen area kilns (in current Okayama and Hyogo Prefectures) and the Karatsu area kilns (in current Saga Prefecture, Kyushu). The trend was consolidated in the early years of the seventeenth century with the growth of yet more local area kiln groups and the widespread introduction of new kiln technologies from the continent. Porcelain was first fired in the 1610s in the Arita area of the Saga domain in northern Kyushu. Within a few decades of Arita's success with porcelain, other domains tried their hand at producing their own brand of porcelain, such as the Himetani kilns in Fukuyama domain (Hiroshima Prefecture), the Hirado Island kilns in the Hirado domain (Nagasaki Prefecture), Hasami kilns in Nagasaki, area kilns in Kumamoto and Kutani in the Kaga domain (Ishikawa Prefecture), to name a few (see Tôyô tôji 1990, 91-3). But the immensely costly and natural resource-depleting industry proved difficult to sustain without substantial external support. The non-Hizen area porcelain-producing kilns closed after a few decades, with the exception of regional Hizen kilns such as the Hasami kilns, which were located only a few kilometres from Arita, but in a neighbouring domain. In addition, the Ureshino kilns, outer Arita area kilns, Imari area kilns and the Kumamoto area kilns continued to produce porcelain. Other porcelain producing kilns in different areas of Japan did not develop until well into the eighteenth century, and many of these porcelain kilns in western Japan were based on Hizen techniques.

33

Hizen porcelain (including that made in Hasami) dominated the Japanese domestic and export market until the later eighteenth century. Hizen porcelain kilns (currently known under kiln, artistic house or area names, such as Arita ware, Imari ware, Hasami ware, Fukagawa, Kôransha, Kakiemon, Imaemon, Gen'emon or Iwao kiln wares) still comprise a major production centre for porcelain in Japan. However, the premier position of this kind of porcelain was eclipsed from the later nineteenth century onwards by porcelain from the larger and more industrially organised kilns of Nagoya and Seto (see Seto City Museum 2004).

The cultural capital of Japan, and importantly where the Emperor resided, was Kyoto in western Honshu from 794 to 1868. With the initiation of the new Meiji era in 1868, the capital and the Emperor were both relocated to Edo in eastern Honshu, which was promptly renamed Tokyo ('Eastern Capital') to commemorate the move. Edo had been the administrative centre for the islands for the previous two and a half centuries. In 1603, Edo was built over a former fishing village, and became home to the ruling military family of shoguns, the Tokugawa. By the 1630s, the 260-odd regional lords (*daimyo*) from all the local domains practised a form of 'alternate residence' (*sankin kôtai*) in Edo. 'Alternate residence' involved the lord and a prescribed retinue, the size of which was dependent on the size of the domain and the lord's status, spending alternate years between Edo and their local domain, while the lord's wife and eldest son resided permanently in the city of Edo in the lord's compound.

By the 1650s, Edo had become one of the largest cities in the world, with over one million inhabitants, many of whom were male, and transient. This alternate residence system and its ramifications had a homogenising effect on local culture, much as television does today. It also provided a constant stimulus for consumption, particularly among the military and merchant classes who formed the greater part of the population in Edo, because of mandatory levels of protocol and entertaining. In addition, the lords had to maintain multiple formal resi-

dences often in three or four cities: their local domain, Edo (the administrative centre), Kyoto (the cultural centre), and Osaka (the economic centre). Despite famines, fires and periodic economic problems, in general in the Edo period (1603-1868) Japan under the Tokugawa Shogunate enjoyed an unprecedented period of peace, sometimes referred to in Western literature as the *Pax Tokugawa*. This was an epoch noted for its flourishing forms of artistic and material culture, including ceramics.

Terminology

The English classification system of ceramics, which divides them into three types – earthenware, stoneware and porcelain – does not translate easily into comparable terms in Japanese, Korean or Chinese. The situation gives rise to all sorts of ambiguities and even misconceptions in discussions of East Asian ceramics using these terms (see Murakami 2005, 281; see also Murakami and Yabe 1993).

In this book the English word 'ceramic' is used as a general designation for earthenware, stoneware and porcelain. 'Earthenware' refers to a particular type of porous ceramic fired at around 800 degrees centigrade. The Japanese earthenware discussed here includes prehistoric Jômon period ware, Nara period glazed earthenware (Nara *sansai*), *kawarake* (undecorated dishes used once and then thrown away), as well as roof tiles and Raku ware or low fired earthenware, produced initially in the Kyoto area from the 1590s onwards (see National Museum of Japanese History 1998, 118-19; Pitelka 2005; and Taoci 2004).

'Stoneware' is used to refer to a ceramic that has a semivitrified body (non-porous) and is fired at the high temperature of at least 1200 degrees centigrade. Japanese terminology for stoneware is currently divided into two categories, *tôki* and *sekki*, distinguished mostly by the length of the firing time, the temperature of the kiln during firing, the style of ware and the presence or non-presence of an intentional glaze. *Tôki* is fired

at between 1000 and 1300 degrees centigrade and is often glazed. *Sekki* is fired at between 1200 and 1300 degrees centigrade, often for a longer period, and is for the most part left unglazed.

The definition of 'porcelain' is roughly similar in English and Japanese; that is to say, porcelain (or *jiki*, in Japanese) refers to a fully vitrified ware with a whitish body that is transparent after firing when thinly potted. Porcelain clay is composed of silica, feldspar and kaolin, and matures at firing temperatures of 1250-1400 degrees centigrade (Sanders 1982, 188). In Japanese, porcelain and stoneware are often referred to together by the catch-all term *tôjiki*, which is similar to the English term 'ceramic' (Wilson 2004, 41-4).

One of the earliest references to Japanese porcelain is found in the *Kakumeiki*, a diary written by the priest Hôrin Shôshô (1592-1668), an abbot of Kinkakuji in Kyoto. He mentions domestic porcelain numerous times in his diary, but the first reference dates to 1639 (Ôhashi 1989, 6-8).[1] Hizen porcelain is also briefly mentioned in a verse entitled 'Kefukigusa' in a poetry compilation by Matsue Shigeyori (1602-1680) dating from the year before, in 1638 (ibid., 7).[2] In both cases, the term used to denote porcelain is *imari yaki*. The term *imari* refers to the town with the same pronunciation eight kilometres north-west of Arita-cho (in Hizen province, Saga domain; current Saga Prefecture). Imari was the principal port from which Hizen porcelain was shipped. Due to its weight and fragile nature, Hizen porcelain was distributed by shipping throughout the archipelago using waterways whenever possible, rather than over land. The characters for the *i* used in the two records mentioned above and the *i* used for the town of Imari differ, but by the mid- to late seventeenth century the Japanese term *imari yaki* (Imari ceramic) was almost uniformly written with characters of the port town of Imari that are still in use today (ibid., 8). The use of the port or a specific town name to refer to ceramic ware produced in an adjoining area was (and still is) common practice. The stoneware of Kyushu, southern Honshu and Shikoku was commonly referred to as *karatsu-mono* after the celebrated stoneware workshops of Karatsu. Kilns of the

Introduction

Seto district provided the generic name *seto-mono* for stoneware produced throughout central and northern Honshu (Sasaki 1994, 2-8). These terms do not distinguish between types of ceramic; they merely refer to the ceramic medium itself.

The term 'Hizen porcelain' (*Hizen jiki*) refers to porcelain made throughout the entire historical Hizen area, which includes Arita-cho *uchiyama* (inner), *sotoyama* (outer) kilns and the *ô-sotoyama* (greater outer kilns), as well as other regional porcelain kilns in Ureshino, Mikawachi, Imari, Ôkawachi, and in neighbouring Nagasaki and Kumamoto Prefectures. The term 'Hizen ware' (*Hizen yaki*) is more comprehensive and includes all the stoneware fired in the area as well, for example both Karatsu and Arita ware. Originally proposed by the Kyushu Ceramic Museum in Arita led by scholars such as Ôhashi Kôji, this term is increasingly used by archaeologists, though not yet in a uniform manner. The Tokyo National Museum uses the term 'Imari' while the Idemitsu Museum of Arts uses the term 'Arita', reflecting the fact that a consensus on terminology has not yet been reached. The Kyushu Ceramic Museum argues that the adoption or standardisation of the generic term 'Hizen porcelain' helps to clarify sub-types produced in the region. Arita ware, the various Imari wares (i.e. Early Imari or *shoki* Imari, Old Imari or *ko-Imari*), Kokutani, and Kakiemon are all considered styles or sub-types of Hizen porcelain. Other scholars claim that this is a contemporary designation and that historically based terminology such as 'Imari' would be more accurate and accord with the documentary record. While use of the designation 'Arita' for porcelain made in the Arita area is probably the most common, certainly outside Japan, this identification is problematic since much of the historical porcelain labelled 'Arita' was produced near but in fact outside the administrative boundaries of Arita, and possibly even in different domains.

Historically-based Japanese terms used to refer to Chinese and Korean nationals are no less problematic. Early modern period documents often do not distinguish between the sover-

eign entities of China and Korea; the geographical areas are merged together under the rubric of the 'Middle Kingdom' – Korea being nominally a tribute state of the Ming Empire. The records of the Nabeshima family, who were the lords (daimyo) of the Hizen domain from the late sixteenth century through to 1868, and were responsible for the development of the porcelain industry in their domain, do not shed light on this problem. In the case of porcelain, for example, a document referred to as the Nabeshima domain document (*Saga honpon*) of 1637 employs the term *tōjin* (literally 'Tang [or Chinese] person') to refer to all foreign ceramicists, but historians currently interpret it here as referring to those of Korean descent.[3] The common conflation of China and Korea into the word *tō* is also seen in a memorandum signed by the Korean-born potter Kanegae Sanbei I (d. 1655, also known as Ri Sanpei) in which he refers to himself and his compatriots as *tōjin*.[4] In general, Chinese nationals in Japan during the sixteenth to eighteenth centuries, when not referred to as *tōjin* (perhaps translatable as 'continental'), were called *minjin* or Ming people (Fig. 2). In eighteenth- and nineteenth-century documents, however, Chinese nationals are also referred to as *shinjin*, or 'Qing people' (Qing period 1662-1911). Korean nationals in early modern Japanese documents are recorded as *tōjin*, *chōsenjin* or *kōraijin*.

The argument for the Korean origins of Japanese porcelain and the attribution of porcelain production to Kanagae Sanpei, particularly from the early twentieth century, and their endurance into the twenty-first century, are tied into the complicated historical relationship that Japan shares with Korea. The two countries' relationship is long and entwined. Certainly the Korean Peninsula has been the source of inspiration and knowledge of ceramics from the fourth century onwards in the Japanese archipelago. Korean ceramics were prized from early periods, and were certainly held in high esteem by the cultural elite in Japan from the fifteenth century to the present day. But rather than a national transfer of knowledge, technical exchange in kiln technology from Korea to Japan surely took the form of individuals migrating and local exchanges and technology

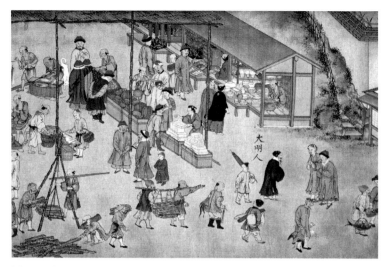

Fig. 2. Handscroll with scenes of life in the Chinese Settlement in Nagasaki (*Tôjin yashiki*), late eighteenth century. Ink and colours on silk, inscribed. H. 33cm, L. 463cm. British Museum 1944, 1014,0.23.

transfers on a regional and sporadic basis.

The larger national histories are more complicated. There is a current generalised feeling of shame in Japan about Japanese imperialism and the annexation of the Korean Peninsula in 1910-1945. This shame is mixed with the desire to absolve the 'self' and compensate the 'other' by esteeming the products and the contributions that were made by Korean individuals, such as the itinerant potters who were employed in the Saga domain to create everyday ceramics. Interestingly this does not apply to such a degree in other fields where Korean nationals made contributions to Japanese heritage, such as calligraphy, painting, printing and lacquer. In addition there is the factor of the exotic, or the 'other'. The fact that porcelain was introduced in the image of China and made as a substitute for Chinese porcelain meant that its production, even if in Japan, was boosted through the association with things foreign. The Nabeshima lords certainly realised the importance of the association of their new porcelain with some kind of continen-

tal authenticity and in their edict in 1637 restricted porcelain potters officially to those who were *tôjin*, or Chinese or Continental (interpreted in the nineteenth to twentieth centuries as Korean nationals). Whether this was actually the case has been debated by Japanese historians. Most agree it was symbolic. But even so, it is telling of the branding power of China.

Plan of the book

This book examines the scholarship surrounding the use and meaning of Chinese porcelain in Japan and the origins of Japanese domestic porcelain production. Often what is not expressed in these debates is just as telling as what is. It becomes clear through an examination of the circumstances surrounding what I term these porcelain 'vessels of influence', that rather than being preoccupied by a quest for origin or for identifying the right constellation of fortuitous circumstances, it is much more fruitful to see the development of porcelain production in terms of consumer demand and pan-Asian trade, which resulted in significant profits for the ruling elite, local officials and well-placed merchants. The porcelain debates as they exist today reveal more about contemporary issues than they do about the motivating factors of past events. Concerns with nationality, specific product definition and linear progression of style are certainly of recent origin.

In summary, the study of porcelain can reveal much about the past and present through an examination of how it has been produced and also, importantly, how it has been consumed (what styles were popular, by whom, in what quantity, in what distributional patterns) in the many years since its manufacture. Shifting discourses involving porcelain in Japan provide windows into the research fields of material culture and art history that can also be usefully applied to other media.

This book offers a new approach to our understanding of porcelain 'vessels of influence'. While examining the role of Chinese porcelain in medieval and early modern Japan, it also delves into the meaning of, motivation for, and rapid develop-

ment of Japanese porcelain. There were 260 odd semi-independent domains during the Edo period (1615-1868). Each of these domains needed to be fiscally independent with sources of income. The Nabeshima were the lords (daimyo) of the Saga domain in Hizen, and controlled in part the only international trading port of Nagasaki for the Tokugawa government. The Nabeshima lords and their advisers must have been aware of the fiscal advantage of having a domestic supply of porcelain to compete with Chinese imports, especially when the Chinese imports became difficult to acquire and with an continued domestic market for porcelain in Japan. Porcelain was to become for the Nabeshima and continues to be for Saga Prefecture today, an important industry that helps to support the local economy. The Nabeshima succeeded in a relatively short period in creating their own successful brand of China through their locally produced porcelain.

Through the examination of the role of the image of China and that of a domesticated and commercialised 'china' in Japan, a more complete picture of Japan's extraordinarily rich material culture emerges that uncovers the complex interactions between governments, taste-makers, traders, merchants, consumers, imports and technologies.

Chapter 1 examines the scholarship in the field of ceramic study, using Japanese and non-Japanese sources. An in-depth look at the scholarship reveals how debates on porcelain are more than studies of ceramic production and design.

Chapter 2 provides a discussion of the curators, connoisseurs and China brokers who created the market for porcelain in Japan in the medieval and early modern periods. It includes a review of the debates that surround the complex history of tea in Japan, and of tea masters, both of which have a deeply intertwined relationship with ceramics that continues to the present day. The large quantities of Chinese porcelain (tradeware) imported into Japan in the sixteenth to seventeenth centuries, hitherto generally uncommented upon, are introduced and placed in historical context. The significant presence of such tradeware clearly calls for a reassessment of the role of

porcelain as a prestige good in the lifestyle of samurai, priests and the merchant elite in early modern Japan.

Chapter 3 focuses on the mechanics of international trade and early domestic responses to Chinese ceramics, with a brief examination of domestic stoneware production. Here we touch upon the most contentious period of Japanese ceramic history, Toyotomi Hideyoshi's misguided invasions of the Korean Peninsula in 1592 and 1597-8. This chapter outlines the debates on this politically charged topic, and describes some of the latest archaeological evidence. It addresses the formation of a domestic porcelain production as a response to the growing influx and general popularity of Chinese porcelain. Early kiln sites in the Arita area, the major production centre for porcelain in Japan until the late eighteenth century, have been well surveyed and excavated, and provide ample material for reassessment of the domestic porcelain industry. Notwithstanding market forces and domestic consumer demand, the style of early Japanese porcelain was based on a generalised image of China and chinaware, adapted to Japanese consumer tastes. By the seventeenth century, within a few decades of production and the establishment of a brand image, the Arita area kilns began to cater to a broad range of customers with varying tastes and price range, much of which was still in the image of China and Chinese porcelain, even going so far as to bear Chinese reign dates on their bases.

The conclusion points to advances in Japan in the debate regarding the meaning of porcelain and future directions for study. In particular, advances in the studies of early Japanese porcelain in the Southeast Asian context point to interesting new interpretations and ways forward in the larger picture of the role of East Asian porcelain and trade in the early modern period. The fact that Japanese porcelain has been uncovered in archaeological contexts in Cuba in the 1660s adds incrementally to our knowledge of the role and importance of international trade in the formation of the Japanese porcelain industry.

From the seventeenth century onwards, the growth of a

Introduction

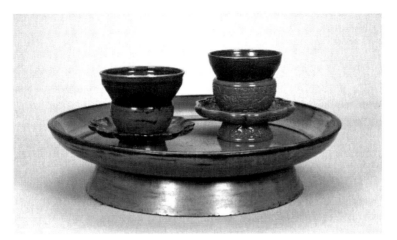

Fig. 3. Two Chinese Jian ware bowls on Japanese carved Negoro lacquer stands resting on a Japanese Negoro lacquer tray (Jian ware, c. thirteenth to fourteenth century, and lacquer stands and tray c. fifteenth to sixteenth century). Idemitsu Museum of Arts, Tokyo.

merchant economy, social and political stability, coupled with increasing leisure time and an emphasis on pageantry and entertaining in the newly formed social order in Japan, all coalesced to encourage domestic demand for porcelain. This in turn encouraged the rapid growth of the domestic industry to provide substitutes for imported ceramics. When porcelain is examined within the theme of the shifting role of chinaware as taste marker in medieval to early modern Japan, the emergence of a domestic industry at the beginning of the Edo period becomes readily understandable. Chinese ceramics such as Jian ware (Fig. 3) and Longquan celadon ware were luxury items that were individually procured in assembled collections of the wealthy and powerful in medieval Japan. With the shifting role of porcelain to that of Chinese blue and white ceramics from Jingdezhen and Zhangzhou area kilns arriving in Japan in larger and larger quantities and furthermore in sets to be used in entertaining among a greater swath of society, Chinese porcelain had become an attainable power symbol for the newly empowered samurai and wealthy classes. It is at this point,

with the saturation of the market with Chinese wares, that a domestic industry could successfully be established with a more or less guaranteed market share. The Nabeshima lords of the Saga domain carefully nurtured and oversaw the core of their porcelain industry in inner Arita-cho from 1637 to the nineteenth century. For the Nabeshima these porcelains produced in their own domain were certainly vessels of influence.

The narratives about lineage, bloodlines and nationality are interesting footnotes that, to be sure, may play a part in deepening our understanding, but in reality are more to do with a longing, shared by potters and researchers alike, for a founding myth. They belong to debates other than those regarding porcelain in medieval and early modern Japan.

1

Porcelain Debates in Japan and in the West

At least half the specimens figured, and a large number of them described, come under the definition of 'export goods', many of which are doubtless very beautiful, but as much out of place in a collection of Japanese pottery as would be a lot of Manchester-made Java sarongs in a collection of English prints.

 Edward Sylvester Morse (1901)

The pressing issues for Japanese and Western scholars are indeed different and defined by national concerns. However, art-historical scholarship on porcelain in general has been limited to concerns based on collecting, specific collectors and assembled collections. This in turn places emphasis of study on classification and connoisseurship, often to the detriment of context. Archaeological study, while privileging context, often leaves the history of porcelain and the individual works behind. It is hoped that this study reveals the potential for an integrated approach, leading to a deeper understanding of porcelain in and of itself, and as part of the material culture of medieval and early modern Japan.

The start of the debate in the West

The study of porcelain has generated much passion both in Japan and abroad, fuelling debates that sometimes find their way into the press, and even occasionally cross entire oceans and continents. The vehement view quoted above, expressed at

the start of the twentieth century by the American zoologist and archaeologist Edward Sylvester Morse (1838-1925) was directed towards his rival James Lord Bowes (1834-1899), a British textile merchant based in Liverpool, England, who also had an passion for Japanese ceramics and like Morse put together a large collection and created public displays. The vehemence was typical of many a curator and collector debating on the nature of what constituted an 'authentic' example.

When he made this statement, Morse, soon to become Director of the Peabody Museum in Salem (the present Peabody Essex Museum), had spent twenty-five years collecting and studying Japanese ceramics, and had travelled in Japan extensively on three occasions. On his first trip, in 1877, which had been in the capacity of a brachiopod specialist, Morse had located and excavated the Ômori Shell Middens. Here he discovered well-preserved ceramics and other remains of the Jômon ('cord-marked') culture; he was in fact the person who coined the name for this type of ceramic decoration after which the period was named (Morse 1879, 29). Morse continued to further explore Japan's ceramic legacy, focusing first on shell-shaped ceramics and then addressing his attention to the entire history of the Japanese ceramic industry with the help of Ninagawa Noritane (1835-1885), a retired government official with a small museum, printing press and ceramic shop in Tokyo (Rousmaniere 2000-2001).

In the course of Morse's impassioned collecting of what he sincerely believed were ceramics made for the home market in Japan, as opposed to items made for export, he amassed a huge collection of over six thousand pieces, which in 1890 was purchased for a high price by the fledgling Museum of Fine Arts, Boston, through public subscription. By 1901 Morse had completed a catalogue for the museum of his beloved collection, which consisted mostly of stoneware examples from the many regional kilns throughout Japan at the time of the late Edo and Meiji periods. He was deeply influenced by Ninagawa's classification system, which will be discussed below (see Morse 1901, see also Wayman 1942).

1. Porcelain Debates in Japan and in the West

James Lord Bowes, in contrast, never set foot in Japan (Baird 2000, Rousmaniere 2001, 2008). Nevertheless, he was a passionate collector of Japanese porcelain and decorative arts. In 1879 he co-authored one of the first books on Japanese ceramics in English, entitled *Keramic Art of Japan* (Audsley and Bowes 1879). He subsequently became Her Majesty's Honorary Consul for Japan at Liverpool and opened one of the first museums in the United Kingdom dedicated solely to Japanese art. Bowes' museum collection was unfortunately dispersed shortly after his death, but his legacy lives on through his many publications and, ironically, through the heated debates he had with Morse on the nature and aesthetics of Japanese ceramics, particularly porcelain.

With humour and insight, the ceramic historian Richard Wilson has named the exchanges between Morse and Bowes the 'porcelain debates' (Wilson 1987). The debates lasted for approximately twenty years, culminating in Bowes' book aptly titled *A Vindication of Japanese Porcelain* (1891), which polarised the Western scholarly community interested in things Japanese. The argument was ostensibly over what each collector thought was truly 'authentic' about Japanese ceramics (basically stoneware versus porcelain), but in fact these quibbles reflected more each man's own attitudes and concerns about the idea of the nation as well as self-identity issues, a feature often seen in present-day research.

Morse, a scientist at heart, firmly believed that having lived in Japan, having studied with Japanese specialists using Japanese sources, and having witnessed Japanese ceramic production, he had privileged access to and a clear understanding of Japanese ceramics and their typology. Bowes, on the other hand, flatly dismissed Morse's focus on stoneware, stating emphatically that Japanese porcelain was a more worthy topic of study and display as it was beautiful and, incidentally, was being promoted by the Japanese government. Bowes felt pained that Morse did not recognise the true artistic genius of Japanese porcelain that he had intuitively discovered through examples studied and purchased during International

47

Expositions and from numerous dealers supplying Europe with Japanese ceramics at the time (see Takeuchi 2001, 60-3). Shortly before his death in 1891, Bowes wrote:

> I am aware that the rude objects which come within the first category [undecorated wares] have exercised a strange and, to others beside myself, an unaccountable fascination over the minds of certain American collectors, who have become so absorbed in the contemplation of these early chajin [tea specialists] wares that they are apparently unable to see any beauty in the artistic works produced during the past two centuries (Bowes 1891).

Since the time of these initial debates, and in partial consequence of them, studies of East Asian porcelain, particularly in Western literature, have separated into the somewhat arbitrary categories of 'porcelain for export' versus 'domestic stoneware'. Much Japanese porcelain is still thought in the West to be made almost exclusively for export, with a few exceptions. In general, porcelain studies in the West, as detailed below, focus either on export porcelain or on domestic stoneware.

As an inevitable result, Western publications and exhibitions rarely allude to domestic-style porcelain (as opposed to stoneware) in the context of Japanese traditional aesthetics. If Japanese porcelain is discussed in European literature at all, in general the discussion refers to wares from the Hizen (Arita area) kilns or nearby Mikawachi (Hirado), two major export producing areas, rather than wares from Seto or Kyoto, two major domestic porcelain producing areas in the later Edo period, for the reason that the former are familiar to Western audiences due to their large export production. The result is that a full picture of Japanese porcelain production is sadly left unexplored in Western scholarship. The bulk of Japanese porcelain production from its inception until today was made for the domestic market.

The Western bias for the study of wares that were produced for or made available to the West is readily understandable,

but should be corrected in order to gain a more comprehensive understanding of this important craft industry.

Ceramic scholarship in Japan

Ceramic study in Japan has tended to focus on certain specific topics, usually connoisseurship and typology. Research also centres on issues of tea gatherings, such as histories of objects commented on by tea masters in their diaries and records or written descriptions of certain historical important gatherings. A number of factors have contributed to this situation. These include the renewed importance of tea practice and gatherings, the rise of contemporary schools of tea, the emphasis placed on heirloom objects and their documentation in the art market in Japan, and the codification of connoisseurship, classification and ranking of ceramic wares that took place from the fifteenth century onwards.[1]

In medieval Japan Chinese ceramics were ranked in a tripartite system according to their level of desirability and rarity in manuals of taste commissioned by the ruling elite. One such manual of taste is the *Kundaikan sôchôki* (Record of Arrangements in the Shogunal Guest Hall) originally created by Nôami and Sôami in 1522 (Kawai 2002, 39-40) (see Fig. 5 on p. 71). While the method of ranking ceramics in these documents was clearly based on earlier Chinese prototypes, the type of wares that were considered desirable in Japan differed (see Clunas 1988, 49). In medieval Japanese society, Chinese stoneware such as Jian and Longquan received pride of place over ancient Guan and Ding wares preferred by the Chinese elite of the period (see Hayashiya 1973; see also Rousmaniere 2002, 94-5).[2] Chinese ceramics in medieval Japan and the manuals are further discussed in Chapter 2.

In the twentieth- to twenty-first-century art historical discourse, the study of ceramics within Japan is basically the preserve of museums, tea aficionados and collectors' circles. Many excellent institutions actively publish research on ceramics through exhibition catalogues, newsletters and special

publications. In recent years, cutting-edge research and discoveries have been first published in catalogues for exhibitions at museums. These museums include the Idemitsu Museum of Arts, the Nezu Museum, the Museum of Oriental Ceramics, Osaka, the Kyushu Ceramic Museum, the Museum of Ceramic Art, Hyogo, Aichi Prefectural Ceramic Museum, the Gifu Prefectural Ceramic Museum and the Fukui Prefectural Museum of Ceramics.[3]

In archaeological circles in Japan ceramic research is advanced. All the archaeological societies, of which there are many, publish papers on ceramic studies. Certain publications are devoted solely to the study of ceramics in archaeological contexts. Such, for example, is the *Bôeki tôji kenkyûkai* [Overseas Trade Ceramic Society]. Many of these societies focus on a geographical area or historical period, such as the *Edo iseki kenkyûkai* [Edo Archaeological Society, which specialises in seventeenth- to nineteenth-century sites], *Kansai kôkogaku kenkyûkai* [Kansai Archaeological Society, which places emphasis on the Kansai area and work done by Kansai archaeologists], *Kyûshu kinsei tôji kenkyûkai* [Early Modern Kyushu Ceramic Society, which focuses on Kyushu archaeology and related topics], and *Banten iseki kenkyûkai* [Bantan Archaeological Society, which focuses on Indonesia and Southeast Asian trade, often in relation to Japan]. Challenges faced by the ceramic scholar wanting to access these materials include: the limited distribution of journals and conference proceedings; the difficulty, especially for overseas researchers, in accessing many of the smaller societies' newsletters and journals; and the fact that research on ceramics in Japan is published almost exclusively in Japanese. Recently, however, there is a growing trend of attaching a plate list, summaries, or even a selection of sections, in translation, mostly in English, which helps to disseminate the research to a larger international community. The internet has also greatly helped dissemination.

The *Tôyô tôji gakkai* [Japanese Society of Oriental Ceramic Studies] is an example of a scholarly society that publishes a

1. Porcelain Debates in Japan and in the West

truly exceptional yearly publication based on vetted papers presented at its sponsored conferences. Its membership includes archaeologists and art historians, as well as a few tea specialists and ceramic artists. This society, which has an elected membership, was formed in 1973 under the direction of the eminent ceramic historian Koyama Fujio (1900-1975), at that time a Trustee of the Idemitsu Museum of Arts (see Idemitsu Museum of Arts, 2003). Its model was the Oriental Ceramic Society (OCS) in London, which publishes annual proceedings of its sponsored lecture series and a newsletter.[4]

While both societies focus on all Asian-related ceramics, including European ceramics influenced by Asian prototypes, the OCS draws from the long European tradition of the passionate amateur scholar, such as the above-mentioned James Lord Bowes, and its base comprises well-informed collectors and museum curators. The *Tôyô tôji gakkai*, however, has managed to bridge the gap between amateur and professional, and attracts professional academics and archaeologists as well as amateur collectors.

Specialist journals in Japanese, often scholarly in content, are available to the general public and help to disseminate ceramic research. One monthly journal devoted to the study of ceramics from a multidisciplinary approach, including tea-related studies, archaeology and art history, is *Tôsetsu* [Magazine of the Tokyo Ceramic Society], created in 1953 by Okuda Seiichi. This important ceramic scholar and professor at Tokyo University marvelled at the many examples of Kakiemon-style Hizen porcelain he viewed at exhibitions and private collections during his foreign travels, rarely seen in Japan at the time. In his youth, well prior to his trip to Europe, Okuda had an interest in overglaze enamel porcelains and formed with Ôkôchi Masatoshi and other scholars from the University of Tokyo in 1914 a study group called the *Saikôkai* [Overglaze Decorated Jar Society], which proved to be quite influential in the study of ceramics, and published its own journal until it was disbanded in 1923 (see Arakawa 2004, 11-16).[5] Other popular monthly journals mostly devoted to ceramics include

51

Me no me [Viewing Through Your Own Eyes] which has arti-
cles by scholars, dealers and collectors as well as exhibitions
and dealer listings, and the innovative but unfortunately now
defunct journal *Tôjirô* [Ceramic Gentleman], each issue of
which revisited old topics or attempted new ways of looking at
ceramics both modern and historical. Certain tea-related jour-
nals also include articles on ceramic history, such as *Chadôshi,
Tankô* [History of the Way of Tea, Brief Acquaintances], a
beautifully illustrated magazine sponsored by the Urasenke
International, one of the major whipped tea appreciation
schools with a worldwide network.

Porcelain has long held a marginal position in the world of
Japanese ceramics, in part because it is a relatively recent
phenomenon (initiated approximately 11,600 years after earth-
enware was first fired), but also because porcelain has always
been intricately linked with Chinese aesthetics, and was often
historically labelled *Nankin sometsuke* (Nanjing [Chinese] un-
derglaze blue porcelain) even though the chronicler usually
was well aware that the object in question was in fact made in
Japan (see Rousmaniere 2002). Additionally, developments in
early modern tea taste (*chanoyu* or whipped tea), to be explored
in the next chapter, contributed to a privileging of earthenware
and stoneware vessels over porcelain as these are the utensils
mostly employed. This bias influenced the opinions of certain
late nineteenth-century Western scholars who had travelled to
Japan, such as those held by Edward Sylvester Morse.

In reality, in the market place if not in the journals, porce-
lain in late nineteenth-century Japan witnessed a heady
revival of fortunes. Its association with things Chinese, and
with the growing use of steeped tea (*sencha,* as opposed to
whipped tea or *matcha*), linked with Qing period (1644-1912)
scholarly tastes, ensured its practical popularity. In addition,
technological developments brought to Japan by ceramic spe-
cialists from abroad such as Gottfried Wagener (1831-1892) of
Germany enabled the production of new styles and cheaper
wares. All these factors, coupled with a booming export market
at the end of the nineteenth century, accounted for porcelain's

commercial revival at this time (Pollard 2002, 47-79, and Schaap 1987).

Japanese porcelain (as opposed to earthenware and stoneware) is occasionally and specifically mentioned in early modern documents and tea records. Referred to as 'Imari', Hizen porcelain gradually came to be a well-known product (*meibutsu*) of the Saga domain by the second half of the eighteenth century. 'Imari' even warranted mention in late Edo-period popular guidebooks, such as the 1799 *Sankai meisan zue* [Illustrated Delicacies of Local Regions], which recorded famous products and sites of interest in Japan (see Nishida 1974, Introduction).[6] Hizen 'Imari' porcelain was known as a famous local product throughout the Meiji period and is illustrated in the 1877 guidebook *Dai Nippon bussan zu-e* [Illustrated Produce of the Country of Japan] illustrated by the print artist Andô Hiroshige III (1842-1894).

Attempts at systematic study of Japanese ceramics began in earnest with Ninagawa Noritane's six-volume work, *Kanko zusetsu* [Illustrated Discourse on Ancient Objects], published from 1875-79 (Rousmaniere 2000-1, 83-92). In these handsomely illustrated volumes published by the author's own press, Ninagawa attempted a survey of the entire history of Japanese ceramics. In Volume 5 he tried to corroborate his statements in earlier chapters by including descriptions of digging up kiln sites and comparing extracted sherds with ceramics at hand. The volumes were rapidly and poorly translated into French by the pre-eminent porcelain manufacturer, the Sèvres Factory, and published by Ahrens & Co. in Yokohama in small format without any illustrations, meant to accompany the large and lavish Japanese volumes that were hand-coloured. Most copies of the Japanese limited edition with their French translations found their way to Europe; Augustus Wollaston Franks (1826-1897), then Keeper at the British Museum, acquired them serially as early as 1877.

These volumes certainly appear to have influenced the formation of European Japanese ceramic collections, such as those of the British Museum, the Guimet Museum, and the

Vessels of Influence

Fig. 4. A page of one of the hand-coloured and printed five-volume set titled *Kanko zusetsu* [Illustrated Catalogue of Archaeological Objects] by Ninagawa Noritane (1835-1882), 1875-9, with a Kishû ware dish purchased from Noritane by A.W. Franks for the British Museum. British Museum.

Corfu Museum of Asian Art (see Rousmaniere 2000-1, 83-92). And this was doubtless Ninagawa's intention; he appears expressly to have created a beautifully illustrated and historically informative order manual (Volumes 1-5) for the main purpose of helping foreign collectors to assemble collections of Japanese ceramics (Fig. 4).

It is significant that Ninagawa included little porcelain in his volumes, which focused instead on prehistoric earthenware, early and medieval stoneware, and a wide range of localised Edo and early Meiji stoneware production, some of which would have been used during tea gatherings. It would seem that Ninagawa was attempting to reflect the range of Japanese domestic earthenware and stoneware production from prehistory to his own time, and focused on wares that were readily available and that could be purchased in some quantity. One result of this was that wares that represented the high end of artistic production as recognised in Japan, that is to say ceram-

54

ics made by individual famous potters such as Nonomura Nin-
sei (active second half of seventeenth century), and wares that
were difficult to procure at that point, such as Nabeshima
domain presentation porcelains, were left out of the picture and
out of his book.

In 1878, the historian Kurokawa Maeyori (1829-1906),
working with Ninagawa and active in the building of collec-
tions for the newly created Japanese nation, compiled the
important *Kôgei shiryô* [Compendium of Decorative Arts]. Dur-
ing this same period, another ceramic work titled *Nihon
tôkôshi* [History of Japanese Ceramics] was written by Shiota
Makoto (1837-1917). This last volume provided the intellectual
foundation for the first attempt at representing the history of
Japanese ceramics at the 1876 Philadelphia Centennial Exhi-
bition. The innovative idea of displaying at the Philadelphia
Exhibition not only recently produced ceramics for sale, but
also an historical overview of Japanese ceramics, from prehis-
toric Jômon examples to the present day, was in part the
brainchild of Augustus Wollaston Franks and colleagues in
London, who convinced the British government to provide the
funds to subsidise the study and purchase of these ceramics for
the British nation. The resulting ceramic collection, after being
on view in Philadelphia, was sent to London *in toto* and acces-
sioned into the new South Kensington Museum (now the
Victoria and Albert Museum). Franks subsequently wrote the
Japanese Pottery handbook for the South Kensington Museum,
using Shiota's thorough study (see Franks 1876, 1880 and
1906).

The study of porcelain in Japan

The systematic study of Hizen porcelain, in particular in Ja-
pan, began with the manuscript *Sarayama sôgyô shirabe* (Sur-
vey of Porcelain Production at Sarayama [Arita-cho]), compiled
in 1873. The study was organised and edited by Kume Kuni-
take, an amateur historian, and was based on documents
housed in the newly formed Saga Prefectural Office (see

Nishida 1974: Introduction; see also Arita-cho shi hensan iinkai 1985, 1-46 and 475-608). Researchers working on the history of Japanese porcelain have tended to accept the documents listed in Kume's text at face value, often without confirming matters of authenticity, which to be fair is a complicated matter as the documents are often held in the potting families and hard to access or extant only in copies.

Scientific research concerning Hizen overglaze porcelain began in earnest in the second decade of the twentieth century, when the study and collection of Japanese ceramics became popular among non-tea affiliated enthusiasts in Japan (see Ôkôchi 1916). In 1916, Ôkôchi Masatoshi published the first formalised definition of Kakiemon and Nabeshima ware, and was also the first to publish the Kakiemon family chronology, based on privately held Kakiemon family documents (see Ishikawa Prefectural Museum and Kyushu Ceramic Museum 1987).[7] In 1919, Ôkôchi went on to publish '*Kokutani-ron*' [An Argument for Old Kutani] in the *Saikôkai kôenroku* [Record of Lectures for the Saikôkai Group]. In this paper he classifies eight categories of Kokutani: *Nankin-de* (Nanjing style), *Sôtatsu-de* (Sôtatsu style, after the artist Tawaraya Sôtatsu, d. 1634?), *Morikage-de* (Morikage style; after the artist Kusumi Morikage, *c.* 1620-1690), *Imari-de* (Imari style), *Perusha-de* (Persian style), *ao Kutani-de* (Blue Kutani style), *suisaka-de* (Suisaka style, a type of iron-oxide glaze), and *seiji-de* (celadon). Interestingly, he identifies porcelain styles from the Edo period in four general categories; those from foreign countries (China and Persia); those with local porcelain traditions (Imari and Kutani); those with glaze colouring; and those associated with famous painting artists of the period (Sôtatsu and Morikage).

This type of analysis is standard for the period – part national style, part typology and part traditional art history. What is unusual and innovative is that Ôkôchi's analysis is applied to ceramics, as opposed to painting or sculpture. Ôkôchi also adeptly highlighted the two topics in Japanese porcelain production that still continue to fuel passionate de-

bate, those that surround the 'Kokutani style' and of 'Kakiemon style' respectively. His research definitively positioned ceramic studies in the academic discourse.

By 1935, the same year that war with China began, eleven Kakiemon-style porcelain pieces and seventeen Kokutani style-porcelain pieces were registered as National Treasures in the pre-war classification system as a direct result of the interest in overglaze enamel porcelain style generated by Ôkôchi and others. At the same time, and possibly for related reasons, major collectors, such as Idemitsu Sazô (1885-1981) and Nezu Koichirô Sr. (1860-1940) started to turn their attention to Kokutani ware (see Arakawa 2004).[8] The timing of the elevation of Japanese porcelain, both export porcelain and domestic porcelain, to the status of high art that was recognised by the nation, was perhaps a reflection of a sense of national competition with previous Chinese prototypes upon which these styles were based.

Government sanction for the two styles of porcelain, Kakiemon and Kokutani, had the effect of codifying these styles as well as opening them up to further scrutiny. The following year an amateur historian, Nakajima Hiroki, compiled all the available written documentation, oral history and legends that he could locate regarding Hizen porcelain. His publication *Hizen tôjishi kô* [Compendium of Hizen Ceramics histories] was undiscriminating in the information included with the result that legends started to be taken as fact by subsequent researchers and enthusiasts (see Nakajima 1936).

Nakajima included the documents in possession of the Kakiemon family. Here the debate centres on the historical existence and role of the original artisan named Kakiemon, who is said to have been active in the Nagasaki-Arita-cho area in the mid-seventeenth century, and whose descendants continue to produce very beautifully decorated high-quality porcelain in Arita today in the same location.

A summary of the Kakiemon debate is useful. The Japanese potter Sakaida Kizaemon (1596-1666) is thought either to have taken or been given the name 'Kakiemon', in celebration of the

bright red colour of the persimmon (*kaki*), the red colour of overglaze enamel of which he is said to have been a consummate master. The legend goes that Kakiemon learnt the overglaze enamel technique of decorating porcelain (*aka-e*, literally red overglazing) from a Chinese merchant in the Nagasaki area and successfully recreated the process himself on Hizen porcelain in 1647. The present-day Kakiemon XIV (born in 1934) still supervises his family's wood-fired climbing kiln and the production of bright overglaze colours, similar to those made by his ancestors, particularly of the second half of the seventeenth century (considered 'classic' Kakiemon style) on creamy white porcelain surfaces.

The history and heritage of this style of ware are, however, based on a nineteenth-century document that is a transcription of an earlier one, now lost. Notwithstanding the question of the authenticity of the document itself, the current Kakiemon kiln received Japanese government-listed status in 1971 for its preservation of overglaze enamelling technique, and Sakaida Kakiemon XIV has been designated a Living National Treasure from 2001 for his mastery of the technique. He is very active, not only creating his own and his workshop's ceramics and designs, but in also studying the history of Kakiemon wares and actively promoting Hizen porcelain in general in Japan and abroad. He was until 2009 the honorary head of the former Japanese government-designated Center of Excellence (COE) programme for the Kakiemon-style Ceramic Art Research Center at Kyoto Sangyô University, Fukuoka.

Official recognition that Kakiemon-style porcelain could be traced back in an unbroken line to the mid-seventeenth century has had a significant impact on the kiln and its products' status, popularity and profitability. However, the date of 1647 noted in the Kakiemon records for the first use of overglaze enamel on Hizen ware has not been confirmed archaeologically. Further, the kiln identified in the 1950s as the original Kakiemon kiln (in a different location from the present Kakiemon kiln) appears to have been run possibly by different workshops and even other families at different times, and

produced divergent styles. This was typical for climbing kilns of the period, which were large and expensive to maintain, and as a rule not run by a single family. There was a distinct high-end Kakiemon style however, certainly from the 1670s onwards until the mid eighteenth century. After that time the Kakiemon name is used on ceramics of a different style and it is certain that the family continued to produce porcelain. The issue is quite complicated, not least because research is sometimes conducted by scholars who feel protective of Arita's history. Recently, however, Ôhashi Kôji has put his full efforts behind clarifying the issue of exactly what is Kakiemon style. He has focused on the period between the 1670s and 1690s and proposed a definition of 'Classic' Kakiemon and 'Broadly-based' Kakiemon style (Ôhashi 2010). This is a helpful step in clarifying the issue, but more work still needs to be done to explore what happened to the Kakiemon family and the Kakiemon kiln in the eighteenth century.

The debate surrounding Kokutani-style porcelain and its relation to Kutani ware is one of the more lasting controversies in Japanese ceramic scholarship. The debate centres on where the porcelain was actually fired. One thesis, known as the 'Hizen theory', holds that it was fired in the Arita area (Hizen). Another, known as the 'Kaga theory', holds that it was fired in the Kutani area (Kaga domain, in current Ishikawa Prefecture). From the late Edo period until the 1970s the Kaga theory held sway. However, after more recent archaeological and scientific analysis, the Hizen theory has come into favour. But questions still remain, and the debate is far from settled.

As early as 1940, Matsumoto Satarô published *Teihon Kutani* [The Fundamental Kutani], the first comprehensive work to examine the controversy over the actual location of Kokutani-style porcelain kilns (Matsumoto 1940).[9] Matsumoto could not find the original kiln site, but he concluded that it must have been located in the Kaga domain. He confirmed, in effect, the existing theory that Kokutani-style porcelain was made for the Maeda lords at their domainal kiln, much as Nabeshima

Vessels of Influence

porcelain was made for the Nabeshima lords of Hizen. The Daishôji branch of the powerful Maeda family possessed a number of Kokutani style large dishes, and so some type of relationship certainly appears plausible. In 1824, the Yoshidaya kiln was constructed intentionally right next to the remains of a mid-seventeenth-century porcelain kiln in Kutani (Ishikawa Prefecture). Although it was active for only seven years, the Yoshidaya kiln produced wares of striking similarity to those of the previous Kokutani style, but with brighter colours and strong designs. Today, historical Kutani ceramics contribute not only to the local economy, but also to the historical aura of the area, and are thus important for tourism and as a heritage destination.[10] Indeed former Prime Minister Koizumi Junichirô made a special point of visiting Kanazawa City's Kutani-Kôsenyô kiln, which specialises in producing revival Kokutani-style porcelains in his visit to Ishikawa Prefecture in May 2006. The Ishikawa Prefectural Museum has what is considered to be the most comprehensive collection of Kokutani-style porcelains collected in the post-war period, rivalled only by that of the Idemitsu Museum of Arts.

Excavations of the Kutani kilns in Ishikawa Prefecture first began in 1970-1972 in an attempt to end the speculation on the origin of Kokutani-style ware. Unfortunately, the excavations failed to find any sherds that resembled the original Kokutani-style ware. They did, however, uncover greyish porcelain sherds decorated with underglaze cobalt blue dated to the seventeenth century (see Kutani koyô chôsa iinkai 1971, 1972; see also Ishikawa Prefectural Museum of Art and Kyushu Ceramic Museum 1987, 14-19).[11] From the excavation of Kutani no. 1 kiln, a porcelain sherd was found with an inscription reading '6th day of the 7th month of the 2nd year of the Meireki era', or 1656, which suggests a porcelain kiln was active at that time. However, of the over 20,000 sherds recovered from the excavation, none has matched any existing Kokutani-style porcelain examples or any other known porcelain heirloom object.

Another adjacent site, Kutani A kiln, has been excavated sporadically since 1994 and has produced a number of sherds

60

evidently destined to be overglaze decorated. However, still no conclusive proof has emerged of any link between this kiln and the Kokutani style or indeed any other style of seventeenth-century porcelain. While it is certain that porcelain was fired in the Kutani kilns in the mid-seventeenth century, the style of porcelain produced is yet to be ascertained. It could be that these kilns were short-lived, as they may not have been deemed profitable.

In 1972-1975, the outer Arita-cho area kiln group called Yanbeta was excavated and many sherds from nos. 3 and 4 kilns were found to be identical to known Kokutani-style types, including heirloom items. Since that time archaeological excavations at the neighbouring Maruo kiln and kilns farther away in central Arita-cho such as Kusunokidani, Tataranomoto, Sarugawa and Chôkichidani have all yielded sherds that have counterparts in Kokutani-style ware pieces in known collections. In addition, in 1983 Kokutani-style sherds were excavated for the first time from a domestic site at the Daishôji domainal official residence, on the Hongo campus of the University of Tokyo (see University of Tokyo Early Modern Archaeological Research Institute 1989). These sherds from undisturbed levels were subjected to various scientific tests, which confirmed their Hizen origin; but despite the evidence (indeed, perhaps because of it) the debate continues (see Kawashima and Ogi 1991). Since the results of the tests on the sherds were released in 1989-90 a number of symposiums and a *Tôyô tôji gakkai* special meeting have been held to discuss the history of overglaze enamel technique in Japan and in particular the origins of Kokutani style. Arakawa Masa'aki produced a definitive exhibition on the subject which sets out the debates and the findings from an archaeological and art historical perspective at the Idemitsu Museum of Art (see Arakawa 2004).

Kanazawa-based archaeologists who have produced seminal work in pursuing the debate to its logical conclusion, such as Professor Sasaki Tatsuo and Sasaki Hanae, have recently turned their attention to the intriguing issue of the revival of the Kokutani style in the nineteenth century in the Kutani

kilns and the different styles that followed in rapid succession. They and other Kanazawa-based ceramic scholars have helped to demonstrate that there was a clear connection between the Kaga kilns and early overglaze porcelain decoration in particular patterns and colourations. Arakawa Masa'aki with the support of Higashi Mariko from the Asahi Shimbun helped to assemble the first conclusive exhibition on Yoshidaya-style porcelain (Arakawa 2005). In addition, Tokuda Yasokichi III (1933-2009), designated by the government in 1997 as an Important Intangible Cultural Asset or, as commonly termed, a 'Living National Treasure', for his coloured glazing (*saiyû jiki*) technique, has also studied the revival of Kutani styles, which involved his ancestors and to which he traces the inspiration for his own art. He contributed an article originally presented for the Oriental Ceramic Society of Japan [*Tôyô tôji gakkai*] special symposium on the Kutani revival in October 2006 for their Bulletin, which was published in 2008. Tokuda's work highlights another important avenue of research, all too often overlooked, namely the significance of first-hand oral histories of Japanese potters who practised in the Meiji and Taisho (1912-1926) periods.

Post-war Japanese porcelain research shifted towards a more inductive and applied approach not so much by amateur historians as by amateur archaeologists. *Nabeshima hanyô no kenkyû* [Research on the Official Nabeshima Domain Kiln] was published in 1954, followed three years later in 1957 by *Kakiemon* and then in 1959 by *Koimari* (see Nabeshima hanyô chôsa iinkai 1954 and 1957; see also Koimari chôsa iinkai 1959). Following these studies the trend from amateur to professional archaeological researcher was codified by Mikami Tsugio, a student of Koyama Fujio and an internationally established archaeologist who excavated for many decades at Fustat, Egypt, as well as in multiple sites in Japan (see Mikami 1987). Mikami was responsible for some of the initial and most important porcelain kiln excavations in Arita, including the famous Tengudani site, originally believed to be the first porcelain kiln founded by Kanegae Sanbei I, though this was

subsequently disproved by the results of Mikami's excavation (see Arita-cho kyôiku iinkai 1972).

Mikami's research and publications helped to establish early modern archaeological ceramic studies as a separate field in Japan. Mikami trained many future trade ceramic-archaeologists, professors and museum curators, such as Ôhashi Kôji, Director Emeritus of the Kyushu Ceramic Museum, and Sasaki Tatsuo, Professor of Archaeology at Kanazawa University. He was one of the first to seek out and work with scholars of ceramics working outside Japan, such as James C.Y. Watt, former Brooke Russell Astor Chairman of Asian Art at the Metropolitan Museum of Art, New York City, the late Dr Oliver Impey, former Senior Associate Keeper at the Ashmolean Museum, Oxford, and the late Henry Trubner, former curator at the Seattle Art Museum, among others. In Japan, the field has come into greater prominence with East Asian porcelain scholars such as Satô Masahiko, Kamei Meitoku, Hasabe Gakuji, Hayashiya Seizô, Itoh Ikutarô, as well as Ôhashi Kôji, Nishida Hiroko, Yuba Tadanori, Akanuma Taka and Yabe Yoshiaki, and the next generation of scholars, Kanazawa Yoh, Suzuta Yukio, Arakawa Masa'aki, Itô Yoshiaki, Satô Sarah, Inoue Kikuo, Murakami Nobuyoshi, Nogami Takeshi, Horiuchi Hideki and Katayama Mabi, to name but a few.

Part of Mikami's legacy can be seen in the Saga Prefectural Kyushu Ceramic Museum, which he helped to found in 1980. The Museum holds special exhibitions, houses a permanent collection along with the comprehensive Shibata porcelain collection, and contains a study collection of sherds from regional Kyushu excavations. Ôhashi Kôji, until recently the Director of the Museum, has been the main force behind continuing research at the Kyushu Ceramic Museum from its inception, and has examined much of the excavated porcelain from early modern sites throughout the Japanese archipelago. The current guideline of the Kyushu Ceramic Museum, as well as the newly created Kyushu National Museum, is to view Hizen porcelain through a pan-Asian prism. This can be partly attributed to the fact that the Museum is funded by Saga Prefecture, which

naturally seeks to promote its domestic products (both historical and contemporary) in an international Asian arena, as well as within Japan. To promote its place within world porcelain production, the town of Arita is twinned with Jingdezhen in China, the major porcelain production centre of Asia, and with Dresden in Germany, next to the original Meissen kilns where porcelain was first produced in Europe. It also maintains close ties with the Republic of Korea.

Some of the early development of Hizen porcelain remains shrouded in mystery. Three troublesome issues in the development of Hizen porcelain still fuel the debates: the implications for Hizen porcelain of Hideyoshi's invasions of the Korean Peninsula; the role of Kanegae Sanbei I (Ri Sanpei) in the origins of a porcelain industry in Japan; and the authenticity of the Kakiemon family records regarding the origins of the overglaze enamel technique (see Ôhashi 1989, Nishida 1993, and Sasaki 1994). These topics are briefly explored in the following chapters.

The Arita-cho Board of Education houses an archaeological unit funded by the municipality of Arita-cho. The two employed archaeologists, Murakami Nobuyuki and Nogami Takenori, are both active in excavating Arita-cho kiln sites thought to be endangered by development, and when possible conduct research excavations. The results of their excavations are disseminated through site reports and analytical articles. The Board has a museum displaying developments in the industry, and several monuments to porcelain production in the Arita-cho area.

Archaeological excavations in the last two decades conducted by Murakami and Nogami have begun to clarify concerns regarding Hizen porcelain styles and the role of specific historical personages. One such example is the site of the 'Aka-e machi', or 'Overglaze Enamellers' District', which was discovered and subsequently excavated in 1990 as a result of the expansion of the central Arita post office. Porcelain uncovered during the excavation demonstrated that certain types of Kakiemon-style as well as Imari-style porcelain were made

1. Porcelain Debates in Japan and in the West

both for domestic and for export markets. Both styles, hitherto thought entirely distinct, were decorated with overglaze enamels in the same place by the same licensed overglaze enamellers. Styles differ mostly on account of market orders or by period fashions. In other words, overglaze Hizen porcelain styles were not the exclusive property of individual families that ran separate kilns, with certain notable exceptions. Certainly not all porcelain was overglaze enamel decorated at the Aka-e machi. This is especially true of high-level overglaze ware such as the Classic Kakiemon style. Especially in the early years (1640-50s) and in the outer kilns, overglaze enamels were applied using smaller muffle kilns close to the site of production. The relationship between the location of the overglaze enamellers' quarters and Hizen ware overglaze styles is a continuing source of debate.

Nishida Hiroko at the Nezu Museum, Arakawa Masa'aki, formerly at the the Idemitsu Museum of Arts and currently a professor at Gakushuin University, and Itô Yoshiaki, formerly at the Tokyo National Museum but currently chief curator at the Kyushu National Museum, combine the insights of archaeology and the sensibilities of art history to relate in depth and with factual accuracy the history of porcelain to other media. Horiuchi Hideki and Naruse Kôji, both at the Tokyo University Early Modern Archaeological Research Institute, have taken an alternative approach and pursued research on porcelain as a means towards understanding context and daily life in Edo Japan based on over twenty years of excavations in a specific area. In particular Horiuchi has looked at the role of export wares through the archaeological record in China, Vietnam, Thailand, Holland and England, and as a result has a broad view of Hizen tradewares (Horiuchi 2010, 7-42). The potential of their studies should not be underestimated. The Hongo campus excavations at the University of Tokyo done by the University of Tokyo Early Modern Archaeological Research Institute have set the standard for early modern site excavation, recording and analysis in Japan and provide a unique time capsule for Edo life and ceramics.

Ôhashi Kôji has singularly focused on quantifying porcelain production in the Japanese archipelago with special reference to Hizen porcelain, with an emphasis on precisely dating verified excavations and history of technology. He focuses on the archaeological record and looks as well at distribution of Hizen porcelain throughout Asia and recently in Europe and the Americas. Since his recent retirement he has chosen to look at the reasons behind the evolution of certain ceramic styles such as the Nabeshima and more recently Kakiemon and Imari style export wares (Ôhashi 2007). Nogami Takenori and Murakami Nobuyuki have tried to elucidate the entire porcelain progression in Hizen from kiln construction to manufacturing techniques. Murakami has an extensive website displaying the findings from his excavations and his thinking on the evolution of Hizen porcelain production. Most of these scholars have focused their innovative approaches on the Arita area or on Hizen porcelains themselves.

In contrast, porcelain produced at non-Hizen kiln sites has received less attention, with the exception of Ishikawa-based archaeologists (that is to say, the Kutani kilns mentioned above). In fact, while Hizen was certainly the earliest area to fire porcelain, a number of porcelain kilns were created in the mid-seventeenth century, primarily the Himetani kiln in Bingo (current Fukuyama City, Hiroshima Prefecture), the Hirado Island kilns, and kilns in Kutani, to name a few (Sekiguchi 1993, 69-78, and Narasaki 1993, 95-112). However, most of these early porcelain kilns were short-lived. Significant porcelain-producing centres in Aichi and Gifu Prefectures, flourishing from the mid-eighteenth century onwards, have not received enough attention, notwithstanding the excellent facilities of their respective prefectural museums. It is only recently that Tobe porcelain, fired in Shikoku, and porcelain from Kyoto and even the famous Mikawachi kiln group, which produced the well-known Hirado ware exported in large amounts to the West in the nineteenth century, have begun to be archaeologically explored. Possible reasons for the delayed interest in the non-Hizen porcelain kilns include all too brief production peri-

ods, lack of contemporary porcelain production that needs to draw authority from past regional prototypes, paucity of comparable identifiable heirloom objects, lack of real estate development in the area which would necessitate archaeology as a condition for building, and a reluctance on the part of the local municipality to sponsor sometimes costly excavation on the grounds that it would not necessarily enhance the heritage industry of the area.

While much has been done to advance the study of porcelain in Japan through research papers, excavations and exhibitions, fuelled in part by the Japanese public's interest in porcelain, the large investments in archaeology surrounding particular porcelain sites, and the importance of collections within the country, it is surprising that porcelain still does not play a more prominent role in the general discourse of Japanese medieval and early modern archaeological, historical and art historical studies.

The study of Japanese porcelain outside Japan

Porcelain, both Chinese and Japanese, has been widely collected in Europe since the early seventeenth century, when direct importation was introduced through the Dutch East India Company. In the early eighteenth century Daniel Defoe lamented that 'Queen Mary introduced the custom ... of furnishing houses with Chinaware ... piling the China upon the tops of Cabinets, Scrutores, and every Chymney piece' (see Impey 1986, 36). Oliver Impey interprets Defoe to refer to the ready availability of Chinese and Japanese porcelain in Europe. Other documentary evidence of Japanese porcelains exists in several forms, principally trade records and house inventories. The Dutch East India Company (VOC or Vereenigde Oostindische Compagnie) kept ample records of the Japanese porcelain officially traded through their offices from the 1640s, both to Europe and to the rest of Asia, noting destination, amount and sometimes details as to shapes and patterns (see Volker 1954). The marginalia on these well-kept

records are a fascinating source of information regarding both Dutch trade and Japan. Prices, tastes and lack of stock are all mentioned. In fact the *Deshima Dagregisters*, as these records are known, as well as those compiled for the factory in Taiwan (Zeelandia), now housed in The Hague, are the only completely intact record of any of the many VOC trading factories (see Blussé, van Opstall and Ts'ao 1986).

One of the earliest house inventories that records Japanese porcelain is the 'Devonshire schedule' of 1690, part of the last will and testament of the dowager Countess of Devonshire, of Burghley House in Stamford, England (Munroe and Richards 1986). Oliver Impey worked extensively on these inventories, which has helped to enhance a general understanding of how, what and when Japanese porcelains were imported to Europe and their reception vis-à-vis Chinese porcelain (Impey 2002). Another significant porcelain collection was assembled and inventoried by Frederick Augustus (1670-1733), Elector of Saxony and King of Poland, known popularly as Augustus the Strong. This Dresden collection is composed of Chinese, Japanese and local Meissen pieces brought together from 1715 onwards. The collection is important not only for its quality and quantity, but also for Augustus the Strong's passion for having it assiduously recorded and marked in terms of country of origin in codes incised onto the base of each piece. In most other European collections, however, Japanese porcelain was generically labelled 'Chinaware' or 'Nankeen ware' (after the major port city of Nanjing) until the nineteenth century (and sometimes even after that). It is for this reason that it is hard to differentiate Japanese wares in written sources from the significant amount of Chinese porcelain also present in European collections.

As is well known, perceptions of Japan and of Japanese goods, including porcelain, changed dramatically in the second half of the nineteenth century. In 1853, Commodore Matthew Calbraith Perry (1794-1858), under orders from the American President Fillimore, entered Edo Bay demanding both supplies and trade access from the Tokugawa government. Perry's

steam ships were soon followed by fleets of ships from other nations entering Japanese waters. The British *H.M.S. Furious*, for example, landed in Edo Bay in 1858 and negotiated a highly favourable trade treaty for Great Britain. This foreign intervention gave a final fatal push to the Tokugawa government, already on the brink of collapse. A new government, nominally headed by the Emperor Meiji, was installed in 1868, and this was rapidly followed by a period of active international interaction and expansion.

With the new political environment, the samurai system was disbanded, domains abolished and prefectures established. These new prefectures needed to secure local industries and establish new infrastructures as quickly as possible to supplant the now defunct domain patronage, which had heretofore helped to support among other industries ceramic kilns and ceramic artisans. Overseas trade was one means to encourage production and garner valuable foreign currency. The new Meiji government actively encouraged participation in international exhibitions popular in Europe and the United States of America at the time.

The Japanese objects displayed at these international exhibitions were either pre-sold or for sale, and initially they accounted for as much as ten per cent of the foreign currency entering Japan (Fukui 1927; see also Mori 1993).[12] The presence of Japan and things Japanese at these exhibitions created an instant market for Japanese goods both in Europe and America, which in turn encouraged collecting and collections on a significant scale. Large international exhibitions continued on a periodic basis till the beginning of the twentieth century.

As a result, significant quantities of ceramics, and in particular porcelain, were produced in numerous areas in Japan aimed at the newly expanding European and American markets. A plethora of new potteries producing ceramics in a multitude of different styles led, paradoxically, to the search in Europe and the United States during the late nineteenth century among the self-styled *cognoscenti* for acquisitions of what

was perceived to be the 'authentic Japanese object'. The debates between Edward Sylvester Morse and James Lord Bowes are just one example of the acquisitional zealotry that ensued.

The curatorial tastes of Augustus Wollaston Franks, mentioned above, help to illuminate late nineteenth-century scholarly attitudes to porcelain, which in turn have influenced current concepts. In particular they elucidate the shifting perception of the importance of porcelain versus stoneware and earthenware, most of which was termed 'pottery' in Europe up until the last few decades.

Franks was responsible for shaping the collections of Japanese and Chinese porcelain in both the British Museum, where he was Keeper, and the Victoria and Albert Museum. He was associated with the British Museum from 1851 to 1896, and was responsible for forming many of its present departments, including the Oriental section (now Department of Asia) and the Islamic Antiquities section. For these efforts, David Wilson, a former Director, has called him 'the second founder of the British Museum' (Wilson 1997, 4). From the 1870s, Franks purchased personally and professionally over 2,500 Japanese ceramics for the British Museum with the intention to create a complete assemblage to illustrate the Japanese ceramic industry in its entirety. He favoured signed or documented objects and scrupulously attempted to use Japanese sources wherever possible, such as Ninagawa's *Kanko zusetsu* (Fig. 4). According to Wilson, Franks 'saw himself as using his money to perform a public service not dissimilar to those carried out at the same period by gentlemen of means in the Foreign Service, in parliament or in the higher ranks of the Church' (Wilson 1997, 4).

In 1876, just prior to the Philadelphia Centennial Exposition, only ten years after the start of the Meiji period and in the same year as Ninagawa's first publications on Japanese ceramics, Franks wrote a *Catalogue of a Collection of Oriental Porcelain and Pottery* for an exhibition of his personal collection of East Asian ceramics, most of which later entered the British Museum collections, held at the Bethnal Green Branch

1. Porcelain Debates in Japan and in the West

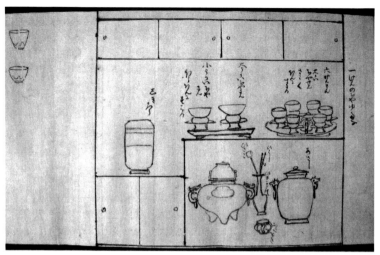

Fig. 5. Handscroll of *Kundaikan sôchôki* (Records of Arrangement in the Shogunal Guest Hall), Muromachi period, sixteenth century. Handscroll, ink on paper, detail. H. 27.3cm, L. 427.9 cm. Private collection, Japan.

Museum (then part of the Science and Art Department of the Committee of the Council of Education, South Kensington, and now the Museum of Childhood, Victoria and Albert Museum). In the preface to the first edition of the catalogue Franks wrote that the purpose of the exhibition was to illustrate fully the different historical varieties of Japanese ceramics within different historical periods by means of commonplace and contemporary examples. He included 115 entries for Japanese porcelain and only nine entries for Japanese stoneware and earthenware in this volume.

Unusually, and tellingly, Franks first officially in 1878 and then privately in 1879 published a revised edition. The revised edition was significantly different, and switched his previous emphasis on porcelain to earthenware and stoneware, which he now felt reflected true 'domestic' Japanese taste. In the preface to the second edition he wrote: 'Since the publication of the first edition of this catalogue I have endeavoured to render the collection more complete, especially in the Japanese sec-

71

tions, which were far from illustrating in a satisfactory manner that important branch of ceramic art'. Franks went on to state: 'The report, however, which accompanied the Japanese collection exhibited at Philadelphia, and acquired by the South Kensington Museum, has furnished the most trustworthy and valuable information as yet obtained' (Franks 1879, vii-viii). The ceramics discussed and their accompanying Japanese text by Shiota Makoto form the basis of his second edition of the catalogue, which now included a total of 1,700 East Asian examples.

Franks writes in the second edition: 'With regard to both porcelain and pottery it may be well to remark that the taste of the Japanese is quite different from that of Western nations. While lacquer of the highest finish and perfection of manufacture is desired, in the ceramic production, a rough artistic specimen is far more valued in Japan than one of those marvels of finish admired in Europe. Most of the large and highly ornamented specimens are in fact made for exportation not for home use' (Franks 1879, vii-viii). Franks felt that he was collecting not for himself but on behalf of the nation, for which what he termed an 'accurate' assemblage of Japanese ceramics appeared to play a significant role.

Other Keepers in the Japanese Antiquities Department followed Franks' lead in pursuing East Asian ceramics and producing publications on the subject. They included R.L. Hobson (1872-1941), an influential scholar of East Asian ceramics, and Roger Soame Jenyns (1900-1976), Deputy Keeper at the British Museum. These men were part collector, part scholar: mostly independently wealthy, they personally collected East Asian ceramics, donating pieces to the British Museum, as well as other regional museums.[13] This practice enlarged the British Museum's collection in a collector-driven fashion that centred on specific ceramic styles, such as Kakiemon style, popular at the time.

Jenyns' comments in his book *Japanese Pottery* reflect his predecessor Hobson's opinions: 'The fact is that our public collections were mostly made at this time [second half of the

nineteenth century] and consist of principally third-rate material; thus giving an entirely false impression of Japan' (Jenyns 1971, 1). Jenyns is, in fact, repeating the acrimony of the earlier porcelain debate illustrated at the beginning of this chapter. Jenyns continues: 'It is impossible to pass over either the Morse collection or its creator in silence. For its existence illustrates the ideas upon which, and the conditions under which, our worthless nineteenth century collections of pottery have been amassed. ... It is the prototype of several other large collections of Japanese pottery in both Europe and America, including those of the Freer Gallery, and that of the British Museum, when Morse was the acknowledged international authority on the subject.'

While opinions continue to be divided to the present day on the Morse Collection in the Boston Museum of Fine Arts, and his other Japanese ceramic collections found in the Peabody Essex Museum, the Cincinnati Museum of Art and private collections, the acrimonious nature of the porcelain debates has had the effect of preventing both his collections and those of Franks from being studied as attentively as they deserve, at least until recently (Akiko of Mikasa 2010). Shifts in the tastes of any given period, the definitions of what at any given historical period constitutes 'art' and which items are considered worthy of study are of course all worthy of consideration in themselves.

In the early 1950s, Dr John Pope, Director of the Freer Gallery, Smithsonian Institution, and Jenyns travelled to Japan to examine porcelain produced for the Japanese domestic market. Pope and Jenyns were both instructed on Japanese ceramic styles by Japanese scholars, including Mikami, and as a result two significant exhibitions subsequently took place in London, at the British Museum and the Royal Academy.

The 1956 British Museum exhibit, entitled *Japanese Porcelain*, was the first attempt in Europe to address the history of Japanese porcelain in its entirety. This exhibition was motivated in part by the earlier large Japanese Government loan show at the Royal Academy of Art in London illustrating the

highlights of Japanese art, which, unusually for this type of show, included high-quality Japanese porcelain, of which the recently registered Kakiemon-style Hizen porcelain took pride of place. Jenyns wrote a reference book on Japanese porcelain, based on his visits to Japan and drawing in part on his own private collection of porcelain and those in the British Museum and private collections in Europe (Jenyns 1965). The book reproduces the Japanese academic account at the time of the history of porcelain – that Korean potters had initially made pottery in their native style, then utilised a Chinese style, and finally found their own transmuted Japanese voice. Jenyns tended to use export wares as a basis for his analysis of the Japanese porcelain industry, which inadvertently continued a trend in the Bowes tradition. Importantly, he is the first scholar either in the West or Japan to state in a publication that Koku-tani-style porcelains were fired in Arita and not Kutani, which caused a notable stir in academic ceramic circles.

Two years prior to the British Museum exhibition, in 1954, Paul Volker published his seminal work, *Porcelain and the Dutch East India Company*. This important study was based exclusively upon the Dutch East India Colonial Archives (VOC) located in The Hague. Five years later, in 1959, he published *The Japanese Porcelain Trade of the Dutch East India Company after 1683* (Volker 1954, 1959). These two books remain the foundation of Western research on the Japanese porcelain trade.

While undoubtedly important, they have however also had the unfortunate effect of reinforcing a Eurocentric trend of western scholarship on Japanese porcelain, based on porcelain holdings in Europe and America that were often created from export wares destined specifically for those markets (see Nishida 1974, 225). In addition, as Oliver Impey has pointed out, Volker based his research on Dutch orders for goods, rather than the porcelain that was actually delivered (Impey 1996). Some specific bills of lading are still extant, however, and Menno Fitski, a knowledgeable Japanese ceramic scholar and a student of Impey, curator of Japanese and Chinese art at

the Rijksmuseum in Amsterdam, has transcribed and trans-
lated bills of lading from the Amsterdam Office (housed at the
Algemeen Rijksarchief in The Hague) for the decade 1650-60
(see Impey 1996: 132-9). Nagazumi Yôko has made a complete
annotation in Japanese of the VOC records for the years 1637-
1833 (see Nagazumi 1987; van der Velde and Bachofner 1992;
and Viallè 1992; see also Bronson 1990).[14]

In North America, a significant breakthrough in the study of
Japanese porcelain came with the International Symposium on
Japanese Ceramics held in Seattle in 1972, which brought
together Japanese and Western scholars. Impey read a pro-
vocative paper entitled 'A Tentative Classification of the Arita
Kilns' at the conference, which challenged many existing ideas
on early Japanese porcelain held in the West. His book on early
Japanese porcelain, written just before his untimely death in
2005, which includes a comprehensive catalogue of the Japa-
nese porcelain holdings in the Ashmolean Museum, expounded
his analysis of Japanese porcelain history (see Impey 1972,
1978, 2005; see also Impey and Tregear 1983).

The history of the scholarship on porcelain has shown that
some of the issues still debated both in Japan and in the West
are rooted in issues of identity. The porcelain debates in Japan
are founded on narratives about places of origin, direct connec-
tions with historical personages, links with traditional local
famous products, and, most sensitively, about national histo-
ries and international relations. These issues in turn have
specific ramifications, often related to heritage tourism or to
the pedigree of current porcelain products.

2

Chinese Ceramics in Japan during the Medieval Period, and their Significance in Tea Gatherings

> Even though from a *theoretical* point of view human actors encode things with significance, from a *methodological* point of view it is the things-in-motion that illuminate their social status and human context.
>
> Arjun Appadarai (1986), 5

Things Chinese in medieval Japan

This chapter explores the importance of the image of China in Asian trade ceramics entering Japan and their use particularly in tea gatherings within Japan. Beginning in the Kamakura period (1185-1333) and continuing apace through the subsequent Nambokuchô (1333-1392) and Muromachi periods (1392-1573), China held up to Japan an image to be admired, emulated, and at times even superseded. Chinese ceramics, from the medieval period onwards, were an integral part of social life, especially for the nobility; they were present in Buddhist temples and rituals and also in the residences of the samurai class and increasingly the wealthy merchant class. Chinese ceramics in households, temples and official spaces added a much sought-after continental lustre. Archaeological excavations from a range of medieval sites throughout the Japanese archipelago have uncovered unexpectedly large quantities of Chinese ceramics dating from the twelfth century onwards that have not yet been ade-

2. *Chinese Ceramics in Japan during the Medieval Period*

quately accounted for or explored in scholarly literature. The continuing excavations at Ichijôdani site in the southeast part of present-day Fukui Prefecture on the main island of Japan, Honshu, in particular, have revealed an astonishing range of Chinese ceramics clearly used in both domestic and more formal arenas (Fukui Prefecture Ichijôdani Asakura Clan Archaeological Museum 1994).

The shifting importance attached to Chinese ceramics in cultural transactions can be best assessed from an analysis of death inventories, archaeologically retrieved trade ceramics and their contexts, entertaining practices and the manner in which Japan received and adapted Chinese customs of drinking tea. Examination of the specific customs associated with drinking tea, social entertaining and the collections of utensils used in tea gatherings as gleaned from documentary sources and the archaeological record certainly provide a useful ground for the debates on the use of Chinese ceramics in Japan.

In order to demonstrate further how Chinese ceramics were utilised, copied and adapted in medieval and early modern Japan, this chapter then addresses southern Chinese Jian wares, one of the main staple of Chinese wares entering Japan during the medieval period, and their Japanese Seto counterparts. Significant sites that have uncovered large amounts of Chinese underglaze cobalt blue porcelains from Jingdezhen and Zhangzhou kilns in context are examined at the end of the chapter in order to give a fuller understanding of the late medieval and early modern context of Chinese ceramic distribution and use in Japan.

By an examination of the use of Chinese ceramics as signifiers of power through tea drinking, high-level entertaining, and mere possession of the objects *per se*, we can turn our attention to customs and examine the objects in context, rather than simply focusing on issues of taste as interpreted by tea masters (Plutschow 2003).

The drinking of whipped tea in Japan

The rapidly increasing presence of Chinese ceramics in Japan in the twelfth to sixteenth centuries is often explained in standard Japanese history texts as related in some way to the growing taste for tea. Tea was first introduced from China in the eighth century, and has subsequently had a profound and continuing effect on Japanese culture. By the eighteenth century, the pastime of drinking whipped tea with associated rituals became codified into 'schools', or practices based roughly on the *iemoto* system (Rosenfield 1993, 8-18). In addition to high-level traditional daimyo tea practices and other types of tea-drinking such as 'steeped tea' (*sencha*), three main lineages emerged for 'whipped tea' drinking that traced their ancestry back to a central figure, Sen no Rikyû (1522-1591): the Urasenke, Omote Senke and Mushanokôjisenke schools (see Pitelka 2003, 1-17).

In the Meiji period, these schools opened their teachings to the broader public and eventually to the international community, having lost their previous systems of patronage in the social restructuring that took place at this time. In need of a higher profile, these schools promoted the practice of tea among social strata of society not officially included in the Edo period, including women. In addition, they sponsored research and publication on certain approved tea masters, tea histories and tea utensils. Important research on these gatherings in Japanese and English resulted, though mostly of an inductive rather than a deductive nature.[1] However, because of the lack of collaboration among tea historians on the one hand and archaeologists of the medieval and early modern period on the other, the interpretations made by each group are often divergent.

A history of tea and Chinese ceramics

Since its introduction during the Nara period (710-794), the consumption of tea has continued apace, albeit in different forms. Today tea is the national beverage, with the average person in Japan consuming eight cups of steeped tea a day.

2. Chinese Ceramics in Japan during the Medieval Period

Two anthologies of poetry compiled by the order of Emperor Saga (786-842, r. 809-823) indicate that tea was drunk at court functions in the ninth century (Hayashiya, Nakamura and Hayashi 1974, 11).[2] It is recorded in these anthologies that the monk Eichû (743-816), who spent thirty years in Chang'an (Xian), one of China's capitals during the Tang period (618-907), returned to Japan during Emperor Saga's rule and served him tea in the fourth month of 815 (Murai 1989, 7).[3] In the same year Emperor Saga ordered various provinces to grow tea for presentation to the court as tribute (Murai 1989, 5). The emperor's interest in tea reflected the court's desire to adopt customs practised in Tang period China.

Brick tea, and subsequently steeped tea, came thereafter to be consumed for medicinal purposes at Buddhist temples, and at religious and seasonal ceremonies at the imperial court (first in Nara and then later in Kyoto after the transfer of the capital in 794).[4] Tea soon became an integral part of *naorai*, a banquet held at the end of royal ceremonies. In the early Heian period (794-1185), a new style of tea drinking was imported from Tang China, which involved drinking tea while reciting poetry in a specially designated room (Tsutsui 1994, 170). Tea, sake drinking and poetry recitation were often accompanied by music played on a *koto*, a stringed musical instrument also introduced from China. Tea gradually became an elegant backdrop to other more performative pastimes, such as linked verse (*renga*) poetry composition at court gatherings.

The Kamakura period (1185-1333) witnessed a prodigious rise in the popularity of tea and the introduction of a new style of preparing the beverage called *matcha* in Japanese, or 'whipped tea', from Song China (960-1279).[5] Whipped green tea prepared in brown and black glazed bowls was popular during the Song period, first among court officials and then Buddhist monks, who prized it for its anti-soporific properties.

The introduction of whipped tea and associated Chinese utensils and preparation rituals has been traditionally ascribed to the priest Eisai (1141-1215). Eisai travelled to Song China twice between 1187 and 1191, returning to Japan on the

latter occasion as a convert to Chan Buddhism (or 'Zen' Buddhism). Historians have also credited Eisai with the introduction into Japan of *tenmoku* or southern Chinese Jian ware bowls and tea seeds.[6]

Eisai's actual role, however, has recently come in for reexamination. Surviving documents reveal that two forms of tea were in use in the twelfth century. One type, *tencha* (a precursor to *sencha*), a type of steeped tea, reached Japan during the second half of the eleventh century; the other, *matcha*, was introduced to Japan during the first half of the twelfth century. The introduction of both of these teas thus predates Eisai's trips for China. In addition, Chinese Jian ware bowls have been found in excavations of the port city of Hakata dating from the eleventh century onwards, before Eisai was even born (Kawazoe 1988, 135). Eisai can still, however, be credited with the popularisation of drinking whipped tea in Chinese Jian ware bowls.

By the mid-fourteenth century, administrative control of Japan rested with a military government based in the capital Kyoto, home of the emperor and his court. Perhaps because of the close proximity to the imperial court, entertainment in formal settings with specific protocols and rituals, including new types of amusements associated with tea drinking and other Chinese-style practices, began to develop among the military and their circle.

A fourteenth-century document entitled *Kissa ôrai* [Traditions of Tea] written by the Tendai monk Gen'e (d. 1350) describes popular tea practices and 'tea judging' (*tôchakai*), as well as noting the necessary protocol on adorning specific events with backdrops of objects perceived to be in Chinese taste (Kawai 2002, 36 and Gen'e's *Kissa ôrai* 1958). Gen'e outlined, for example, the specific décor for a tea pavilion. Further, it is clear from the *Kissa ôrai* that it was not the individual items but the total assemblage that created the desired impact. Assemblages of Chinese objects provided the appropriate backdrop for particular social events, and were potent visual signifiers for the prestige, taste and political power of the host.

2. Chinese Ceramics in Japan during the Medieval Period

The formal name for tea gatherings that involve the consumption of whipped tea, *chanoyu* (literally 'hot water for tea'), first appears in documents during the early Muromachi period (1392-1573). Associated with tea gatherings were *kaisho* or 'meeting places', temporary structures constructed in gardens or alongside residences of shogun and high-ranking *samurai*, to host special events. Tea would be made nearby and brought into the *kaisho* by young male servants. In addition to *kaisho*, which were temporary structures, the more permanent *kazari zashiki*, or reception rooms, were also used to host tea gatherings. In the Muromachi period, formal display in a reception room and installations (*shitsurai*) based around Chinese art objects provided a setting for the appreciation of art. Tea and other beverages would accompany the revelries taking place in front of these Chinese-inspired installations (see Kawai 2002, 34).

The increasing popularity of tea and tea utensils, particularly in the fifteenth century, was intimately tied to a phenomenon called *karamono suki*, which could be translated as 'taste for Chinese goods'. This was linked to the much larger tendency of *basara* (a contemporary term for 'extravagance', or 'excess'), a passion for lavish display that began in the medieval period and continued in the sixteenth and seventeenth centuries, with foreign objects playing a significant role.

By the 1420s, rules were set in place for formal ceremonies and the display of objects that accompanied these occasions for the upper echelons of society. These formalised procedures reflected a growing concern in the military for protocol, already present in Zen monasteries. This in turn resulted in the classification of objects, which reflected growing consumer awareness among the court and the monastic, military and merchant elites. Classifications of imported luxury objects were also an indicator of the burgeoning and lucrative maritime trade with China and Southeast Asia. By the fifteenth century, new styles of trade ceramic began to be imported, fuelled by fresh wealth created as a result of international trade. People of high rank in Japan were compelled to own

recognised types of Chinese objects to differentiate themselves from the less sophisticated and those of lower rank. It became necessary to hire curators, connoisseurs and China brokers to store and appraise the newly imported luxury goods.

Official curators of Chinese goods in medieval Japan

Ashikaga Yoshimasa, the eighth Ashikaga Shogun, used the stylistic formulae of China to best effect, with his legendary collections, curatorial manuals and rituals of display. His and his family's attempts to control the Asian trade networks are suggestive of the power behind the China boom.

Not surprisingly, the Ashikaga shoguns, nominally in control of the country during the Muromachi period (1392-1573), attempted to harness the bounty of overseas trade to use for their own ends. Their trusted 'guest hall companions' (*kaisho no dôbôshû*, or simply *dôbôshû*), who were a mixture of curator, entertainer and party coordinator, were also placed in charge of overseeing the lucrative China trade for the country. The formal title of these men was 'Chinese object administrator' (*karamono bugyô*). While some of these 'guest hall companions' were artists or connoisseurs, their basic function was to provide money-lending, consulting, flower arranging and other services as needed. Many 'guest hall companions' belonged to the Ji sect of Buddhism and took the prefix of *ami*, borrowed from the first character of Amida Buddha. Even though many were originally from the lower echelons of society, this new position afforded them ready access to central political power. The 'guest hall companions' set cultural rules as to what object or painting was worthy of purchase, especially for a shogunal collection, and they were in charge of the display of these objects. They employed a three-tiered classification system for the quality of the objects, separated into high (*jô*), middle (*chû*), and low (*ge*) rank, each of which had similar tripartite rankings. Chinese scholars had been ranking paintings and ceramics from at least the thirteenth century onwards in similar fashion (Clunas

1991, 49). The 'guest hall companions' were thus following well-trodden ground in their evaluation system.

The most well known of the 'guest hall companions' were called the 'Three Ami': they were Nôami (1397-1471), Gei'ami (1431-85) and Sôami (d. 1525), all of whom worked for the shoguns Yoshinori and Yoshimasa (r. 1435-1490), and they helped to catalogue the shoguns' vast holdings of Chinese paintings and antiquities. A document entitled *Kundaikan sôchôki* (Record of Arrangements in the Shogunal Guest Hall) the original of which has been lost, compiled by either Nôami or possibly Sôami, has been passed down in two main, and many related, versions (see Fig. 5) (Hayashiya 1973).[7] The document treats the shogun's comprehensive collections and is divided into three general sections: lists and rankings of Chinese painters; accounts of formal display in reception rooms; and descriptions and ranking of Chinese utensils, in particular ceramics, with accompanying diagrams and object drawings.

One manuscript of the document dated to 1476 includes two sections on Chinese ceramics and how to display them, with the first section on Chinese brown and black glazed wares (*tenmoku*), and the second on *Guan* (official) ware.[8] Chinese brown and black glazed wares are ranked in descending order: *yôhen* ('iridescent', a reference to Jian ware with coloured splashes), *yuteki* ('oil spot', Jian ware with silvery splashes), and *kensan* (standard Jian ware).[9] These three ceramic wares were considered appropriate for the shogunal collection (see Tankôsha 2009). The rankings continue in descending order with ordinary *usan* ('black glaze', perhaps Jian, Jizhou or Cizhou wares), *hai-katsugi* (Jian ware with a grey, ash-coloured glaze), and finally *taihi* ('tortoise shell', Jizhou ware). The last three were considered too humble to be worthy of a shogunal collection.

Other manuscripts such as *Zashiki kazari shidai* (Arrangements for Reception Room Display, c. 1511) and *Okazari sho* (Records of Display, dated 1523) compiled by Sôami give variations on ceramic choices and appropriate display (Akamatsu 1958). Tellingly, Sôami also annotated the record of paintings

Vessels of Influence

in the Treasure House of the Chinese Song period Emperor Huizhong in a manuscript entitled *Kokawa gosho narabi ni Higashiyama dono okazari-zu* (Illustrations of Displays in the Kokawa Palace and the Higashiyama Villa), currently in the Tokugawa Art Museum. This conscientious paralleling of the art of Japan and China reflects the Ashikaga shoguns' attempt to emulate both the customs and famous collections of the famous Northern Song Dynasty emperor (Kawai 2002, 40).

Bakôhan

The Japanese recreation of China is encapsulated in the historical biography of one single Chinese porcelain bowl of which Ashikaga Yoshimasa was said to be particularly fond, which has been given the sobriquet Bakôhan, or 'Horse Locust Staples' (Fig. 6). The naming of famous ceramics in Japan, be they Chinese, Korean or Japanese in origin, did not start as a common practice until the time of the early Edo tea master Kobori Enshû (1579-1647) in the mid-seventeenth century. Once officially named, most often by a famous personage or owner, these objects then become known by this name. The bowl named Bakôhan is now designated an Important Cultural Property by the Japanese government and housed in the collection of the Tokyo National Museum.[10]

The provenance of this bowl was recorded in the eighteenth century by the famous Neo-Confucian scholar Itô Tôgai (1670-1738). Tôgai's document accompanies Bakôhan in a specially fitted box. Tôgai wrote that the bowl was originally given to Taira no Shigemori (1138-79), son of Taira no Kiyomori and then second-in-command in Japan, by a Chinese priest, in gratitude for a donation of gold to his temple in China. Some three hundred years later, having found its way into Ashikaga Yoshimasa's collection and become one of his favourite pieces, the bowl was accidentally broken. Yoshimasa sent it back to China to find a replacement, but was told that nothing of such fine quality could be found, and the bowl was then repaired in China with metal clamps (hence its name) and returned to

Fig. 6. Foliate shaped bowl named Bakôhan ('Horse Locust Staples'), China, *c.* thirteenth century. Stoneware with celadon glaze and metal staples. H. 9.6, D. 15.4cm. Tokyo National Museum, TG2354. Gift of Mr Mitsui Takahiro. Important Cultural Property.

Japan. It was then given by Yoshimasa to his faithful retainer Yoshida Sôrin and subsequently passed down in the Suminokura family of which Tôgai himself was the ninth generation. (In the Meiji period (1868-1912) the bowl was acquired by the wealthy industrialist Mitsui Takashi (1848-1938, see Kyoto National Museum 1991, fig. 39; Guth 1993, 47.)

An elegant example of southern Chinese Longquan celadon, the bowl most probably dates to the thirteenth and not the early twelfth century as is claimed by its accompanying document. But rather than its artistic merits, far more important is its pedigree – that is to say the stories that surround it, and their cumulative symbolic significance; these are what have led the Japanese government to bestow on it protected registered status (despite it in fact being of Chinese origin). Stripped of its recorded history, the bowl would be nothing more than a beautiful cracked Chinese celadon bowl with metal staples keeping it intact.[11] The history that accompanies this bowl is a reflection both of Ashikaga shogunal taste and of the continuing

appeal of Chinese porcelain as a symbol of Japan's cultural prestige.

The demise of the Ashikaga government in the early sixteenth century and the dispersal of the Ashikaga shogunal collections created opportunities for new collectors and allowed for the possibility of new types of collection, which could include wares from other countries as well as those fired in Japan itself (Guth 1993, 49-52). Three military unifiers arose in the second half of the sixteenth century: Oda Nobunaga (1534-1582), Toyotomi Hideyoshi (1536-1598) and Tokugawa Ieyasu (1542-1616). Like the Ashikaga before them they had a strong interest in Chinese and other foreign objects as well as the lucrative Asian trade. Indeed, the Asian trade was in fact more active than ever before, now that the Portuguese, who had landed on the Japanese island of Tanegashima in 1543, had entered into Japan's trading sphere.

Chidori

The shifting symbolic power of Chinese ceramics in Japanese society during this period is similarly illustrated in the history of a Chinese Longquan celadon incense burner dating from the thirteenth century, named 'Chidori' (Plover). This diminutive incense burner is thought to have been owned by each of the above-mentioned three unifiers of Japan in turn, a fitting example of what Arjun Appadarai termed 'things in motion'. It has since been passed down in the ruling Tokugawa family, and is currently held by the descendents of the Owari branch and housed in the Tokugawa family museum in Nagoya.

Chidori actually consists of three parts, each of which dates from a different period: the incense-burner itself, which is a thirteenth-century Song-period Longquan celadon ceramic, rather small and ordinary; an ornamental Ming-period carved lacquer-and-gilt-metal stand; and a Japanese metal lid, furnished with a tiny plover, thought to have been fashioned by the celebrated metalworker and swordsmith to the Ashikaga shoguns, Gotô Yûjô (1440-1512). Even though it is not particu-

larly elegant, the unification of Song, Ming and Ashikaga periods in this one piece must have made Chidori particularly attractive to its three famous owners; and its association with them in turn adds to its present-day aura of authority.

A hybrid work, Chidori is accompanied by three boxes as well as several accompanying documents, which purport to explain its provenance. One of these documents relates the story of how when Nobunaga was forced to commit suicide in 1582 the incense burner was passed on to his trusted general Hideyoshi. This incense burner happened to have been placed in Hideyoshi's bedroom one night when the famous thief Ishikawa Goemon (1558?-1594) entered with intent to steal; and the plover on its lid is said to have broken into song, saving its owner and exposing the presence of the thief, who was subsequently forced to endure his legendary punishment of death by boiling. Whether or not one cares to believe the story, it is a fact that after Hideyoshi's death the next leader Tokugawa Ieyasu inherited Chidori. Dating from a particularly formative period in Japan's history, and associated with three great leaders, the piece is a physical embodiment of accumulated power.

Taste and tea in the sixteenth century

Historians in Japan have traditionally viewed the evolution of taste and tea aesthetics in the sixteenth century as having been refined through the lineage of three important tastemakers: Murata Shukô (1423-1502), Takeno Jôô (1502-1555) and Sen no Rikyû (1522-1591). The last of these in particular has had a profound influence on what is generally known in modern times as the 'Tea Ceremony', but which I advisedly call 'tea gatherings'.

Shukô was a Nara merchant who was said to have become friendly with Nôami just before the latter's death when Nôami had escaped from Kyoto to Nara during the Ônin war (1467-1477). Shukô is thought to have received a copy of the *Kundaikan sôchôki* from Nôami, but he himself could never

have afforded to own one of the designated Jian ware bowls. Shukô came to advocate a new style of tea for a new era, focusing on simpler utensils in more informal and seasonal settings.

Takeno Jôô was a wealthy Sakai merchant (and occasional arms trader), who moved to Kyoto in 1525. Following in the footsteps of Shukô, he advocated gathering for tea in informal rooms without the use of a *daisu* (a lacquered stand for the display of tea utensils). In what might have been heretical practice for *dôbôshû* such as Nôami, Jôô had his pupils place tea utensils, such as Chinese Jian ware bowls, directly on the matted floor. This practice gave greater prominence to each object in and of itself rather than encouraging the viewer to appreciate the total assemblage.

Placing objects directly on a mat floor created a different type of dynamic between the objects, one that was at once less hierarchical and more kinetic. For the new generation of tea aesthetes, it also had the effect of implicitly emphasising the individual role of the tea master (as opposed to the guest hall companion) as tastemaker and arbiter of the correct assemblages. Tea gatherings in this period were no longer bolstered by lavish groupings of exquisitely beautiful objects solely from China in set displays approved of by *dôbôshû*, but became more integrated and fluid arrangements with different styles of foreign ware mixed with domestic products depending on the taste and acumen of the host. Jôô classified tea gatherings into three styles in line with calligraphy practice: formal or Chinese (*shin*), semi-formal (*gyo*), and informal (*so*), all of which employed different protocols and types of object.

Merchants who dealt in these objects not only became wealthy, but also grew into a new breed of arbiters of taste for the era, focused around the trading ports of Sakai and Hakata. Hakata, in particular, was a trading entrepôt close to Korea and benefited from active Korean trade brokered in part by the Sô family lords of Tsushima Island and pirate (*wakô*) activities.

Korean bowls are noted in tea diaries as being in use in tea

gatherings from 1530s onwards, used along with locally pro-
duced ceramics made to order from kiln areas such as
Shigaraki (Chadô shiryôkan 1990, 102-3).[12] The archaeological
record, however, clearly demonstrates that Korean bowls in
similar shapes to those used for tea in the sixteenth century
were present in habitation sites in increasing numbers from
the fourteenth century onwards, and must certainly have been
used in tea gatherings at least a century or more earlier, even
if on a sporadic basis. There is also compelling evidence from
the famous Sinan shipwreck, serving to illustrate the level and
the nature of the Asian ceramic trade in the fourteenth cen-
tury. This shipwreck, located off the southwest coast of Korea,
was thoroughly excavated by the Korean Cultural Properties
Commission in 1976 (Youn 1983, 82; Kim 1986, and Munghwa
Kongbobu 1983). The ship was loaded heavily with a cargo of
ceramics, metal, lacquer, and stone goods, mostly of Chinese
origin. It appears to have foundered during a storm in 1322.
Uncovered in the cargo were 9,639 celadon vessels (mostly from
Longquan kilns), 4,813 items of white porcelain from Jing-
dezhen, 371 brown and black glazed examples of Jian ware and
1,789 miscellaneous trade ceramics, including Japanese *ten-
moku* models fired in the Seto kilns (Youn 1983, 82). The trade
ship's journey originated in China, with a possible stop in
Korea, and while on its way to Japan and other Asian destina-
tions it sank, giving us a window onto the complex nature of
Asian trade.

Trade ceramics made in other Asian countries than China
and Korea also have a long history in Japan. Thai stoneware
with dark brown glazes, celadon-glazed or iron-oxide painted
decorated wares were imported into Japan in significant num-
bers from the fourteenth to sixteenth centuries, and were
particularly popular in the Ryukyu Islands and Kyushu (Japa-
nese Society for Southeast Asian Archaeology 2004, and Cort
1993, 27-44). Trade ceramics, however, were often imported for
what they contained, and once the container was empty it was
often re-employed for other quite distinct purposes. One Thai
jar of a shape frequently favoured for holding fresh tea leaves

in Japan, for example, was excavated from a late sixteenth-century site in Sakai and found to contain potassium nitrate, for gun powder (Sakai City Municipal Museum 1989).

Ceramics from Vietnam are present in the late medieval and early modern archaeological sites in Japan, and still extant in heirloom examples. A shop (discussed further in Chapter 3) excavated in Kyoto, in the merchant area of Sanjô and dating from the early seventeenth century, for example, clearly specialised in domestic Mino wares that imitated Vietnamese wares (Gifu City Municipal Museum 2001). Burmese, Cambodian, Dutch and Iznik ceramics have similarly been uncovered in sixteenth- to seventeenth-century Japanese deposits, attesting to the cosmopolitan flavour of the market place and their accessibility at that time. The significant amount of trade wares uncovered on Japanese archaeological sites attests to both the availability of these ceramics and a strong consumer demand.

The Ryukyu Islands (current Okinawa Prefecture) played a pivotal role in the ceramic trade, at least up until the early seventeenth century (Pearson 2008). In 1372, formal relations were established between the Ryukyu Kingdom and Imperial Ming China. The Ryukyu King Satto (1321-1395) sent his brother as a delegate to China to establish a tributary system, which remained intact until the Satsuma invasion of the island kingdom in 1607. As a result of the tributary status with China from the fifteenth to the first half of the sixteenth century, the Ryukyu Kingdom became an active player in the China trade route between Ming China, Joeson Korea, Tsushima Island, Iki Island and the Japanese Seto Inland Sea via Hakata, Hyogo and Kinai regions.

The scale of this trade should not be underestimated. For example, in 1371 the initial record detailing trade ceramics brought from China to the Ryukyu Kingdom recorded 1,000 special examples as a gift from the Chinese emperor and an additional 69,500 ceramics for trade purposes (Kerr 2000, 74-8). Five years later in 1376, records show that the Ryukyu islanders exchanged horses for 70,000 Chinese ceramics on a

single vessel. These wares were destined not just for Japanese markets, but also for distribution throughout Southeast Asia (Kamei 2009, 63-70). The last Ryukyu-based ship bound for Southeast Asia was recorded in 1570. Chinese ceramics then cease to be found in significant numbers in archaeological sites on the Ryukyu Islands until the eighteenth century. From this period until the mid-seventeenth century, Japanese traders based in Kyushu and Honshu dominated the local China trade.

Part of the reason for the Ryukyu Kingdom's loss of strategic trade advantage in the mid-sixteenth century was the growing dominance of Japanese merchants based in the powerful port entrepôt cities of Sakai and Hakata. Besides wielding economic power through trade, particularly in weapons, merchants such as Takeno Jôô, mentioned earlier, were also 'tastemakers' in that they created new categories of desirable trade wares and utensils. Jôô, for example, was the first to give prominence to the concept of 'found' objects in tea taste. Objects made of various materials and originating in differing countries, produced for daily use, but identified (i.e. 'found') by tea masters and transformed into the role of tea utensils, were worth commercially a great deal more. Inexpensive Korean rice bowls (such as Buncheong ware and non-official porcelain) and rustic domestic wares became coveted objects for tea practitioners if sanctioned by a famous tastemaker (Cort 1992, 7-30).

In addition, new ceramic kilns were constructed in central and southern Honshu as well as in Kyushu to accommodate the new and growing demand for specific new styles of ceramic (such as Shino-style Mino wares, or Karatsu ware, discussed in Chapter 3), and older kiln areas such as Shigaraki and Bizen expanded production.

In 1540, Jôô is recorded as returning to Sakai and befriending a much younger merchant (and arms dealer) named Sen no Rikyû (1522-91). Rikyû was soon to become a powerful taste arbiter, first one of Oda Nobunaga's tea instructors from 1575, and then from 1582 till his death in 1591 a tea and personal advisor to Toyotomi Hideyoshi (Murai 1990). Both Nobunaga

and Hideyoshi were busy consolidating their power through warfare, political machinations and social endeavours. This last included holding tea gatherings with coveted objects such as Chidori, discussed earlier.

Rikyû came to define a style that was to become a hallmark of tea practice today. He continued a shift away from tea's traditional Chinese *karamono suki* roots and defined an entirely new lexicon of aesthetic value based on Japanese indigenous terms such as *wabi*, roughly translatable as 'an aura of solitariness', *sabi*, the aura being mellowed from use, and *shibui*, an aura of austerity.

Despite Rikyû's popularity and his impact on the practice of tea in Japan, however, the older, lavish gatherings with their Chinese exotica displayed on lacquered stands did not disappear and continued to be popular among the elite (Shiodome chiku iseki chôsakai 1994; University of Tokyo Archaeological Research Institute 1989).[13] Previously famous Jian ware bowls were still carefully preserved in temples and daimyo collections, and gradually acquired new, and more antiquarian, significance. Chinese wares owned by the Ashikaga shoguns, such as Bakôhan, still lent cultural legitimacy to their possessors' claims to power, and they were ascribed a new special status of *gyomotsu* (or sometimes *gomotsu*, 'honourable object') (Shimizu 1984). From the second half of the seventeenth century onwards the Edo-based shogunate along with high-ranking lords (daimyo) practised ritualised tea gatherings that once again made use of a *daisu* (lacquered stand) and displays of Chinese treasures, reviving the Ashikaga style in what is sometimes termed 'daimyo tea' (Shimizu 1984, 101).

This type of gathering continued, though in a transformed fashion, in the Meiji period (1868-1912) – for example, the industrialist Masuda Takashi, who at the time owned Bakôhan, revived a custom of elite formal tea gatherings with displays of important historic objects, some even from the Ashikaga collections (Guth 1993, 46-9, 72-9, 83-99). Even as tastes changed and individual tastemakers left their respective

2. Chinese Ceramics in Japan during the Medieval Period

marks on the practice of tea, the authority that the earlier specific Chinese wares possessed remained undiminished.

The domestication of Chinese Jian ware

An examination of Chinese brown and black glazed stoneware (*karamono tenmoku*) in Japan helps to provide insights in order to corroborate recorded information in tea diaries and historical accounts. The earliest document to mention Chinese brown and black wares appears to be a letter written by Kanazawa Teiken (1278-1333), a vassal of the ruling Hôjô family, to his son Sadamasa in Kyoto (Akanuma 1994, 178). In his letter Teiken mentions that *karamono* used for tea was becoming more popular in Kamakura (the then capital), and he urges his son to purchase Chinese ceramics while in Kyoto. In a separate letter to the priest Ken'a (active late thirteenth to early fourteenth century) at Shômyôji in Kamakura, Teiken uses the term *kensan* (Jian ware) to describe a tea bowl, indicating that the Japanese elite of this period were aware of the categories of Chinese dark-glazed ceramics, and were able to distinguish products from different kiln sites, more than a century before Nôami and Sôami regularised the practice in the manual *Kundaikan sôchôki*. Knowledge about and possession of these Chinese wares appear to be an advantage in the politically charged atmosphere around the Kamakura government at this time, as witnessed by the letter of Ken'a.

Chinese ceramics as seen in painted hand scrolls

The continuing importance of high-quality Jian ware tea bowls to the elite during the Muromachi period is also attested to in illustrated hand scrolls popular in this period, such as the *Boki ekotoba* (Illustrated Life of Priest Kakunyô [1270-1351]; the scrolls were painted in 1351-1360). The *Boki ekotoba*, now designated as an Important Cultural Property, is particularly important as it depicts with attention to detail and high artistic quality the interiors of upper-class households and temples,

which clearly held many types of fine imported ceramics, among them brown- and black-glazed tea bowls (Noba 1990, 24-44).

Another hand scroll provides an interesting juxtaposition to the *Boki ekotoba* example; it is titled the *Fukutomi zôshi emaki* ('Tales of Fukutomi'), dates to the mid-fourteenth century, and is currently in the Cleveland Museum of Art. Unlike the *Boki ekotoba*, which is basically a religious biography of a priest, 'Tales of Fukutomi' illustrates a farcical rags-to-riches story in which the protagonist learns to break wind to great effect and as a result gains incredible riches for his efforts. The hand scroll features a scene where the newly wealthy Fukutomi and his wife are surrounded by luxury items, including numerous Chinese Jian ware tea bowls each with Chinese red lacquer stands and large Longquan celadon bowls. Archaeological records such as a single site in Hakata from a similar date to the *Fukutomi zôshi* hand scroll, which uncovered more than 35,000 Chinese ceramic sherds, confirm the volume and type of Chinese ceramics entering Japan (Kamei 1994, 158).

Japanese medieval stoneware production

Most medieval Japanese ceramic workshops produced high-fired unglazed stoneware (Narasaki 1977).[14] This style of unglazed stoneware was made in three principal shapes still in use today: the storage jar (*tsubo*), the mortar (*suribachi*), and the wide-mouthed jar (*kame*). From the late twelfth to the mid-sixteenth century, the Seto and later the neighbouring Mino kilns in central Honshu were the main areas that produced intentionally glazed ceramics, most of which were based on Chinese prototypes. Made from fine-textured off-white stoneware clay and then dipped in glaze, these examples were fired in a single chamber kiln (*anagama*) dug into a mountainside, with a single flame-dividing pillar (Faulkner 1987, 1-3). Decorative effect was achieved using glaze patterning (iron and ash), though certain jars were embellished with line incising, stamping or appliqué. The Seto and Mino kilns did not employ

painted decoration on the vessel surface until the latter half of the sixteenth century.

The earliest Seto wares (called *ko-Seto*, or old Seto) comprised unglazed narrow-mouthed storage jars, wide-mouthed jars, mixing mortars, bowls and small dishes. In the thirteenth century, the Seto kilns began to produce glazed wares in an increasing variety of shapes: jars, flasks, ewers, incense boxes, and teabowls. In the mid- to late fourteenth century, the Seto potters produced a range of utilitarian wares for the table and kitchen; along with bowls for tea gatherings, including *wamono tenmoku* (Japanese copies of Jian ware). These bowls were mass-produced, with decorative effect kept to a minimum, thus cutting both cost and production time.

These domestic imitations at first closely followed their Chinese counterparts, notably in shape rather than glaze colour. At the same time as copying contemporary Chinese ceramic forms, they also reproduced much older styles of Chinese wares that had continued to be popular in Japan.

In the early sixteenth century a significant development occurred in the Seto and Mino kiln areas with the introduction of a new kiln technology. The new type of kiln (*ôgama*, literally large kiln) had a single large chamber with multiple flame-dividing pillars. It was built on a slope, enabling a controlled incline but with a more developed chamber and sophisticated draft system that could accommodate a greater number of wares. The incline and the standard-sized chamber, along with a restricted chimney passage, facilitated efficient firing with consistent results and the ability to control the amount of oxygen entering the kiln during the firing process. The *ôgama* kiln proved to be a substantial improvement on the earlier *anagama* kiln, allowing not only for stable and controllable firing conditions, but also for consistently higher temperatures during the firing process, which in turn meant that feldspathic glazes melted uniformly over vessels (Itô 1994, 223). The Seto and Mino kilns areas were able to standardise and increase production, lower prices, and garner a greater portion of the market share.

Imported Chinese porcelain up to
the sixteenth century

Changing patterns of Chinese ceramic importation are readily apparent through a series of well-executed excavations in the port town of Hakata, in the northern part of Kyushu, which have also been well published (Sakai City Museum 1993; National Museum of History 2005, 84-95; Asahi Shimbun 1993, 64-74). Large quantities of Chinese trade wares have been found in levels dating from the end of the eleventh century through to the fourteenth century. Most of the sherds recovered were from celadon (first Yueh, then Longquan) and white porcelain vessels, with a few Jian ware examples.

Two distinct trading patterns developed in Japan from the twelfth century and continued throughout the Edo period. One extended from Kyushu to Kansai, and then up the Japan Sea coast as far north as Akita and Aomori in northern Tohoku. The areas along this western trading route had greater access to imported trade wares originating in Kyushu and tended to carry more expensive goods partly because of its trade in metal ores. The other, eastern, trade route included the Kanto region, the Seto and Mino region and the Inland Sea. Along this trading route, Japanese copies of foreign trade wares or other domestic ceramics were most commonly distributed. These were less expensive local stoneware and acted as a substitute for the more coveted foreign Chinese porcelain.

The Fukui Prefectural Ichijôdani Asakura Clan Archaeological Museum has conducted a survey of the sixteenth-century sites in the area surrounding Ichijôdani in present-day Fukui Prefecture in order to understand the reception of trade ceramics in Japan along a typical area supplied by the western trading route. The survey uncovered general differences among the three types of site: first, *machiya* or houses of townspeople, second, *buke yashiki* or warrior households, and third, *jiin* or temple compounds (Fukui Prefecture Asakura Clan Archaeological Museum 1994, 36-42). Townhouses (*machiya*) contained small bowls and plates, and Chinese trade goods of

96

low quality meant for everyday use. Occasionally a celadon incense burner (*kôro*, typically of Longquan ware) was found among the houses of the wealthier townspeople (*chônin*). Warrior household (*buke yashiki*) assemblages included wares similar to those found at the *machiya*, but contained larger numbers of higher-quality trade wares, as well as a significant amount of underglaze cobalt blue decorated porcelains, mostly in the form of large plates and bowls. Temple sites (*jiin*) revealed trade wares meant for everyday use as well as larger objects of high quality. Numerous underglaze cobalt blue decorated porcelain dishes and bowls were also present in all sites. However, it was only in the temple sites in that area that Thai stoneware was found (Ono 1985).

The survey clearly reveals that in the sixteenth century even Japanese townspeople had access to and utilised Chinese porcelain, though lower-quality wares. Samurai warrior households certainly appear to have used Chinese porcelains in dining and entertaining. Interestingly, temples also used Chinese porcelains for dining and apparently for decorative or religious purposes. In other words, by the sixteenth century, at least along the western coast of Japan, possession and use of Chinese porcelain had become commonplace.

Chinese porcelain distribution in early modern Japan

The major porcelain-producing centre of China from the fourteenth century onwards, indeed the largest in the world, was Jingdezhen in Jiangxi province. The Jingdezhen kilns had flourished under imperial patronage throughout the early and mid-Ming period along with adjacent kilns that serviced the greater populace at large. However, between the death of the Wanli emperor (1563-1620) in 1620 and 1683 when the kilns were reorganised by the new Qing rulers, the Jingdezhen potteries lost their imperial patronage and a steady source of income. The potteries were destroyed in 1644 during a rebellion against the Qing regime and again in a disastrous fire in

1675.[15] Chinese porcelain kilns in Guangdong and Fujian continued to produce porcelains to some degree until the 1640s, aided in part by international trade with the Portuguese and Dutch (Boxer 1950).

As seen in the Fukui Prefecture Ichijôdani Asakura Clan Archaeological Museum survey outlined above, from the sixteenth century onwards in Japan, Chinese trade ceramics, which originated as individual high-end items for the elite, became more affordable. Chinese porcelain was increasingly purchased in middle-priced sets for dining and entertaining, by merchants as well as nobles and samurai. Sets of Chinese porcelain have been found at Osaka Castle and the residence of the Maeda family in Edo (currently the Hongo campus of the University of Tokyo, see Tokyo City Archaeological Unit 1997, Osaka City Cultural Section 1988, and University of Tokyo Archaeological Research Institute 1990).[16] In many archaeological sites dating to the late sixteenth to mid-seventeenth century, Chinese ceramics are found in equal portion to, or even more plentifully than, Japanese domestic Seto, Mino or Karatsu stoneware (Hasebe and Imai 1995, 127-32; Horiuchi 1991, 185-200).[17]

To understand better the type of distribution patterns of Chinese porcelains in Japan through the Edo period, Ôhashi Kôji has examined sixteenth- to nineteenth-century Chinese underglaze cobalt blue decorated porcelain excavated from sites throughout Kyushu (Ôhashi 1995, 55-68).[18] He argues that the Chinese porcelain uncovered during those three hundred years falls into five chronological phases (Ôhashi 1995, 55-68 and Ôno 1985).

The initial phase (1585-1610s) occurred when Hideyoshi's troops twice invaded the Korean Peninsula. Nagoya Castle in Karatsu, where Hideyoshi's troops were based, and sites in the nearby port city of Hakata, provide the greatest quantities of Chinese ceramics from the first half of this period. Chinese porcelains from this phase include Kraak-style export porcelain, and bowls and dishes with floral designs commonly exported throughout Asia. Material belonging to the second half of the initial phase was mostly uncovered from Hirado

Island, where the Dutch, English and some Chinese traders were based until 1616 (Hirado City Cultural Association 1992). Excavated Chinese porcelains from this island include larger vessels and a greater diversity of styles from different parts of China, including Jingdezhen, Fujian and Guangdong, than found from the slightly earlier Nagoya Castle and Hakata sites.[19]

The second stage (1610-1640s) is characterised by further diversification of Chinese porcelain types and styles, including the Kosometsuke and Shonzui styles fired in the Jingdezhen kilns, thought to be at least in part created for or adapted to the Japanese market. The overall quality of the porcelain is inferior, and many of the vessels have unglazed bases. Similar types of ware are found throughout the Japanese archipelago from Kagoshima to Edo.

The third stage (1640s-1680) witnesses a dramatic reduction in the number of Chinese ceramics uncovered from Kyushu archaeological sites, as such ceramics were replaced by Japanese domestic porcelain counterparts. In the fourth phase (1680-1780s) Chinese porcelains are once again found in Japanese archaeological sites, but they are generally of lower quality and differ significantly from Chinese porcelain styles exported to Europe and America during the same period. During the final phase (from the end of the eighteenth century until the end of the nineteenth century), small, inferior-quality Chinese porcelain bowls (from Zhangzhou area kilns) can be found in abundance at many Kyushu sites. These bowls are for the most part decorated with similar underglaze blue designs, and were inexpensive. Overglaze Chinese porcelain has also been recovered from Kyushu sites, many of similar low quality; and most appear to have been produced at the kilns in Jingdezhen. A few high-quality overglaze examples have been recovered, but these are more the exception than the rule.[20]

A clear pattern emerges from this overview of Chinese porcelain excavated from early modern period sites in Kyushu. To summarise, Chinese porcelain was imported in increasing quantities in the sixteenth to early seventeenth centuries. A disruption in supply occurred from the later 1640s through to

the end of the seventeenth century, resulting in a reduction of the number of non-heirloom Chinese porcelains present in sites from this period, and their replacement by domestic Japanese porcelain. In the late seventeenth century onwards, the import of Chinese porcelain resumes on a smaller and more modest level (Hasebe and Imai 1995, 127-32).

It is generally accepted that most of the sixteenth and early seventeenth-century Chinese porcelain available in Japan was made for the general Asian export market, and not specifically tailored for Japanese tastes. The largest markets for Guangdong Province porcelain appears to be in the Middle East, while blue and white wares made in Jingdezhen, Jiangxi or in Fujian had significant markets throughout the Middle East, South and South East Asia. Kraak-style wares made mostly in Jingdezhen were predominantly destined for Europe and the Middle East, though all of these wares entered Japan as well, placing Japan on the general Asian trade networks.[21] Some ceramic scholars believe that Chinese Kraak wares made at Jingdezhen were exclusively for European consumption. But their significant presence on sixteenth- to seventeenth-century sites in Japan provides a corrective to this assumption.[22] Chinese Kraak wares (*fuyô-de* in Japanese) have been discovered in such diverse sites as the Dutch storehouse at Hirado, which supplied Japanese traders (prior to 1640), Sakai merchant sites, Osaka Castle, and the Maeda lord's residence in Edo (Horiuchi 1991). The name Kraak is an archaic form of the Dutch term *kraken*, which in turn was adopted from the Portuguese *caracas* ('galleon', or 'merchant ship'). It is also related to the English word *carrack*. The origin of the name can be pinpointed with precision: in 1602 and 1603 the Dutch captured two such Portuguese ships laden with Chinese porcelain from Jingdezhen. The cargo, sold at auction in Amsterdam, proved to be exceedingly popular, and the taste for Chinese porcelains spread among Europeans.[23] This enthusiasm in seventeenth-century Europe for Kraak porcelain may frequently be seen in northern still-life paintings, such as Brueghal's *The Vision*.[24] In Japan, the consistent presence of Kraak-style porcelain in

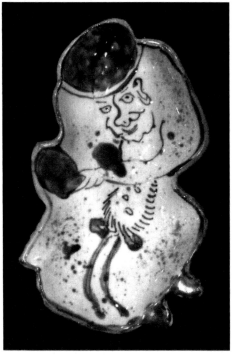

Fig. 7. Moulded dish in the shape of a human figure, Kosometsuke style, Tianqi ware, China. Jingdezhen kilns, *c.* 1620s. Porcelain with underglaze cobalt blue oxide. L. 18.1 cm. British Museum, 2012 3017.1.

archaeological sites of the period also attests to the style's lasting popularity.

Certainly from the 1620s, Japanese merchants began to place orders directly with their Chinese counterparts at the Jingdezhen and other porcelain kilns for wares of certain designs and shapes. In addition, the Jingdezhen popular kilns began to adapt standard designs that were believed to be suited to Japanese tastes, on speculation. Tailored wares from the 1620s, both ordered by or styled for the Japanese market, are labelled in Japanese *Kosometsuke* if decorated in underglaze cobalt blue (as was most common; Fig. 7), *or Tenkei aka-e* if polychrome enamel decorated.[25] These terms (*Kosometsuke* and

Tenkei aka-e), however, are used only in Japan and apply somewhat inconsistently to a small percentage of a much larger category of porcelains known as Tianqi ware, after the Chinese late Ming reign date Tianqi (1621-1627).[26] Examples of what in Japan is termed *Kosometsuke* have been excavated only in limited number in archaeological sites in Japan. Heirloom *Kosometsuke* items, however, are numerous in Japanese collections, which presents a puzzling dilemma.[27]

In the 1630s to 1640s, a different style of Chinese porcelain seems to have been created in China specifically for the Japanese market. This style of underglaze cobalt blue decorated porcelain is termed 'Shonzui' by Japanese scholars and was produced at Jingdezhen kilns and possibly at some southern kilns as well. Shonzui Chinese porcelain is characterised by a pure and sometimes violet coloured blue-cobalt, and in many examples an iron-oxide rim, the unusual design pattern involving a combination of figural, roundel and abstracted geometric elements (Fig. 8). Shonzui ware with overglaze enamel decoration was also produced, in less quantity with designs similar to their underglaze blue counterparts.[28] Shonzui wares appear to be high-end porcelain, in well-executed forms such as water jars (*mizusashi*, the cover illustration), incense boxes (*kôgô*) and teabowls suitable for tea gatherings. Shonzui designs, while based loosely on the popular Kraak styles, have the motifs asymmetrically arranged on a geometric ground to suit Japanese sensibilities.

The term Shonzui was probably taken from the Japanese reading of the characters *gorôdaiyu go shonzui* found occasionally in underglaze cobalt blue on footrings (alternative explanations have been given).[29] Shonzui ware was such a successful style of porcelain in Japan that it subsequently became widely imitated at various Japanese kilns until the end of the Edo period, particularly in the late eighteenth to early nineteenth centuries, giving rise to some controversy especially among western academics.[30] Certainly there are many more examples of the later Japanese Shonzui-style porcelain than their original Chinese counterparts. To date, Chinese Shonzui

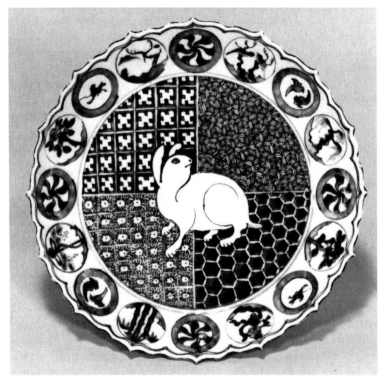

Fig. 8. Foliate dish with design of hare, Shonzui ware, China. Jingdezhen kilns, *c.* 1630-40s. Porcelain with underglaze cobalt blue oxide. Idemitsu Museum of Arts, Tokyo.

ware has been archaeologically excavated from numerous sites in Japan and in only small quantities from Ningbo, an important southern Chinese trading port. This means that almost all Chinese Shonzui wares were made for, and indeed actually exported to, Japan.

To summarise, the image of China has provided the backdrop to multifarious cultural expressions in Japan. Indeed, the image of China played just as important a role for high-end Japanese material culture as for literature. The story of the thirteenth-century Bakôhan, a cracked Chinese Longquan celadon bowl discussed above, continues to carry authority to

the present day and serves as a timely reminder that while China continues to be of lasting cultural importance to Japan, the nature of its importance and its ramifications shift with time and circumstances.

The shifting meanings attached to rituals and objects that have resonances with China have been examined through the cultural pursuit of whipped tea and its accompanying accoutrements. Tea gatherings are usually seen nowadays as the quintessential Japanese pursuit, one in which 'Japanese' objects figure prominently. When tea histories, excavated materials and related documentation are examined together, however, a more complicated picture emerges. The growth in the market for things Chinese and continental from the twelfth century onwards encouraged connoisseurship, a modification of the objects, and eventually the domestic production of such objects adapted to suit local tastes and requirements. This is most clearly demonstrated with domestic Seto ware, which recalled earlier Chinese Jian ware prototypes, and with Korean rice bowls designated for use as tea bowls in Japanese tea gatherings and eventually made to order to Japanese specifications by Korean kilns.

The image of China and its manifestation through ceramic trade wares evolved with the shifts in power to a new military elite in the late sixteenth to seventeenth century, the rise of the merchant class, the opening of the Asian trade arena, and new social configurations in Japan. After the Ashikaga lost power, giving way to a new military elite, different types of Chinese ceramic became available to a larger share of the population, and became part of the fabric of social customs of the upwardly mobile merchant classes. By the 1620s, Japanese-based merchants were able to order their own adapted versions of chinaware from the Chinese kilns of Jingdezhen. By now the image of Chinese porcelain in Japan, while still retaining its cultural significance, had shifted from being that of a symbol of authority and power, to one associated with affluence and newly emergent social status.

3

The Genesis of Japanese Porcelain

... [T]here were no actual barriers by about 1600 [in China] to the spread downward of luxury artefacts of the rich ... The market mechanisms were in place to ensure that brushes from Anhui province or ceramics from Jingdezhen were available across the empire to those who could pay for them.

Clunas (1991), 37-8

Ashikaga Yoshimasa in the fifteenth century used the stylistic formulae of the luxury artefacts cited above of China to perhaps best effect, with his legendary collections, curatorial manuals and rituals of display. His and his family's attempts to control the Asian trade networks are telling indices of the political and financial reality behind the China-boom in medieval Japan. The role of China and its manifestation in Japan through ceramic trade wares evolved with later sixteenth- to seventeenth-century developments in politics, shifts in society in Japan resulting in the consequential social configurations, and changes in the economy with the opening of the Asian trade arena on a larger scale.

By the late sixteenth century, after the Ashikaga lost power and a new military elite became entrenched, Chinese ceramics had become available to a greater percentage of the population and as a result became part of the fabric of social customs of the privileged, wealthy and upwardly mobile. By the early 1600s, Japanese merchants were able to order their own ceramics adapted or made to order as well as multiple versions of Chinese porcelain from the Chinese kilns of Jingdezhen that were

made to suit not only Japanese design tastes but, importantly, Japanese dining customs. This factor ensured their large market appeal among the upper echelons of society, and in particular the warrior classes. By this time, at the beginning of the Edo period, Chinese porcelain, while still retaining its potent cultural significance in Japan, shifted from being a symbol of power and taste for the elite to more of a popular status symbol and coveted necessary luxury good.

The impact of Asian trade on early modern Japan

Craig Clunas refers in the passage quoted at the beginning of this chapter to late Ming China, but his statement could equally describe the availability and dissemination of luxury goods in Japan, certainly from the 1600s onwards. Luxury goods, both foreign and domestic, included both long-established prestige items such as *maki-e* lacquer ware, painting on screens and hanging scrolls, fine textiles and heirloom Chinese ceramics, and newly popular products such as smoking accoutrements, illustrated books, prints, ornaments, tea-related accessories, and of course specialised varieties of stoneware and porcelain.

Patterns of ceramic consumption changed dramatically during the sixteenth and early seventeenth centuries due in part to the growth of cities (*jôkamachi*, or castle towns). Among the reasons for this rapid urbanisation were burgeoning commerce – the introduction of cash-based commerce, unified merchant networks, the rise of newly empowered townspeople (*chônin*) – along with charismatic tastemakers. Orders for newly popular, unusual or luxury ceramics originated not only from courtiers, high-ranking clergy, and the military, but also from merchants who controlled the ceramic trade. In the early seventeenth century, this newly formed consumer base, concentrated for the most part in urban areas, helped to transform the Japanese ceramic industry into a commodity supply base that filled the dual roles of furnishing the daily necessities of dining and catering to the yearning for luxury and prestige.

The impact of Asian trade on early modern commerce in

3. The Genesis of Japanese Porcelain

Japan was inseparable from such dynamics as the formation of internal business practices, local trade networks, monetisation and changes in consumer taste.

Japanese art and material culture produced during the Edo period have often been seen in terms of mainly indigenous styles on the one hand, juxtaposed with foreign-influenced styles on the other. This is the result of the notion still held by some contemporary scholars that Japan was isolated from the outside world, in an state of seclusion (*sakoku*), during most of this period. The term *sakoku* (literally 'isolated or chained country', but normally translated as closed nation) appears to have originated from a Japanese translation of an eighteenth-century English-language book on the history of Japan, and as a concept does not accurately reflect the internally defined social structure of that time.[1] Katô Eiichi, Arano Yasunori, and Ronald Toby, among others, have rethought the terminology of *sakoku* and have made important corrections that have yet to be taken up by many art historians and archaeologists. Arano has suggested that this period be viewed from the more appropriate and widespread Asian phenomenon of 'maritime prohibitions' (*kaikin*).[2] If the construct of 'closed nation' is replaced by 'maritime prohibitions' and early modern Japan is envisioned within the framework of pan-Asian trade and cultural exchange, notwithstanding overseas trade prohibitions by a number of Asian countries at different periods such as Qing period China and Joseon period in Korea, it seems natural that wares produced in Japan were influenced by and responded to international trends.

A brief examination of trading structures and commercial practices by individual domains and entrepreneurial activity in semi-autonomous trading zones like Sakai, Hakata and Osaka, as well as government involvement in maritime affairs and trading practices, makes clear the impact of a vigorous international trade in the late sixteenth to early seventeenth centuries. This expansion was paralleled by domestic growth. The general population increased, as did agricultural production, helped in part by land reclamation and the creation and expansion of

107

cities and towns, and this gave rise to greater consumption of material goods, ceramics, of course, among them.

Scholarly literature has generally overlooked the interrelationship between central government, semi-autonomous domains, regional government, cartels and local merchants during this period, all of which were factors that helped to develop an integrated market distribution system throughout the archipelago. But it was precisely this commercial growth, spurred on in large part by political policies coupled with merchant initiatives, that helped to shift the economic landscape in the late sixteenth and early seventeenth centuries. The increase in commercial activity was not limited to urban centres; it also had a stimulating effect on provincial industries such as lumber and, of course, ceramics.[3] A nationwide capital infrastructure was aided by government control, where possible, of gold, silver and copper bullion mines. In addition, a semi-standardised three-metal system of coinage, weight and volume was also introduced by the end of the sixteenth century.[4]

It was, in fact, the high quality of Japanese bullion that attracted foreign traders to Japanese shores and ensured a strong market for Japanese trade throughout Asia. Kamiki Tetsu and Yamamura Kôzô estimated that between the years 1560 to 1600, 33,750 to 48,750 kilograms of silver per year were exported from Japan, with most of that amount traded in China.[5] The importance of the Sino-Japan silver trade was so readily apparent that even the Englishman Ralph Fitch, travelling in South and South East Asia in the 1580s, recorded:

When the Portuguese go from Macao in China to Japan, they carry much white silk, gold, musk, and porcelain: and they bring from thence nothing but silver. They have a great carrack which goes there every year and she brings from thence every year above six hundred cruzados [approximately 17,000 kilograms]. And all this silver ... they employ to their great advantage in China.[6]

The export of silver continued unabated in the early seven-

teenth century with the consolidation of political power by the Tokugawa. The arrival of additional trading partners, including first the Portuguese and then the Dutch, in addition to the active Japanese trade in the Southeast Asia markets, created an increasing demand for silver resources. Kobata Atsushi has estimated that between the Japanese, Chinese, Portuguese and Dutch ships trading in Japan, exports of silver in the early 1600s may have reached between 150,000 and 187,500 kilograms annually, well above Kamiki and Yamamura's estimates of pre-1600 silver export levels (Kobata 1970; Atwell 1970).[7]

During the sixteenth century the major entrepreneurial trading and commercial centres in Japan were from the southern island of Kyushu, Hakata, Nagasaki and Hirado; on the main island, Kyoto remained at the commercial centre with Sakai, Osaka and Nara conducting much of the international trade for Honshu. By the mid-seventeenth century, Nagasaki, which had officially opened its doors to foreign trade (with the red seal trade, or *shuinsen*), in 1570, became the main international trading centre for the whole of Japan, and remained so for the next two centuries. In 1587 Nagasaki was placed under the direct control of Hideyoshi, later coming under the control of the Tokugawa government. Osaka controlled the rice markets, and became the centre of commercial produce from western Japan, with most of the inbound produce arriving by boat from the Inland Sea.[8] After 1600, Edo became the dominant market centre for eastern Japan.

A multitude of smaller but active trading centres developed with the newly invigorated systems of communication, transport and roads. Products were made increasingly for national markets moving away from an earlier focus on localised distribution. Medieval exchange-based patterns, which have been described as 'producer – periodic trade fair – consumer', became by the end of the sixteenth century 'producer – wholesaler – retailer – consumer' (Crawcour 1961, 12). By the second half of the seventeenth century, formal and previously independent merchant cartels sanctioned by the Tokugawa government proliferated throughout the country.

While facilities, transport systems and consumer goods varied from domain to domain, and city to city, the use of metal-based currency in copper, silver and gold made the rates of exchange uniform for the first time in the commercial history of Japan. Metals as a basis for exchange appear to have reached beyond the major market centres and into the local populace by the Genna era (1615-1623). Emura Senzai (1565-1664) records the use of the metal currency in his *Rôjin zatsuwa* ('Random thoughts of an old man') written *c.* 1650: 'It is only in the last fifty years that money has become plentiful in the world.'[9] Ceramics, both domestic and foreign, were most probably purchased with coined metals measured locally by weight (Maeyama 1989, 17-19).

The internal market structure was both local (inter-domain) and centrally (Tokugawa *bakufu* or government) oriented. The internal markets took shape around the various urban centres newly created throughout Japan. The basis of the Japanese commercial system lay in domain taxes based on rice (*kokudaka*) as assessed by the government in periodic surveys and on other local products (*meibutsu*), such as ceramics, which could be exchanged for coined metals at major commercial centres such as Osaka. For example, a domain could use local products received as tax either to sell the surplus or to convert it into currency in the Osaka markets. The result of this system of domain and central government taxation had a standardising effect on the commercial values of rice and other products between the domains. Merchants and producers in the various domains became increasingly aware of the nationwide commercial value of their products and of markets for them (Wakita 1991, 105-21).

The 260-odd regional lords (daimyo) in nominal control of each semi-autonomous domain had specific and costly extra-domain expenditures that necessitated fiscal liquidity. For these rulers, the three major expenditures were periodic contributions to government building projects, funding for military actions and other projects, and maintenance of an appropriate lifestyle or court. The regularity of these demands was a cen-

tral factor during the first half of the seventeenth century, but continued through the Edo period.[10] As an added expense, the domains were compelled to maintain at least one complete household in Edo, the governmental capital, and reside in Edo during alternate years (*sankin kôtai*), as discussed in Chapter 1. This system started unofficially as early as 1600, after the battle of Sekigahara, and became mandatory in 1635.[11] Renewed emphasis on display encouraged by this alternate residence system, the public processions to and from the respective domains and the codified social and political rankings instituted by the Tokugawa government and reinforced by repeated edicts, placed enormous financial strain on the limited resources of the daimyo. Outward display became a sign of rank and a matter of protocol, much as interior display had been during the Muromachi period. The influential Neo-Confucian scholar Nakae Tôju (1608-1648) was expressing the political realities of the day when he wrote: '... to have what is too shabby for one's status or is insufficient, must be called parsimony.'[12]

The trend towards conspicuous consumption and outward display of wealth probably originated with Oda Nobunaga, and was adhered to subsequently by Toyotomi Hideyoshi and other late sixteenth-century lords such as the Date, Ii and Hosokawa. Events such as Hideyoshi's celebrated grand tea gathering at Kitano Shrine in 1587, and his lavish decoration of Osaka Castle, were but two examples of the kind of ostentatious display felt necessary to express power and prestige. Lois Frois, the Portuguese Jesuit priest who visited both Azuchi Castle built by Oda Nobunaga and Hideyoshi's Osaka Castle, wrote in 1598: 'These new buildings [Osaka Castle] were incomparably finer than those of Azuchiyama in which Nobunaga displayed his power and magnificence' (Shively 1964-5, 138). Visible ostentation continued during the seventeenth century under the Tokugawa regime, even though it became somewhat reined in because of regularly issued Tokugawa sumptuary edicts about the kind of display acceptable, especially by merchants – consumption was linked to station in life.

111

The concept of national isolation continues to cast a shadow on interpretation of domestic and foreign trade by contemporary researchers, causing, for example, the importance of foreign goods to the newly formed Tokugawa government to be overlooked. More importantly, this assumption has precluded the understanding of material culture as an important cultural indicator or index of the actual impact of trade goods on the life of the Japanese in the early modern period. Most historians, however, have subscribed to the general political importance of trade. Mark Ravina writes: 'the shogunate's monopoly on foreign affairs established its legitimacy as the supreme government of Japan'. And quoting Ronald Toby, he continues: 'The ability autonomously to manipulate foreign states and foreign monarchs in the formative years of the dynasty served to preserve the physical security of the Japanese homeland and to prevent the subversion of the new state, on the one hand, and to legitimate the new Tokugawa order on the other.'[13]

In other words, the maritime prohibition edicts of 1634 should be viewed not as throttling what had been a major stimulus to the Japanese economy, but rather as a method of harnessing international trade for the government's benefit, both fiscally and politically. Trade goods, which were symbols of riches and power, were regarded as a lucrative source of capital. It is in this context that porcelain, both Chinese and Japanese, came to play a significant role as an international trade item.[14]

The East Asian porcelain trade

Researchers have depended upon trade documents to help to recreate trade histories and understand the level and type of tradeware imported and exported from Japan. Japanese governmental authorities began to keep international importation records (*tôban kamotsuchô*) from the 1640s onwards.[15] In addition, the seventeenth-century English Trade Company started to keep records from the same period.[16] The most comprehensive records, however, were kept by the Dutch East India

Company (familiarly known by the initials VOC) at its colonial base in Batavia in Indonesia, at Hirado (1609-1641) and at Nagasaki (from 1641) in Japan, where the VOC enjoyed a virtual monopoly on Japanese trade with Europe.[17] The travel accounts of the American Cleveland brothers who travelled to Japan in the early 1800s on a ship showing a Dutch flag, the European travellers such as Engelbert Kaempfer (1651-1716), P. Thunberg (in Deshima in 1775), Isaac Titsingh (1745-1812), and Philipp Franz von Siebold (1796-1866), among others, have also added to the documentary picture.[18]

The Dutch, however, did not maintain a complete record of the official trade until the 1670s, and in addition there are significant discrepancies between the Dutch numbers (VOC) and those compiled by the Japanese government.[19] The VOC records, for example, shows that in Shôtoku 1 (1711), 9,000 pieces of Japanese porcelain were exported, while those for the Japanese government for that year note that the VOC exported 158,583 porcelain vessels (Ôhashi 1996, 18). Part of the reason for the discrepancies could lie with the nature of the export trade, which comprises official versus private or undeclared. Whatever the cause of the numerical differences, discrepancies such as the one above illustrate the uncertain nature of written sources and the need for corroboration when possible by the archaeological record.

Different types of extant record, such as *Tôsen fusetsu gaki* (Records of interviews or rumours from the Asian ships) record statements on the local political situations from the mostly Chinese merchants working in Southeast Asia under those countries' flags (Ishii 1998). What becomes clear from these records is the active trade throughout the Edo period with many Southeast Asian countries, including but not limited to Cochin China (also known as Champa, Guangnan or Quang Nam), Cambodia, Siam (Ayutthaya), Ligor (later to become part of the Thai kingdom), Songkhla (likewise later part of the Thai kingdom), Pattani (located between the Thai and Malay kingdoms), Malacca, Bantan and Kelapa (Batavia) throughout the Edo period. From these sources we get a fascinating

glimpse of the difficulties of trade and especially the seemingly annual occurrence of shipwrecks when suspiciously large amounts of cargo always seem to have been lost or purposefully jettisoned near Kagoshima or Kumamoto before the ships could safely reach Nagasaki harbour.

Accounts of shipwrecks or near-shipwrecks appear to be a standard excuse to explain the rather glaring discrepancies in cargo between what the ships originally carried in their holds and what they unloaded in Nagasaki harbour under the watchful eyes of Japanese government officials. Clearly active illicit trade and smuggling activities occurred on a regular basis throughout the Edo period, which by their very nature cannot be pinned down in the written records. Many of these Chinese ships originated from or passed through south China before arriving in Japanese waters.[20] It is therefore understandable that many of the Chinese ceramics found in excavations from this period throughout Japan are often fired in the southern Chinese kilns of Fujian and Guangdong, and are present alongside porcelain originating from the more famous kilns of Jingdezhen in Jiangxi Province.

Death inventories

Death inventories are one type of documentary source that helps to shed clearer light on individual or familial possession of porcelain. In particular, death inventories help to reveal the importance of the accumulations of sets of ceramics, in other words many examples of the same kind of ceramic form with similar patterns. The collecting of sets is a phenomenon not normally seen among objects that have survived by being passed down through generations (heirloom or *denseihin*), which in general privileges the singular object. Perhaps the most famous death inventory of this period records Tokugawa Ieyasu's (1542-1616) possessions at his base in Sumpu in Genna 2 (1616), the year of his death.[21] Noted under the heading 'Inventory of utensils used when entertaining' are a number of Chinese porcelain sets specifically noted as such. In

114

particular, white porcelain (*hakuji* or undecorated porcelain) is recorded in large quantities. For example, one section of the list includes: blue and white teabowls, 1,000 in ten boxes, small blue and white tea bowls, 700 in seven boxes, and small blue and white dishes, 200 in two boxes. The porcelain numbering is either in the hundreds or sets of ten items to a single box, and the natural division of porcelain appears to be sets or multiples of ten.

Porcelains kept in sets can also be seen listed in death inventories of possessions of wealthy townspeople, such as those recorded in the Hatta family household inventory lists.[22] The Hatta were an important local (non-samurai) family in Yatsushiro, Kôshû (present-day Yamanashi Prefecture). There are five lists extant recording Hatta property completed in the seventeenth century when the head of the family, a certain Hattamura Shinzaemon no jô, died. The inventories suggest that local wealthy households may have had more wealth than previously imagined, judging from the large number of Chinese porcelains recorded. The Keichô 11 (1606) inventory lists both tea utensils and objects used for entertaining. In this list, 330 ceramics are mentioned, with 158 from China, of which 118 were kept together in boxed sets of ten and are duly recorded as underglaze cobalt blue decorated porcelain. Of the total Hatta ceramic assemblage, 70 per cent were porcelain dishes used in entertaining. As these death inventories make clear, the shift in the function of Chinese porcelain from an icon denoting status embodied in a single piece during the medieval period to the use of sets for the purposes of power entertaining in the early modern period was completed by the early seventeenth century.

Tradewares from Japanese archaeological sites

Finds from excavated sixteenth- to seventeenth-century settlement sites in Japan reinforce the data from the death inventories, but suggest interpretations that diverge from common interpretations of preserved heirloom ceramics and tea histo-

ries. For example, a very large number of Chinese porcelains have been uncovered in Oda City in Shimane Prefecture, an area that could be seen as peripheral to the more central power centres of the period, and thus be considered not as wealthy or up on current trends (Ôhashi and Arakawa 2004). In fact we find that is not the case, at least in this immediate area. The porcelains uncovered were mostly from Jingdezhen- and Fujian- (Zhangzhou) based kilns. Revealingly, the excavated site was connected with the Iwami silver mine, corroborating the importance of bullion as a trade item, as discussed earlier. Indeed, the number of mineral extraction sites increased in the later sixteenth to seventeenth centuries in western Japan both in the south (Shimane Prefecture, now a World Heritage Site) and in the north (Sado Island area, Niigata Prefecture, currently applying to be a World Heritage Site) in an attempt to keep pace with demand for bullion for foreign trade.

The wealth associated with these mineral-rich but sparsely populated regional areas and the concomitant quantity of porcelain uncovered from this period is astonishing. Indeed, many local families are known still to preserve intact to this day a large number of Chinese porcelains and early Japanese porcelains in their family storehouses. This phenomenon has recently featured in a high-profile travelling exhibition series on 'Shoki Imari' in 2004-2005 inspired by examples found in the Sado area and organised by Ôhashi Kôji and Arakawa Masa'aki. While treatment of the excavated examples and interesting collections still kept in private hands in the Sado area was necessarily summary, Ôhashi is currently working with officials from Sado to make a more comprehensive exhibition of the early porcelains found in that area, which will in turn contribute to their World Heritage bid and help to create a stronger tourist base for the remote island. Domestic trading ships travelled to mining areas along the Sea of Japan laden with consumer goods such as porcelains, textiles and foodstuffs, and returned filled with silver, gold, copper, sulphur and wood. The largest amounts of Chinese ceramics from the second half of the sixteenth century to the mid-seventeenth

century are found in sites scattered along the western coast of Japan. East-coast Japan with a few exceptions evidently had to make do with domestic copies made in the Seto and Mino kilns.

Two of the most interesting archaeological sites from this period in terms of understanding Chinese porcelain consumption in Japan are the Ichijôdani site just outside Fukui City, which encompasses both the residence and the adjacent village that belonged to the Asakura clan, and Hachiôji Castle, controlled by a branch of the powerful Hôjô lords.

The Ichijôdani site

The Asakura clan ruled over Echizen for just over a hundred years, from roughly 1450 until 1573, when the warlord Oda Nobunaga completely destroyed their base. Unlike most military lords, the Asakura had kept a close relationship with noble families in Kyoto and were known to be very fond of Kyoto court culture. After they were routed, the area was abandoned and not built on afterwards in any comprehensive fashion, which has left the archaeological levels mostly undisturbed. In 1930 the Japanese government designated it as a Special Historical Site and Place of Scenic Beauty. The Ichijôdani site has been extensively excavated over a period of years since 1967, with excellent site reports and a well-designed museum; and was designated an historic park in 1971. The archaeological preservation of the site is excellent: the fire levels are clearly visible and form a distinct *terminus ante quem*. Over 1,500,000 items of ceramic, with Chinese examples in considerable quantity, have been excavated and catalogued. Interestingly, some of the Chinese ceramics even predate the founding of the site by a few centuries (in other words heirloom items).

A number of the Chinese ceramics found at the Ichijôdani site were heirloom items of particularly fine quality, mostly dating to the thirteenth and fourteenth centuries. In particular, fine-quality celadon ware, Qingbai ware, Yuan underglaze cobalt blue decorated porcelains, Jian ware teabowls and tea

caddies, brown-glazed large tea leaf jars, and Goryo-period Korean celadon have all been unearthed. In addition, Ming-period Chinese porcelain decorated in underglaze cobalt blue in sets for entertaining was found in profusion dating from the sixteenth century. The Chinese ceramics excavated from the Ichijôdani site follow the classic pattern that we have seen above, that is to say, individual high-quality Chinese objects used for display in the medieval period giving way in the sixteenth century to more functional sets of underglaze cobalt blue porcelain used for lavish entertaining.

Hachiôji Castle, porcelain possession, distribution and creation

Hachiôji Castle is a branch castle belonging to Hôjô Ujiteru, the younger brother of Hôjô Ujiyasu, head of the powerful Go-Hôjô family based at Odawara Castle in Kanagawa. Hachiôji Castle was constructed in 1587 but destroyed shortly afterwards by the Hokkoku clan, who were part of Toyotomi Hideyoshi's army. The main residence contained 70,000 ceramics destroyed in the fire during the sacking of the castle, a large number of which were Chinese porcelain decorated in underglaze cobalt blue from Jingdezhen and dating to the sixteenth century. Many high-quality wares in sets of ten have been uncovered during the excavation as well as Chinese porcelain dishes in specific patterns in sets of 100. A range of ceramics is thought to have been purchased at this time (just prior to 1587), and probably did not see much use before the destruction of the new castle. The findings included a number of high-quality and expensive Chinese porcelains, including polychrome wares and underglaze cobalt blue glaze examples. This site proves that by the end of the sixteenth century even a rural but wealthy lord in Eastern Japan was able to obtain top-end Chinese ceramics in large quantities. The caretakers of the castle (before Hôjô Ujiteru and his entourage moved in) probably deemed it socially necessary to stock the castle with Chinese porcelain for the purpose of

entertaining and display of power as well as of providing utensils for formal occasions.

Extant inventories and the findings from archaeological data have allowed for a re-evaluation of the significance of Chinese porcelain in the sixteenth and seventeenth centuries in Japan, both in number and in quantity. The taste for *karamono* or Chinese objects established in Japan centuries earlier among the elite was extended to include a broad section of society by the seventeenth century. Porcelain had by this time become a necessary accoutrement in banquets and entertaining in the households of the military elite and in temples as well as in wealthy merchant households. Specific design patterns and shapes seemed to have been popular, or at least widely distributed, whether by choice or necessity. For example, excavations on the island of Deshima, the residence of the VOC in Nagasaki, have uncovered large numbers of cobalt blue decorated small drinking vessels imported from China in similar patterns, often with a disc-shaped kiln tool still attached to their footrings. These small porcelain cups with identical patterns are found on sites throughout Japan. More unusually perhaps, similar sets of seemingly unique underglaze cobalt blue decorated Chinese porcelain have been found both in Osaka Castle and in the Maeda lord's household in Edo.

Certainly lords with their multiple residences and assigned duties that involved entertaining, often on a large scale, must have found it necessary to amass porcelain and other utensils to display appropriate status. It appears that the possession of porcelain, and utilisation of sets of designated size, style or types of design, had become an integral part of the material culture of early modern life for the privileged classes. These examples serve once again to attest to the relevance of archaeological findings, whether to break new ground or to corroborate previously held views.

With the expanding market for porcelain in early seventeenth-century Japan and the resulting profits that must have accrued to the merchants who supplied these tradewares, it seems only

logical that an attempt would be made to produce porcelain domestically. And indeed this is exactly what happened in one case of a newly ennobled lord, Nabeshima, of a small domain, Saga, in northeast Kyushu, located close to the nexus of international trade routes entering Japan. Under Nabeshima's careful watch the first Japanese porcelain was created in kilns that clustered around Arita in the 1610s and subsequently developed as a substitute for Chinese wares by the mid-seventeenth century. The Nabeshima family involvement is discussed at greater length below, in the early porcelain section of this chapter (see p. 130).

And yet, while it seems logical in terms of the newly integrated market-driven economy that was developing in early modern Japan that the domestic porcelain industry would follow the commercial success of Chinese porcelain, the formation of porcelain industry in Japan is, in many quarters, still described merely as a direct by-product of Hideyoshi's two disastrous invasions of the Korean Peninsular in the Keichô and Bunroku eras (1592-1598).

Hideyoshi's invasions most certainly did exert a significant impact on the production of ceramics in Japan and in Korea. It is therefore helpful to examine scholarship on the Korean roots of Japanese Karatsu stoneware that was allegedly made by these relocated Korean potters. It is also necessary to relook at the connection between Karatsu stoneware and early porcelain before drawing final conclusions on the formation of a domestic porcelain industry in Japan (Kyushu Ceramic Museum, 2008; Idemitsu Museum of Arts, 2004).

Korean influence and the genesis of Karatsu ware

Trade and contact with the Korean Peninsula had long been an important factor in the economic and artistic life of the people of Kyushu.[23] It is clear from the archaeological record that there was almost continuous contact between the people of Kyushu and the Korean Peninsula from as early as the end of the Jômon period (i.e. *c.* 300 BC onwards), showing up in the

presence of ceramics and ceramic technology imported from the Korean Peninsula in Kyushu sites.[24]

In the fifteenth century, the Sô lords of the island of Tsushima (located between Kyushu and the coast of Korea) established official trading relations with King Sejong (reign 1418-1450) of the Jeoson Kingdom. In 1492, the Matsura confederation (see below) based in the Kishidake area near the town of Karatsu, opened official trade relations with the continent through the Korean ports of Busan, Ulsan and Jep O (Toby 1984). Close Korea-Kyushu trade connections ensued, confirmed by the discovery of significant numbers of Korean stoneware sherds dating from this time in many sites in northern Kyushu (Morimura 1992; Idemitsu Museum of Arts 2004).

The study of Karatsu kilns from their inception, mostly focusing on the late sixteenth and seventeenth centuries, while a general topic of study in the post-war period, has in the last few years garnered heightened attention as evidenced by large exhibitions, special editions of ceramic specialist magazines and increasing archaeological investigation (Kyushu Ceramic Museum 2008). This recent activity has led to an increasing understanding of this ware. Controversy still surrounds numerous issues regarding the actual circumstances and timing of the first kilns, their direct relationship with Korean prototypes, questions of infrastructure and patronage, marketing processes and so forth, but the general outlines of the kiln groups and variety of production are by now well accepted.

By the 1580s, kilns producing what is currently known as Karatsu ware were constructed at the base of Kishidake Mountains in northeast Kyushu near the coast, which looks out towards the South Korean shore. Karatsu ware flourished over the next few decades (Bunroku and Keichô, 1592-1614) of the Momoyama era, a time when large numbers of Korean potters came to Kyushu, both of their own volition and as a result of forcible relocation. The new technology that these potters brought boosted kiln production and stimulated market demand. For example, the climbing linked chamber kiln

(*renbôshiki noborigama*) was introduced most probably from the Korean Peninsula during the late sixteenth century, and allowed for larger-scale production of stoneware and eventually porcelain with consistent results. This type of kiln was first used in the Kishidake area, but was introduced to the Mino area in central Honshu by 1600 and adopted as the basic large-scale kiln in the Seto-Mino area until the mid-nineteenth century. Karatsu ware production soon spread to kiln groups located in four distinct areas, Kishidake, Imari, Arita and Takeo.

The term 'Karatsu ware' does not denote the product of a single kiln or even of a group of interconnected kilns; rather, it is a particular style of ceramic produced in multiple areas of northern Kyushu that uses similar clay and similar techniques for the ceramic body. Classic Karatsu ware can in fact be classified into three main types: plain (with clear glaze), under-glaze-painted (*e-garatsu*), and Korean style (*Chôsen-garatsu*). There are multiple sub-styles produced in a range of variants at each of the different kiln groups. Takeo Karatsu, for instance, characteristically utilised copper glaze splashes and kaolin slip to great effect.[25] The local northern Kyushu clay used for stoneware production, which is highly plastic and iron rich, produces an easily recognisable strong warm dark reddish colour when fired. Most Momoyama to early Edo-period Karatsu ware ceramics currently housed in museums and private collections are, for the most part, *e-garatsu* (under-glaze-painted Karatsu), decorated with simple, quickly applied bold decorative iron-oxide designs, which have proved to have enduring modern appeal.

The late Nakazato Tarôemon XII, a noted Karatsu area potter and ceramic scholar, and also a designated Living National Treasure, has estimated that in the years from the late Momoyama period to the early Edo period Karatsu ware with strongly painted designs in iron-oxide comprised only 15 per cent of the total production (Nakazato 1981, 102). Most ceramics produced at these area kilns were functional, produced for daily use, without embellishment. Karatsu kilns continue to

3. *The Genesis of Japanese Porcelain*

fire similar traditional ceramics to the present day, in addition to more contemporary works. The ware has retained its popularity, particularly among tea aficionados, and as a result, the Karatsu kiln groups are one of Japan's major ceramic producing centres still thriving.

Karatsu ware was originally linked to patronage by the confederation referred to above as the Matsura confederation, a group of Kyushu warrior families, including the Hata family, led by the Matsura family. Some of the earliest examples of Karatsu ware were fired in the area surrounding the Hata family's Kishidake Castle, south of present-day Karatsu City (Nakazato 1981, 93). The castle was built in the middle of the twelfth century by Hata Tamotsu, and later became the headquarters for the Matsura confederation. The remains of Handôkame and six other kilns have been found near the castle, all of which were patronised by the Hata. When the Hata family fortunes fell, as discussed below, this particular kiln group was abandoned.[26]

Early Karatsu ware kilns were also situated near Nagoya Castle in the present-day town of Chinzei (Saga prefecture) directly facing the Korean Peninsula.[27] Built under Hideyoshi's orders as a place where he could command the planned invasions of Korea, Nagoya Castle was started in the tenth month of 1591 and completed the next year in the fourth month under the powerful generals Katô Kiyomasa (1562-1611) and Terasawa Hirotaka. Up to 200,000 foot soldiers and 100,000 reserves were quartered in the surrounding area, instantly creating a temporary new market for food, consumer goods and, of course, ceramics.

The invasions of the Korean Peninsula, carried out between 1592 and 1598, were a tremendous military and political undertaking with significant and long-lasting ramifications for both sides. Toyotomi Hideyoshi's troops resettled numerous Korean nationals in their captors' domains. There were many reasons for the forcible relocation, including the need for porterage and a low-level work force on the one hand, and the desire for a cadre of Korean specialists and artisans selected

123

specifically for their skills. Korean nationals brought to Japan during this period are thought to be the direct ancestors of many of the current leading Kyushu ceramic families.[28] The presence of these émigré potters was initially considered important for the status of a kiln, adding to the prestige of a ware and the domain, and increasing revenues by association. As mentioned above, the impact on the Japanese ceramic industry of these devastating invasions was such that they are now sometimes referred to as the Pottery or Teabowl Wars.[29] This rather jocular appellation, while understandable and well intentioned, tends to gloss over both the political motivations for the invasions and the human tragedies to which they gave rise. The term is, however, one used by Korean and Japanese scholars alike as perhaps a comfortable way of referring to the invasions, which serves to draw attention to their cultural by-products and the undeniable benefits they brought to the ceramic industry.

Patronage of the Karatsu kilns

During the invasions Hideyoshi became displeased with the performance of Hata Chikashi (birth and death dates unknown) in Korea and exiled him and his family to Ibaragi (just north of present-day Tokyo). Hideyoshi then gave the Hata family castle at Kishidake along with its Karatsu kilns to his general, Terasawa Hirotaka, a samurai who had studied tea practice with Sen no Rikyû. Though Hirotaka soon closed Handôkame and other nearby kilns in the Kishidake group, he encouraged the growth of the Karatsu ware industry and patronised specific kilns in the Imari and Takeo groups, which began to fire speciality items and tea-related vessels. Under his patronage Karatsu ware repertoire and actual production expanded significantly after 1600.

To illustrate the early rapid development of the Karatsu kilns and ceramics during Hirotaka's patronage it is helpful to compare the products from one of the earliest Karatsu kilns, that of Handôgame, which belonged to the Kishidake group, with products from a kiln of the Takeo group that flourished at

roughly the same time. The Handôkame kiln ceramic shapes from the 1570s to the 1590s are well formed and follow standard Japanese medieval stoneware shape prototypes: utilitarian spouted bowls and mortars, wide-mouthed storage jars and closed-necked storage jars, with the addition of rice bowls and dishes. The Karatsu ware kilns of the Takeo kiln group from 1600-1620s exhibit a much wider diversification of ceramic shapes and decorative effects. Forms become specialised and include luxury ware items, such as teabowls, water jars, *mukôzuke* side-dishes, sake bottles, flower vases, incense boxes and burners, fire containers, ewers, sake cups and tea caddies. Glaze effect or painted designs on these objects were utilised alongside undecorated daily ware such as bowls, mortars, jars and dishes, which were standardised and efficiently produced (see Kyushu Ceramic Museum 2004). In sum, after 1600 when Karatsu ware kilns expanded into other areas, such as Takeo, Imari and Arita-cho, and received official patronage, their repertoire was enlarged to include luxury items alongside the more common daily use wares that continued to be the mainstay of production.

The origin of Karatsu ware has been a topic of heated discussion among researchers because of its association with the invasions of Korea. Some researchers hold that it originated with the potters that came over from Korea, others feel that this kind of ware pre-dated the arrival of these artisans. Early Karatsu ceramics do appear to pre-date Hideyoshi's invasions of Korea; indeed their presence in trading sites mirrors the late sixteenth-century expansion of the ceramic industry throughout the archipelago. Though still controversial, it appears that early Karatsu ware sherds were excavated from Ichijôdani, discussed earlier in this chapter. Ichijôdani castle, as noted above, was destroyed by fire in 1573 by Oda Nobunaga; thus the Karatsu sherds found there are thought to be the oldest uncovered so far.[30] In addition, sherds believed to be Karatsu ware have been excavated from a Sakai site dating to the 1580s, though there is debate on the dating of the level from which the ceramics were excavated (Ôhashi 1989, 7).

Evidence that the Handôkame kilns were able to produce well-formed ceramic vessels as early as 1592 can be seen from a tea leaf jar with an incised dated inscription preserved at the Seibô Shrine in Katsumoto City on Iki Island (present-day Nagasaki Prefecture) off the north coast of Kyushu.[31] Excavations at Teramachi sanjô in Kyoto in 1988-89 also uncovered a merchant's storeroom with multiple examples of Karatsu ware dating to the later 1590s, indicating their relatively wide distribution at an early period.[32] These finds combine to help date Karatsu ware's initial production slightly prior to Hideyoshi's invasions of Korea, and justify assigning the ware within the broader context of Momoyama period economic and material culture history. However this is far from a unanimous position and it will take further archaeological discoveries to settle the matter in a satisfactory fashion.

Certainly the two invasions of the Korean Peninsula in 1592 and 1597 had a significant impact on Karatsu ware and the ceramic industry in Kyushu as a whole. However, this impact needs to be viewed within a continuum of ceramic production and trade ware importation that originated before and certainly continued long after the invasions of Korea.[33] Trade between the countries was often active and, as stated above, Korean craftspeople, including potters, appear to have settled in Kyushu voluntarily as well as forcibly before and after the invasions. Their presence led to continuing important technical changes in the ceramic industry, including such diverse techniques as the introduction of the fast-turning kick wheel, the use of a paddle and anvil (*tataki*) to thin and strengthen the walls of a ceramic jar, and the use of clay spurs (*taidome*) to separate vessels stacked together during firing in the kiln. [34]

However, the most revolutionary advance was the introduction into Kyushu of the *noborigama*, or 'climbing kiln', adapted to meet specific local requirements from Korean prototypes.[35] The exact origins of these types of kilns are still a subject of debate. While early Karatsu ware kilns resemble South Korean Buncheong ware kilns, no clear prototype has been yet found in Korea, though similar examples to the very earliest Japanese

3. The Genesis of Japanese Porcelain

kilns used for jars and basic functional ware do exist. Early Karatsu ware kilns, such as those at Handôkame, were built on an incline to strengthen the draft and raise the firing temperature; they were composed of a series of chambers covered by an arched roof, a configuration that resembles a section of split-bamboo in profile, hence the nickname *waridakegama* (split-bamboo kiln).[36] The new kilns, however, were able to reach temperatures in excess of 1,300 degrees centigrade, high enough to fire porcelain. Whereas the walls of the early Handogame kilns were built entirely of clay, by the 1590s the roofs of the individual chambers were domed beehive shapes, and the walls made mostly of brick reinforced with clay, a kiln type that set the pattern for future 'linked chamber climbing kilns' (*renbôshiki noborigama*).

During the later sixteenth century, early Karatsu ware started to be produced as a product for practical purposes but adapted to Japanese requirements in both form and style. Early Karatsu ware soon began to flourish domestically, especially during the first half of the seventeenth century, due to a combination of patronage, demand and market influences. While its popularity diminished slightly thereafter, production continued throughout the ensuing four hundred years, with a continued emphasis on ceramics made for utilitarian purposes.

During the latter part of the nineteenth century to the present day, the popularity of Karatsu ware once again surged. There are many reasons for this. Its identification with Korea at a pivotal period (Momoyama) in Japanese early modern history is currently an attraction. The Momoyama period, though short-lived, saw the birth of Japan as a unified country and the beginnings of contact with countries beyond Asia. The period also witnessed a significant increase in the population's wealth with the consequent fundamental shifts in the nature of society bringing the country into the early modern era.

The minimal decoration on the body surface of Karatsu ware appeals to a more modern agenda. The high esteem in which it is held among aficionados of the tea world will ensure that there will always be orders placed for specialty items. These

contemporary connotations should, however, not be confused with the different market-driven forces that propelled production in the early 1600s. It should not be forgotten that the link to Korea that is so celebrated today must surely have had different resonances during the Edo period.

In 2001, a large international conference and exhibition was held in Korea entitled 'Masterpieces of the Choson Potters' Descendants in Japan' at the World Ceramic Exposition to celebrate the ceramic connections between the two countries by highlighting Japanese potters with Korean ancestry. The conference and exhibition featured Nakazato and fellow ceramicists from Agano and Takatori, which are nearby kilns located in Fukuoka Prefecture. In the course of this conference the potters discussed their feelings regarding their Korean roots and the influence of these roots on their work. The event was a salutary one, and will help in healing the wounds of past wrongs and misconceptions, as well as emphasising and celebrating well-deserved achievements shared between the two countries.

For these twentieth- and early twenty-first-century Japanese potters, the exact nature of their shared artistic identity with Korea and the question of Korean ceramic prototypes and the way they made their influence felt in Japan are matters of deep significance. Korea and Japan have never been closer than today in terms of the search for the facts behind the beginnings of the ceramic industry in both countries, and the influence that each had upon the other at different times. When more archaeology and more discussion between scholars from both nations occurs, a clearer understanding of the role and production of ceramics in Japan, borrowed precedents, and claimed identities, will surely follow.

Early porcelain in Japan

The importance of the concept of origins, as opposed to generalised perceptions of a brand item, is a topic that needs further debate in the context of porcelain. Did it matter to seventeenth-

3. The Genesis of Japanese Porcelain

century consumers in Japan whether the porcelain dish in front of them was from China or Japan, as long as it was of high quality and good finish? Perhaps it depended on the context. As we shall see below, curiously, Japanese porcelains from Hizen dating from the 1630s were often labelled with marks that claim they were 'Made in Ming China', and this continued until well into the eighteenth century. Japanese domestic marks begin to be placed on the porcelains with any regularity only in the nineteenth century.

Academic debate surrounding the late development of the Japanese porcelain industry has been at best tentative. As stated in Chapter 1, many art historians and archaeologists simply explain the initial development of styles of porcelain in Japan following a 'three-country' approach, rarely examining the issues that lie behind production of these wares: porcelain styles developed from Korean styles, to Chinese styles and finally to Japanese styles. Tracing development of porcelain styles and technologies to understand early porcelain history is helpful, but is only a small part of a larger equation: it is also well worth looking at economic, social, political and environmental issues, which clearly were factors in the development of the industry.

The 'three-country' approach, a linking of contact and influence first from the Korean Peninsula, then China and finally within Japan itself, is premised on 'de facto' knowledge of later porcelain developments premised on formal stylistic analysis and a linear connection of historical events. The 'three-country' approach was first posited in the early twentieth century and represents an ethno-historical attempt to place Hizen porcelain production at the centre of a larger field of discourse, based on modern conceptions of East Asian nations and their relations Here we briefly attempt to examine the development of a Japan-based porcelain industry by deconstructing the standard stylistic analyses and then examining the use of Chinese marks on early Japanese porcelain.

The earliest Japanese-produced porcelain dating to the 1610s was fired in kilns in the Arita area in Saga domain. This

domain was controlled from 1584 onwards by the Nabeshima family, who had once been the chief vassals of the powerful Ryûzôji clan, erstwhile rulers of five provinces, Hizen, Chikuzen, Chikugo, Buzen and Higo, as well as the two islands of Iki and Tsushima (Fujino 1981). After the death of Ryûzôji Takanobu (1528-1584) in a battle with the combined forces of Arima and Shimazu, Nabeshima Naoshige (1538-1618) took control of part of Hizen. Naoshige was appointed as *daikan* (governor) of Nagasaki by Hideyoshi in 1588. Naoshige and his son, Katsushige (1581-1657) participated in Hideyoshi's two invasions of Korea, and they also sided with his descendants at the battle of Sekigahara in 1600 (where they were routed). Their allegiance shifted to the Tokugawa in the 1615 Osaka sieges, and perhaps as a result the Nabeshima retained their domain, building a castle and creating a castle town between 1602 and 1610 (present-day Saga City). In 1613, after the completion of the castle, the Nabeshima family were confirmed as lords of Saga domain by the Tokugawa government, with an income of 357,000 bushels of rice. It was during this period that Saga domain began to produce porcelain in its kilns located in the Arita area.

The first type of porcelain that was produced was by the Hirado group of Karatsu kilns in Hizen province. These kilns were previously producing a rough style of Karatsu stoneware, mostly with ash-glaze and high-fired iron-brown brown bodies destined for daily use, as well as a small percentage of specialty wares decorated with underglaze iron-oxide designs. Many of the area potters are thought to have been local farmers operating the kilns according to seasonal farming schedules (wet rice sericulture) during off-seasons. The early Karatsu ware kilns in the Arita (Arita-cho) area of Hizen province were located mostly to the west of Arita-cho (in Nishi Arita-cho) near the rice fields, and not on the steeply inclined area of inner Arita-cho where later porcelain-only producing kilns were to be located.

Ideal conditions for building climbing kilns include an incline (ideally a sloping mountain side), running water (a

3. The Genesis of Japanese Porcelain

stream or a river) and a ready supply of timber (in particular pine) for fuel, in addition to clay deposits.[37] The area surrounding Arita-cho is blessed with mountains, plentiful pine forests and running streams. It was clearly not feasible to import porcelain clay from China, but in the first decade of the seventeenth century, good-quality porcelain stone was discovered at Izumiyama, on the far eastern side of central Arita-cho. Other quarries were discovered nearby, at Shirakawadani (also in Arita-cho), Ryûmon (in Nishi Arita-cho), and Mitsunomata (Hasami-cho, Nagasaki Prefecture). The nature and circumstances surrounding the discovery of the porcelain clay deposits have been the source of much debate – and indeed the story of the discovery lies at the core of the discourse about Japanese porcelain's constructed origins.

Stories and legends about these origins lie at the crux of the main porcelain debate, and so it might be helpful to examine two of the myths regarding the origin of Japanese porcelain. The two most persistent origin myths that have circulated in Japan and western literature have been cogently summarised by the late John Alexander Pope (1906-1982), an East Asian ceramic specialist and former Director of the Freer Gallery, Smithsonian Institution.

The standard book tells, first, that a certain Gorôdaiyu Go Shonzui went to China at the beginning of the sixteenth century to learn porcelain making from the Chinese ... The story goes on to say that he returned to Japan in 1513 bringing with him the necessary materials; that he settled in the province of Hizen where he began, for the first time to make porcelain in Japan ... Shonzui's materials soon became exhausted; and the manufacture of porcelain ground suddenly to a halt ... The second legend tells us that a Korean potter named Ri Sanpei came back to Japan with a certain Nabeshima Naoshige, a Hizen daimyo who was a follower of Hideyoshi in the ill-fated campaign of 1592-8 ... Lord Naoshige put Ri Sanpei to work making pottery and encouraged him in his attempts

to make porcelain ... [he] did not succeed until one day in 1616. (Pope 1970, 1-3)

Considerable speculation surrounds the first legend, of Gorôdaiyu Go Shonzui, particularly since no sixteenth-century document has yet come to light that mentions this name that might corroborate his existence. This legend appears in fact to have been created some time in the nineteenth century. This convenient founder's myth places Hizen porcelain's inception prior to the Edo period (well before the porcelain industry actually began). The legend not only lends a pedigree to the native ware by giving it a longer history and an individual founder, it also most conveniently creates an association with China. Gorôdaiyu follows in the footsteps of some of Japan's most legendary cultural heroes. The story that the birth of the Japanese porcelain industry derives out of the personal quest of a Japanese hero, who after travelling to China in search of the art of making porcelain, returns to Japan and establishes his own porcelain kiln, is highly reminiscent of other Japanese legends down through the centuries that appealed to the popular imagination. One example is Sugawara no Michizane (845-903) the scholar-bureaucrat who perished after being wrongfully exiled but was said to have travelled posthumously to China in his deified state as Karai Tenjin, or Tôtô Tenjin, in the twelfth century (Borgen 1988). Another example is the Buddhist monk ink painter Tôyô Sesshû (1420-1506), who did actually travel to China in the fifteenth century in an attempt to find a perfect painting instructor. The arduous quest for a secret technique coupled with a voyage to China, clearly added lustre to a scholar or artist's reputation. The addition of an individual, personal history and the story of that individual's search for a recondite technology would have helped create an attractive mystique for the ware.

The second legend that Pope mentions, of the Korean potter Ri Sanpei (Sanpei of Yi, referring to the Korean Joseon period or Yi dynasty, 1392-1910; in Korean this name is Lee Cham-Pyung; in Japan he is also known by the name as Kanegae

Sanbei), is one that is still in currency today. He is linked with Toyotomi Hideyoshi's invasions of the Korean Peninsula in 1592 and 1598.

The association of porcelain with Hideyoshi's invasions of the Korean Peninsula, and with the Korean immigrant community in Japan, has numerous implications with regard to Japanese identity, regional and international relations, markets and even the tea industry (which from the late Edo period to the present day has given pride of place to Korean stoneware).[38]

The esteem lavished on Korean stoneware is best recapped by the oft-repeated Japanese tea saying that lists the three highest-ranking types of teabowl for use in tea gatherings (in descending order): 'first Ido, then Raku, and then Karatsu'. Ido is a Japanese term for a style of Korean stoneware; Raku is thought to have been created by a person of Korean or Chinese heritage in Kyoto; and Karatsu (occasionally the third was Hagi, but the same principle applies) is also associated with expatriate Korean nationals.[39]

In 1962, early porcelain links with Korea again became an issue for debate in the scholarly community when Ikeda Chûichi, a designer in the prominent Iwao Porcelain Company in Arita-cho, discovered an entry in the death register for an individual who seemed to be the very Ri Sanpei, in a small temple called Ryûsenji, five miles west of Arita-cho. A single line in the temple's death registry records his Buddhist name as Gesso Joshin followed by the name he used during his lifetime, Kami-shirakawa Sanpei (or Sanpei of Kami-shirakawa). The register recorded that he died on the eleventh day of the eighth month of the first year of the Meireki era (20 September 1655; Pope 1970, 5).

This evidence proves that a man named Sanpei did live and work in the Arita-cho area. Moreover, for Sanpei to have travelled from Korea during the invasions of 1592-8, presumably as a grown man with advanced knowledge of porcelain production and to have died at the date noted, 1655, would have made him unusually long-lived. Certain researchers feel that it is more likely that Sanpei was simply involved in porcelain distribu-

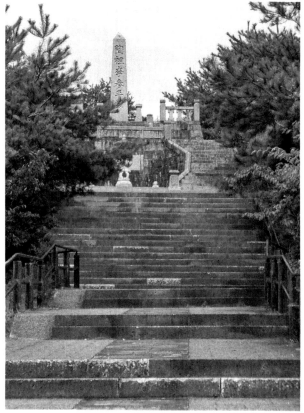

Fig. 9. Monument to Ri Sanpei in the grounds of Tôzan Shrine. Ferro-concrete. Arita, Japan.

tion (Clunas 1986-88, 48). Recently, a large monument has been erected near Izumiyama by South Korean and Saga Prefectural officials to commemorate the discovery of porcelain stone by Ri Sanpei, enforcing a specific origin story in the public arena (Fig. 9).

After the discovery of the death register, in 1966, the eminent trade ceramic archaeologist Mikami Tsugio attempted to clarify the legend of Ri Sanpei by excavating the kiln site of Tengudani, which Sanpei was supposed to have built in 1616

and where he supposedly first fired porcelain, alongside the river Goshirakawa in Arita-cho.[40] Mikami's excavations, and other subsequent surveys of the Tengudani kiln and nearby early porcelain kiln sites, have clarified the chronology of early porcelain production. Mikami's excavation revealed that the Tengudani kiln was in use in the 1620s-40s, and was thus not part of the initial group of porcelain kilns in the area.[41] It belonged rather to a secondary, slightly more recent group of porcelain kilns in the inner area of Arita-cho, which included the Kamanotsuji and Sarukawa kilns. Tengudani kiln has recently been re-surveyed by Murakami Nobuyuki and Nogami Takashi and Mikami's original findings have been re-confirmed.

Mikami's initial excavation gave rise to a spate of further excavations, which have revealed that the first-stage porcelain kilns such as Haraake, Tenjinmori and Komizo-kami kilns in the western area of Arita-cho fired stoneware and porcelain together, in the 1610s.[42] It was not until a decade later, in the 1620s, that exclusively porcelain-producing kilns appear in the area around Tengudani kiln. This makes the legend of Sanpei's discovery of porcelain stone and his involvement in the first porcelain kiln untenable, though it is nevertheless of importance in terms of the intellectual history of the discipline.[43] Despite the lack of historicity in the legends, Ri Sanpei continues to be a major feature in tourist literature, figuring prominently in brochures distributed in Arita-cho. A recent sculpture of him was erected in the grounds of one of the principle shrines in Arita-cho. A monument has also been created to his memory in South Korea, donated by the Arita-cho townspeople. The conference mentioned above that was held in South Korea in 2001 also celebrated Ri Sanpei's contributions along with the achievements of other Korean ceramic artisans and craftsmen brought over to Japan in the aftermath of the 1592-8 wars.[44]

To summarise the basic technological developments of the first stage of porcelain production in the Arita-cho area, porcelain production began approximately in the 1610s with

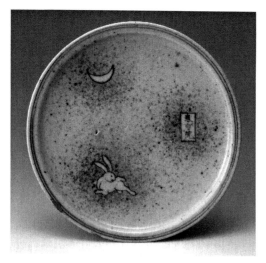

Fig. 10. Dish with design of hare, Shoki Imari style, Hizen ware. Arita kilns, *c*. 1630s. Porcelain with underglaze cobalt blue oxide. D. 20.6 cm. British Museum 1959, 0418.1.

stoneware and porcelain fired together in the same kilns.[45] Even at this early stage, porcelain appears to have been given precedence over stoneware: when stacks of porcelain and stoneware are found fused together in the waster piles, the porcelain is always placed on top in the most advantageous position.

The earliest porcelain shapes follow their Karatsu ware counterparts, consisting mostly of small dishes, bowls and bottles, but the decorative motifs on the vessels differ substantially. The designs on the porcelain were more elaborate than those on their stoneware counterparts. While Karatsu stoneware was usually plain, occasionally painted with simple iron-oxide designs, the early porcelains were nearly all decorated with underglaze cobalt blue, which had to be imported from abroad and was much more expensive than iron oxide. The difference in design motifs is significant, as it reveals a conscious attempt to create a specific product that was differentiated from the previous stoneware industry from its very inception.[46]

136

3. The Genesis of Japanese Porcelain

With the 1620s porcelain began to be fired separately from stoneware, marking the true start of the porcelain industry in Hizen. Early Japanese porcelain made from the 1610s through the 1640s is generally termed 'Shoki Imari' (early Imari) in both English and Japanese (Fig. 10).

Saga domain and Hizen porcelain

The Saga domain became increasingly interested in the porcelain kilns, and in actual fact provided the impetus for the kilns to develop and expand quite rapidly. In 1634 and 1637 the Saga domain reorganised the Arita-cho porcelain kilns and instituted a local magistrate to oversee Hizen porcelain production, as well as a tax and licensing system, discussed below (Ôhashi 1989).

As a result, within a decade of the start of its production, porcelain fired in Hizen was distributed in many areas of Honshu, and in particular the Inland Sea and eastern Japan. The speedy and widespread dissemination of Hizen porcelain most probably had more to do with the Nabeshima domain's networks and perhaps the reasonable price of the ware than the popularity of its design. The fledgling industry also certainly benefited from the fact that the Ming dynasty in China had collapsed, and it was growing difficult in Japan to procure Chinese wares. By the 1650s Japanese wares had largely replaced Chinese porcelains in the domestic market.

The rapid distribution of Japanese-produced porcelain demonstrates not only the effectiveness of Hizen merchants' connections and trade routes but also the domain's encouragement of the fledgling industry. One example of the far-reaching early distribution of Hizen porcelain can be seen from the 1994 excavations by Kôkogakuin University of the earliest occupational levels of Hachijôjima Island in Tokyo Bay.[47] In 1606, thirteen people, mostly fishermen and the occasional exile, were recorded in government documents as living on the island. These residents, along perhaps with visitors to the island, appear to have left offerings at several makeshift Shinto

shrines. Their offerings included bronze mirrors, coins, lacquer and early Hizen porcelain dishes. The dishes date to the 1620s-30s, the predominant design being cobalt blue depiction of the Hare and the Moon, which symbolises longevity.[48] Offered to a shrine, these dishes are graphic reminders that Japanese porcelain quickly entered the fabric of everyday life in Japan.

One other feature becomes clear through an examination of early porcelain technology, proving that the technological transfer said to have occurred from Korea as a result of Hideyoshi's invasions did not in fact provide the direct impetus for the development of the porcelain industry. The increase in the efficiency of climbing kiln technology was, as we have seen, a gradual process, owing much to regional adaptation of the original technology, which was already in use in the decades before porcelain manufacture started in Hizen. Korea certainly influenced Japan in multiple ways, but it is also possible that Korean and Japanese ceramic technology also developed separately albeit along similar tangents, responding to local, central and international markets and popular styles (Becker 1979, 71-9).[49]

Notwithstanding the legend of Ri Sanpei, porcelain was only fired in Japan on a significant level once the market demand for porcelain was present and recognised by both merchants and entrepreneurs; when the resources for its production were made available; and when the technology needed to create the product was understood and could be implemented by local potters. These three factors, market, materials and technology, coalesced in the early 1600s, accounting for porcelain production's late entry in Japan.[50]

The Nabeshima family's involvement with porcelain production is demonstrated by the 1637 reorganisation of the kilns in the town of Arita-cho proper with the consequent upgrading in quality and rate of production (Ôhashi 1987, 7-13). First in 1634, and then again definitively in 1637, the Saga domain organised the restructuring of the Arita area kilns. The domain officials were afraid of the depletion of resources, especially forestland in Imari port and Arita-cho areas, but were also

mindful of the potential profit to be made by developing this new industry. The domain's early involvement with the porcelain kilns is known from a contemporary diary, referred to as the *Saga honpon*, held in the Taku family in Saga prefecture.[51] The diary was written by Yamamoto Jin'emon Shigezumi (1590-1669), and is the oldest known document that describes porcelain production in the Arita-cho area. In the diary, Shigezumi records the instructions by Nabeshima Katsushige, the first lord of Saga domain, on the twentieth of the third month, Kan'ei 14 (1637), to deport 826 Japanese porcelain workers (the actual term used in the document is *tôjin*, or Continentals, literally Tang era Chinese). The instructions also restricted the number of porcelain kilns and their locations, and ordered the closure of all non-porcelain firing kilns.[52] In the enactment of the edict, which demonstrated and enforced the domain's control, thirteen kiln areas were delineated in Arita-cho. This area was called the *uchiyama* or the 'area within', referring to a narrow valley between two mountain ranges, and they were the officially designated kilns.

These thirteen kilns were enclosed by two guardhouses, placed at either end of the *uchiyama*, which exerted tight supervision and control on the movement of technology, goods and people. One guardhouse was located on the western side of a narrow valley, and was called Iwayaguchi; the other was located at Izumiyama: the former served as an entrance to the porcelain production area, the latter as the exit. Izumiyama was also where the magistrate's office was located (*Sarayama daikansho*). The porcelain potteries thus formed a cluster that was encircled by three mountains that together encompassed Kamishirakawa and the *uchiyama*, namely Kuromata, Iwayakawachi, and Kamitoshikiyama mountains.

In 1637, Nabeshima Katsushige gave an order that resulted in eleven kilns being shut down. Four of these were in the Imari area and seven in the Arita-cho area.[53] The eleven kilns were most likely those still firing Karatsu-style stoneware along with porcelain. The order expelling 826 'non-continental' potters described in the *Saga honpon* can be interpreted in

several ways. As discussed previously, at this time *tôjin* referred to both Chinese and Koreans, so it is clear that the domain wanted to dismiss potters that were neither Chinese nor Korean – hence the translation of this term as 'Japanese'. The use of the term *tôjin* should perhaps be seen as reflecting an attempt at eliminating disenfranchised samurai and ordinary townspeople at this time who had jumped on the bandwagon of the burgeoning ceramic industry and the desire on the part of the authorities to professionalise the porcelain industry and make it more marketable. Domestic porcelain was from its very inception something that was made assuming an association in the popular mind with Chinese porcelain, and the idea that it was made by foreign workers – whether true or not – made it more marketable.

The magistrate's office oversaw the porcelain industry, controlling taxation and licensing. From this time forward there was a distinct difference, not only in quality but also in types of design produced, between the sanctioned inner kilns (*uchiyama*) and the more entrepreneurial but unprotected independent outer kilns (*sotoyama*), such as Maruo and Yanbeta.[54] In general, the inner kilns produced smaller, more refined wares. The outer kilns, on the other hand, produced larger, often bolder and rougher wares, that find favour in the art market today and (I would argue) are disproportionately represented in museums and galleries in Japan, the USA and Europe.

In order to work with porcelain in the domain-controlled areas, it became necessary to have a licence (*fuda*). Procedures were put into place by the domain to protect and regulate the budding industry. Soon after the Keichô era (1596-1615), and before 1637, a guardhouse was built at Izumiyama, Arita-cho, to guard the porcelain clay source for the domain. The guardhouse housed domain-appointed officials called *tsuchi shoya* who were responsible for supervising the mining of porcelain stone. In the mining area, a director of the mining operation, called a *tsuchi anamochi*, hired miners (*tsuchi kiriko*) to remove the porcelain stone. A different group was responsible for

3. The Genesis of Japanese Porcelain

transporting the stone, all under the watchful eye of domain officials (Maeyama 1990).

A *kamiyaki*, or a person in charge of running a kiln, purchased the porcelain stone after it was mined. The *kamayaki* was responsible for all aspects of running the kiln, including being responsible for adequate licensing from the domain and payment of taxes. Kilns often possessed a water hammer or mortar (*mizu'usu*), used to pound the porcelain stone into a fine powder. Employees of the kilns each had specific tasks with titles such as *saikunin* (people who made the forms of the vessels), *ekaki* (painters) and *arashiko* (various tasks). Each separate position also required a licence, distributed by the magistrate's office in Sarayama.[55] To further exert its control in 1647 the domain restricted the number of licences it issued to master potters to 155 – who were known as 'one hundred and fifty-five wheels'.

Kilns on the periphery (*sotoyama*) of Arita-cho, and especially to the west of the *uchiyama*, continued to pursue markets throughout Japan and occasionally in Southeast Asia, even though they were not under the direct control and protection of the domain and official trade routes. Often these *sotoyama* wares had striking and innovative designs, as in the case of the Kokutani-style wares, but they were not placed under the strict quality control that was exerted in the *uchiyama* kilns, particularly in the second half of the seventeenth century. The result was that these kilns were occasionally more innovative but also erratic in quality.

Reign marks and their meaning

One strategy to attempt to capture the domestic market and the new export market appears to have been the conscious use of Chinese reign dates on the bases and occasionally in the interior of these Japanese-made bowls and dishes. Chinese marks on Japanese porcelains begin as a simple 'made in China' signifier, and developed within thirty years into carefully written inscriptions signifying a distinct reign period,

Fig. 11. Japanese Hizen ware dish with spurious Chinese reign date reading 'made in Chenghua Era Great Ming' [*Dai min seika nensei*] on the base. Arita kilns, *c.* 1670s. Porcelain with underglaze cobalt blue oxide. D. 19cm, H. 2.9cm. British Museum 1997, 0121,48.

which most likely reflects the growing sophistication of the market.[56]

From the 1630s onwards, Hizen porcelains were inscribed with marks such as 'Made in Great Ming', 'Made in Great Ming, Chenghua Era' or 'Great Ming, Wanli Era', in sometimes incorrectly executed Chinese characters in underglaze cobalt blue. Ôhashi Kôji has identified 138 kinds of Chinese marks, which he divides into three groups; name and reign marks from the Chinese Ming dynasty; Chinese characters meaning variations on the theme 'Good Luck'; and illegible or unreadable marks (Ôhashi 1987-89).

The spurious reign marks chiefly comprised Xuande (1426-1435), Chenghua (1465-1487) (see Fig. 11), Jiajing (1522-1566) and Wanli (1573-1615) – that is to say, most marks dated the ware to at least a century or even earlier. Needless to say, these reign periods, whether selected by the potters or merchants ordering the vessels, were generally recognised as adorning the

3. The Genesis of Japanese Porcelain

highest quality porcelain. Such use of borrowed marks evidently allowed Japanese porcelain to be associated with a famous and recognisable foreign luxury product. Reign dates were, in effect, a brand mark.

The 'Good Luck' symbols executed on the bases of Japanese porcelains in underglaze cobalt blue likewise imitated inscriptions found on the bases of Chinese trade ceramics. The most common characters or symbols are *fuku* (luck), *ju* (happiness or longevity), and *sei* (youth). The widespread use of these characters on Japanese-produced porcelains ended in the early eighteenth century, though one occasionally comes across them even in the present day. The third category of symbols and characters are unreadable, but they are also thought to imitate inscriptions found on Chinese porcelain.[57]

The spurious Chinese reign marks painted onto the bases of Japanese porcelains during the seventeenth century are one more demonstration of the all-encompassing influence Asian trade exerted on the formation of early modern commerce in Japan. This trade was inseparable from the formation of domain business practices, trade networks, monetisation, and changes in consumer taste. This is just one example, however fanciful, of the identification of Japanese porcelains at its genesis with the wares from China.

Although the shadow from across the sea was long, Japan during the early seventeenth century was able to start what was to become its own porcelain industry. Various timely factors nurtured this growth. The expansion in demographics, the establishment of cities (*jōkamachi*), trading centres and trading routes, the wider distribution of ceramics due to the stable political situation, a more materialistic trend in society, advances in record keeping and a more sophisticated range of ceramic wares, techniques and better kiln construction allowed the nascent porcelain industry not only to compete with China but also to flourish in its own right.

Conclusion

Their Purcellin, or Japon earthen Ware, is finer than China Ware, but much thicker and heavier, and the Colours brighter, and it sells much dearer, either in India or Europe, than what is made in China, but their Tea is not half so good.

A New Account of the East Indies by Alexander Hamilton
(ed. Foster 1930)

Alexander Hamilton, writing in the early eighteenth century, was clearly aware of the differences between Japanese and Chinese porcelain, and he clearly viewed Japanese porcelain as the finer-quality item. Such ability to distinguish, however, was not the case for many Europeans. Indeed, even Japanese records of early Japanese porcelain refer to the objects in ways that imply they originate from China, as for example *Nankin sometsuke* (blue and white ware from Nanjing) or *karamono* (things Chinese). Whether this was an attempt at intentional deception or reflective of wishful thinking is impossible to tell. The reality is that Japanese porcelain was made from its inception in the image of China and Chinese porcelain.

Chinese ceramics in Japan: a summary of the market

Chinese ceramics, in particular Longquan celadon, Jian brown and black wares and white porcelains were imported in increasing numbers into Japan from the eleventh century onwards. A significant shift occurred in the second half of the

144

sixteenth and the first half of the seventeenth century. During that period large quantities of underglaze cobalt blue decorated dishes were imported into Japan in increasing numbers and are found even in mid-level merchant household sites of the period. In addition, growing numbers of Southeast Asian and Korean wares also appear in the archaeological record, attesting to new trade routes, such as through the Ryukyu Islands, and a more cosmopolitan market.

Between 1580 and 1650 Chinese porcelain was acquired in unprecedented quantities in Japan. The large volume and the uniformity of certain designs and shapes of imported tradeware during this period point toward its possible meanings and use. Never before was porcelain possessed by such a wide section of society. Chinese ceramics have been excavated from most early seventeenth-century daimyo, upper level samurai and wealthy merchant sites in Japan (Hasebe and Imai 1995). The taste for *karamono*, or love of things Chinese, established in Japan centuries earlier among the elite of the medieval period as seen in the field of ceramics through the connoisseurship of Jian ware *tenmoku* teabowls, was now being actualised by a broad section of society.

The quantities of trade ceramics (in particular Chinese underglaze cobalt blue decorated porcelain) referred to in documentary sources and found in archaeological excavations demonstrate that these objects had become a necessary part of the upper-class lifestyle, which included high level merchants. This display of luxury, which focused on methods of presentation, was an integral part of Momoyama- and Edo-period life for the growing number of samurai and wealthy merchant classes. During this period luxury was displayed through elaborate social protocol, which included the ownership and use of Chinese-style porcelain (either Chinese or Japanese).

It is from this milieu that Japanese porcelain in its own right begins to be produced for the first time in the early seventeenth century. From the 1630s onwards, Japanese porcelains were increasingly signed with 'made in China marks', and these became rather sophisticated by the mid-seventeenth century.

The signing of China on the bases of the porcelains lent an air of authenticity to the product most likely simply for branding purposes rather than to fool the owner. The Nabeshima lords of Saga domain in the early 1620s capitalised not only on the resources of their new domain but also on the market for objects associated with China. From 1637 onwards the domain carefully regulated Hizen porcelain in order to develop the industry to its full advantage.

The development of early Japanese porcelain and its implications

Japanese porcelain began to be produced for the first time in northern Kyushu in the 1610s, as detailed in Chapter 3. By 1637 the core of the nascent industry was regulated and tightly controlled by the new lords, the Nabeshima. The regulation of the local industry at this time must surely have been a response to the diminishing supplies of Chinese porcelain being imported to Japan due to internal strife in China during the transition from the Ming to the Qing dynasties particularly affecting the south and the porcelain producing areas. The Nabeshima would be acutely aware of the limited stock coming into Nagasaki and the continuing demand within Japan for Chinese porcelains. The Nabeshima were one of the lords assigned to overseeing Nagasaki during this period for the Tokugawa government. The Nabeshima at this point must have realised the potential of its own domain's porcelain to replace the missing Chinese wares in the internal market, and acted to promote the industry.

The 1637 Nabeshima-sponsored porcelain regulations were to prove to be far sighted, as the clan managed a monopoly of the porcelain industry until the late eighteenth century. Even today, Arita-produced porcelain still is one of the dominant centres of porcelain in Japan and continues to diversify its production for market demand, with for example porcelain chips for computers. Porcelain vessels for dining and for tea enthusiasts are still sold in the Arita area in large quantities,

Conclusion

providing a substantial income to many potters and businesses, though profits are said to be limited in the current economic climate.

It is clear that the beginning of Japanese porcelain is not a simple matter of technology transfer by Koreans forcibly repatriated to Japan in the 1590s. Rather, it began as a local industry of farmer-potters firing Karatsu stoneware sometime in the 1580s and then rough porcelain in the 1610s particularly during the off-season for farming. Porcelain production gradually developed in the first two decades, and its potential was recognised by the Nabeshima domain officials who nurtured this nascent industry as an important source of revenue for the otherwise mineral-poor domain. After 1637 in the central domain controlled areas, porcelain was made by skilled full-time potters, the less skilled ones and the farmers having been excluded by the 1637 decree banning non-professionals from the field.

The early Hizen porcelains had to compete initially with Chinese imports, which were still entering the market, though in decreasing supply. Luckily for Hizen porcelain, this competition soon ceased as Chinese production and distribution became difficult for a number of decades from 1650 to the 1690s. The style of early Japanese porcelain was Chinese in inspiration. For example, even the initial wares sported cobalt-oxide decoration, an expensive pigment, despite the fact that the objects themselves were still quite rough in quality. The porcelain production methods and technology used to create these early wares were a combination of Continental (Korean and Chinese) and Japanese techniques.

When researchers focus simply on the ethnicity of the potters and try to link the history of the accumulation of techniques in a teleological fashion, they tend to overlook the basic role and significance of Japanese porcelain in the market. Perhaps of even more importance in the evolution of a native porcelain industry are the questions why the porcelain was created and for whom. I have argued that the role of Japanese porcelain from its inception through its maturation in the

147

1660s or slightly later was as a loose copy of China replacing the original Chinese wares when the export market was temporarily halted. Early Japanese porcelain was initially import substitution, but as the industry developed and grew and new domestic markets and export markets were secured for Japanese-produced porcelain, it took on a separate life of its own certainly by the Enpô era (1673-81).

The meaning of porcelain

On 11-13 February 2005 an international conference organised in the Kyushu Ceramic Museum in Arita brought together possibly for the first time early modern archaeologists and art historians from Japan, Korea and China to examine technology transfer in East Asian porcelain and stoneware during the sixteenth and seventeenth centuries. The conference also marked the fifteenth year of an annual event, the Kyushu Conference on Early Modern Ceramics (*Kyushu kinsei tôji gakkai*), founded in memory of the eminent trade ceramic scholar and archaeologist Mikami Tsugio, by Ôhashi Kôji and Maeyama Hiroshi in 1980. The conference highlighted archaeological matters, national identities and language issues that have both propelled, consumed and plagued the study of medieval and early modern ceramics in Japan. Issues debated during the conference, both positive and negative, have come into even greater focus as international dialogue in East Asia continues to develop these last few years. The attendance of over 150 archaeologists was evidence of the goodwill and interest in dialogue that exist among East Asia archaeologists. It was clear to all present, however, that many hurdles still have to be cleared before a fluid dialogue can take place.

An issue that the conference helped to highlight was the need to consider the amount of raw data available when comparing archaeological results in China, Korea and Japan in the early modern period. The large number of excavations conducted in Japan far exceeds those of other countries, which means that comparisons cannot be conclusive. In addition,

there are clearly historical, national and geographic priorities at work when choosing which site to excavate specific to each country and region, even with 'rescue archaeology'. In general, the excavation of sites that date to the late medieval and early modern periods has not been a priority in Korea and China, but has been for certain areas of Japan. As in most countries, a significant portion of local archaeological intervention in Japan is regionally and economically driven. The large number of excellent excavations conducted in the Arita-cho area of Saga Prefecture, where the porcelain industry originally commenced and still thrives today, is part of a clear policy by the local government to support current industry and to develop tourist potential.

The varying strategies for preserving and animating archaeological heritage, coupled with the pitfalls of linguistic fuzziness in terminology and different nationally defined historical priorities and interpretations, highlight the challenges in creating an international archaeological template. For example, the paucity of information regarding seemingly equivalent sites in different countries is a factor that should be borne in mind. In China, though the porcelain-producing Jingdezhen and Zhangzhou kiln complex sites have been excavated with due care, in general other non-porcelain-producing kiln sites from earlier periods receive greater attention. In Korea, excavations of Goryeo period (918-1392) kiln sites are much more developed than the subsequent mid- and later Joseon period Buncheong and their porcelain kiln counterparts. The reasons for the choice of where and when to excavate are understandable given the political necessity of resource allocation. In addition, kiln sites that are important but not threatened by development may also be left unexcavated, inevitably with an effect on any hypothesis or conclusions that may be drawn.

Murakami Nobuyuki of the Arita-cho Educational Board gave the last and perhaps most provocative paper of the conference held in 2005. He is one of two municipally employed archaeologists who have overseen excavations of multiple kiln

sites in the Arita-cho area over the last twenty years. Mu-rakami suggested that the wrong questions have been repeatedly asked in research on early Japanese porcelain and its continental roots. When looking for links and shared proto-types between Japan, Korea and China, the focus has traditionally been on technology transfer and individuals' forced labour (Korean nationals forcibly brought over to Japan to create porcelain). Rather than technology transfer or specific human agency, Murakami argued, researchers should look at what was being produced, by whom and for whom, and then at the local means used to create the desired product; what is needed to remedy the current opaque situation is a rigorous re-examination of the definitions built into our current argu-ments of the origins of porcelain; any definitions that we decide to use, old or new, should be based on scientific proof and archaeologically retrieved evidence, but at the same time be flexible enough to adapt to the period in question.

One issue that Murakami neglected to mention in his paper was the twentieth-century preoccupation with linking particu-lar local areas in Japan with locally manufactured products (*meibutsu*), corroborated by 'authenticating' narratives (Rous-maniere 2007). In Arita-cho, for example, scholarship, archaeology and disseminated tourist information are all mobi-lised to portray the current Arita porcelain industry as a natural and direct outcome of early seventeenth-century pot-ters. Many Arita-based potters (including the nationally designated Kakiemon XIV and Imaizumi Imaemon XIV) trace their origins back to early Arita porcelain potters and in some cases to Korean Peninsular origins. Local potters' signboards in Arita often specify the number of generations that the pot-ter's family has been in practising in the same area.

Undoubtedly, local potters did produce porcelain during the early seventeenth century in the Arita area and its periphery. Some of these potters were certainly ethnically Korean, Chinese or Japanese. Anonymous potters in early seventeenth-century Japan belonged to the lowest echelons of society, and were often equal in status to itinerant workmen. Today, some four

hundred years later, many ceramic artists, with a much deserved raised status and income, still work in the area, and some, even many, may be directly related to the original early pioneering porcelain potters. However, to draw a straight line over the four hundred years of porcelain production, even if there is a direct blood connection, is surely far too simplistic to understand the porcelain industry in the Arita-cho area. To do so without discussing the historical and market circumstances is to contribute to the propagation of a myth of origins for porcelain in Japan and not honour the realities and the challenges that faced porcelain potters in the development of their craft and the distribution of their porcelain wares.

Murakami was correct in his call to rethink the questions we researchers ask in our inquiries into early porcelain industry. He went on to conclude his paper with thoughts on the terminology used in international comparisons. The English word 'porcelain' (*jiki* in Japanese), he argued, can be defined with reasonable scientific accuracy; but even in contemporary English, Japanese, Chinese and Korean, the words for porcelain, stoneware and earthenware differ in their linguistic boundaries, making for pitfalls in international dialogue, and raising questions as to the scientific nature of the debate.

Fundamentally, he argued, there was no specific term for porcelain in seventeenth-century East Asia as it is defined in English today. The current word *hakuji* ('white ware') was most likely used for what is now termed both porcelain (*jiki*) and stoneware (*tôki*) that was whitish in colour and high fired. Additionally, one should recognise the potential difference between what is perceived currently as white and what used to be considered white four hundred years ago. For example, silver was often described as 'white' in Edo literature (see Arakawa 2004). Indeed, terminology is still an issue when translating early modern kiln excavation reports in the Korean language where it is often unclear whether the text is referring to the English terms stoneware or porcelain.

At the Kyushu conference referred to above, the Korean word for white ware was translated into Japanese as *jiki* (Arita

being the home of *jiki,* or porcelain, in Japan), but it became apparent during the conference that the speaker from Korea was referring to Buncheong or whitish stoneware (classified as *tôki* in Japanese). Indeed, it seems that initially in the early seventeenth century Karatsu ware (currently termed *tôki*) and porcelain (*jiki*) were not given separate categories at all. Rather, they were seen as different styles of the same product: they were indeed fired together in the same kiln on the same stacks from 1610-1630s. The only difference appears to be that porcelain was seen as a more refined and a continental-style ceramic than the stoneware, which was mostly for daily use, with occasional high-end examples, such as tea ware, made to special order.

In February 2010 the Kyushu Conference on Early Modern Ceramics held a conference entitled 'Hizen Ceramics Exported all over the World' with an accompanying publication of even broader scope than the papers presented. A smaller and more focussed group reformed in 2011 and continues to address specific topics of relevance in Japanese porcelain on an annual basis, but the twentieth-anniversary conference was meant as a closure on the large-scale topics that have been addressed so far. The conference summarised recent scholarship on Japanese porcelain focussing on the export trade, with particular attention to Southeast Asia. Scholars based in Macao, Laos, Vietnam, Indonesia, Taiwan and Holland gave papers along with Japanese archaeologists on the current state of Japanese ceramics found abroad from the seventeenth to nineteenth centuries.

New discoveries, such as the existence of Japanese trade wares in Cuba and Mexico from the 1660s, were announced, but what seems to be the most important conclusion of the conference was the role of the Zheng family and the Chinese southern Ming resistance to the Japanese porcelain trade in the 1640-1670s. The Zheng family, who were based first in Fujian but then took over Taiwan from the Dutch in the 1660s when the Qing Chinese uprooted them from their coastal perch on the mainland, funded a good deal of their efforts of resis-

tance to the Qing through a highly developed trade system throughout Southeast Asia. It was proposed that they even ordered and perhaps created a series of spurious Chinese Ming reign marks on the bases of Japanese porcelain from the 1650-60s. The Zheng were eventually ousted from Taiwan and from the Southeast Asian trade, but the Dutch had by this point in the 1660-70s taken a greater interest in Japanese porcelain, despite their initial reluctance to enter into international trade with those wares. These important finds shed new light on the international scope and impact of Japanese porcelain in the seventeenth century, and while beyond the remit of this book, happily show that the field is alive and that new discoveries are being made, especially in the international arena. Japanese scholarship on porcelain is gradually becoming available to international audiences and this should enliven these debates significantly in the very near future.

The growing importance of porcelain in the early to mid-seventeenth century can be seen as a response to the internal political consolidation of Japan and new Asian realignments in trade due to shifting market and political forces at the time. The domestication of the merchant economy with the new *Pax Tokugawa*, coupled with a growing leisure industry and the ever-expanding importance of pageantry and entertaining in the newly formed social order, has been reviewed in relation to porcelain.

This book has outlined research by Western and Japanese archaeologists and art historians who examine Chinese ceramics in Japanese contexts, as well as the birth of the native manufacture of Japanese porcelain. Consideration in this study of ceramics has also been given to the influence of such peripheral issues such as changing societal and political patterns within the archipelago, period aesthetic tastes, input from recent archaeological finds and new avenues of research from international conferences on trade routes, exchange of nationals and other topics.

I hope that this book will suggest new avenues of approach to this evolving and fascinating field of discourse. It is my

sincere hope that a knowledge and appreciation of porcelain and of ceramic tradeware in general will take its rightful place within the discourses of Japanese culture and history.

Postscript: The Impact on Porcelain of Imperial Taste in Meiji Japan

If any further proof were needed of the readiness with which the Japanese adapt themselves to the necessities of European civilization, it may be found in the fact that the Mikado, no longer content with his old vessels of lac [lacquer] and porcelain, has resolved on dining off silver-gilt plates, like any King or Emperor of the West ... In order to meet his wishes the execution of the Mikado's order has been entrusted to Messrs. Garrard, the Queen's goldsmiths, of the Haymarket ...

The Times, 31 May 1876

Just eight years after leading his country into a new era, *The Times* informs us, the Japanese Emperor Meiji preferred to dine using silver-gilt tableware and cutlery made in England rather than traditional Japanese utensils such as lacquer and porcelain. This announcement chimes with the statement from *Harper's New Monthly Magazine* quoted at the beginning of this book, also dating from the mid-nineteenth century, that dining habits reflect people's 'rank among civilised beings'. Inherent in this quotation is the desire of the Meiji government to be considered part of the civilised Western world. The linking of perceptions of civilisation and culture to accoutrements of dining and entertaining is not exclusive to a specific culture, as hopefully has been demonstrated in the previous chapters. The abandonment of porcelain for silver on the part of the

155

Emperor reflects international trends, of which the Japanese were always aware. In 1868, the Emperor and his entourage (currently the household agency) took the reigns of power from the Tokugawa government and impressed their own pageantry and symbolic imagery on the material culture that surrounded them and on objects they patronised. While there was an external nod to Europe as in this example of an order of silverware for the imperial household, much of the symbolism remained Chinese in content, but that topic lies beyond the purview of the current book.

Key Japanese Terms

anagama	穴窯
Asakura clan	朝倉氏
Baekje Kingdom	百済
chônin	町人
Chôsenjin or *Kôraijin*	朝鮮人（高麗人）
Cizhou wares	磁州窯
daimyo	大名
denseihin	伝世品
dôbôshû	同朋衆
Hachiôji Castle	八王子城
hakuji	白磁
Hasami	波佐見
Hebei province	河北省
Himetani	姫谷
Hizen	肥前

Ichijôdani	一乗谷
Imari	伊万里
jiki	磁器
Jizhou wares	吉州窯
jôkamachi	城下町
Jômon	縄文
kaikin	海禁
kaisho	会所
Kakiemon	柿右衛門
Kakumeiki	隔冥記
Kanegae Sanbei I	金ヶ江三兵衛
Kanko zusetsu	観古図説
karamono bugyô	唐物奉行
karamonosuki	唐物数寄
karamono tenmoku	唐物天目
Karatsu	唐津
kawarake	土器
kazari zashiki	飾り座敷
Kefukigusa	毛吹草
Kokutani	古九谷
kosometsuke	古染付
Kundaikan sôchôki	君台観左右帳記

Key Japanese Terms

Kutani	九谷
Mikawachi (Hirado)	三川内（平戸）
Minjin	明人
Nabeshima	鍋島
Nambokuchô	南北朝
Ninagawa Noritane	蜷川 式胤
Oda Nobunaga	織田信長
ôgama	大窯
Ôkawachi	大河内
Raku ware	楽焼
renbôshiki noborigama	連房式登窯
Sado	佐渡
Saikôkai kôenroku	彩講会講演録
sakoku	鎖国
sansai	三彩
sekki	石器
Seto	瀬戸
shifuku	仕服
Shinjin	清人
shitsurai	室礼
Shoki Imari	初期伊万里

Vessels of Influence

Shonzui	祥瑞
shuinsen	朱印船
Silla Kingdom	新羅
sueki, or Sue ware	須恵器（須恵焼）
Sui dynasty	隋朝
Tôjin	唐人
tôki	陶器
Tokugawa Ieyasu	徳川家康
Tôsen fûsetsu gaki	唐船風説書
Toyotomi Hideyoshi	豊臣秀吉
Ureshino	嬉野
Xing kilns	邢窯

Notes

Introduction

1. Ôhashi Kôji, *Hizen tôji* [Hizen Ceramics] (1989), 6-8. Three different types of character combinations are used for the term *imari*. The term *(imari)* is mentioned 69 times in the *Kakumeiki* diary between 1640 and 1650. The earliest mention of porcelain in his diary is recorded as *imari-yaki fujinomi sometsukeno kôgô* [An Imari incense box with an underglaze cobalt-blue design of wisteria], and dates to Kan'ei 16 (1639).

2. See Ôhashi (1989), 7. The reference to porcelain in *Kefukigusa* [Compendium of haiku poetry] is noted as *karatsu imarino yakimono* [Karatsu Imari ceramic], and is dated to Kan'ei 15 (1638).

3. 1637 (Kan'ei 14) recorded in the Yamamoto Jineomon Shigezumi diary, known as the *Saga honpon* [Saga domain Records] currently in the Taku Library, Taku, Saga Prefecture. The document records the restructuring of the Arita-cho kilns with the deportation of 826 Japanese potters, the closing of eleven kilns, and the maintenance of thirteen kilns. This is discussed further in Chapter 3.

4. He is popularly known in Japan as Ri Sanpei. The document is dated 'Twentieth of the Fourth Month, Year of the Snake', and relates a brief history of his life and his service for Lord Nagato. Sanpei is attributed with the discovery of porcelain stone at Izumiyama. He is thought to have been born in Korea and been brought to Japan by Nabeshima Nagato during the Korean invasions of 1592 and 1598. See Nishida Hiroko, 'Japanese Export Porcelain in the 17th and 18th Centuries' (1974), 32. The Kanagae family documents are still in the family's possession in Arita-cho. The documents are reproduced and transcribed in Ishikawa Prefectural Museum of Art and the Kyushu Ceramic Museum (eds), *Imari kokutani meihinten* [An Exhibition of Masterpieces of Kokutani and Imari] (1987), 12-13, 160-1. This is discussed further in Chapter 3.

1. Porcelain Debates in Japan and in the West

1. The three largest tea schools advocating whipped tea currently operating from Japan are named Urasenke, Omotesenke and

161

Mushanokôjisenke. The senke in the last part of each of their names is a reaffirmation of the direct line to the house (*ke*) of Sen (Sen no Rikyû).

2. See Hayashiya Tatsusaburô (ed.), *Nihon shisô taikei* [The History of Japanese Thought], vol. 23: *Kodai chûsei geijutsuron* [Ancient and Medieval Aesthetic Theory] 1973, for a basic description of the text and a discussion of its historical importance. See also Nicole Rousmaniere (ed.), *Kazari, Decoration and Display in Japan, 15th-19th Centuries* (2002), 94-5 for illustrations of two versions of this manual.

3. For example, a recent catalogue on Edo-period Karatsu ware, which has been insufficiently studied, recognises this fact in the title of the catalogue. See the Nezu Institute of Art (ed.), *Shirarezaru Karatsu* [The Little-known Karatsu Wares of the Edo Period] (2002).

4. For Koyama Fujio's life and his long-term relationship with ceramics see Idemitsu Museum of Arts (ed.), *Koyama Fujio no me to waza, tô no shijin* [Koyama Fujio, A Potter's Dream] (2003).

5. Arakawa Masa'aki has discussed Ôkuda's role in the study of Japanese porcelain in several publications, most notably in his catalogue *Kokutani* (2004), 11-16.

6. Nishida Hiroko, 'Japanese Export Porcelain in the 17th and 18th Century', unpublished PhD thesis (Oxford University, 1974), Introduction (pages unnumbered).

7. For the Kakiemon family documents regarding the beginning of the overglaze technique see Ishikawa Prefectural Museum and Kyushu Ceramic Museum (1987), 12-13, 160-1.

8. Arakawa (2004) summarises the debates on this topic.

9. Matsumoto Satarô, *Teihon Kutani* [Handbook for Kutani] (1940). This book contains an annotated bibliography as well as illustrations of porcelain marks.

10. The then Prime Minister Koizumi Junichirô on his 20-21 May 2006 visit to Ishikawa Prefecture made a special point of visiting the Kutani-Kôsenyô kiln in Kanazawa City that specialises in producing revival Kokutani style porcelains. See 'What's Up Around the Prime Minister', 20-21 May 2006, accessed on 15 March 2010. http://www.kantei.go.jp/foreign/koizumiphoto/2006/05/20hokuriku_e .html.

11. Kutani koyô chôsa iinkai [Kutani Kiln Research Group] (ed.), *Kutani dai 1 chôsa hôkoku* and *Kutani dai 2 chôsa hôkoku* [Archaeological Report on the Survey of the Kutani no. 1 and no. 2 Kiln Sites] (Ishikawaken kyôiku iinkai, 1971, 1972) and Ishikawa Prefecture, Enuma-gun Yamanaka-cho kyôiku iinkai (ed.), *Kutani* (Yamanaka-cho: Ishikawa Prefecture, Enuma-gun Yamanaka-cho kyôiku iinkai, 2004). See also Ishikawa Prefectural Museum of Art and Kyushu Ceramic Museum (1987), 14-19.

Notes to pages 69-80

12. Fukui Kikusaburô, *Japanese Ceramic Art and National Characteristics, Nihon tôjiki to sono kokuminsei* (Tokyo, 1927), 59-60. For a discussion of early example of Japanese market building in France in 1867 see Mori Hitoshi, '1867-nen Pari bankoku hakurankai ni okeru Nihon, Nihon shuppin o megutte' [Japan in the Universal Exhibition on Paris in 1867, on Japanese exhibits], *Tôjô ronsô*, vol. 3 (1993), 1-28.
13. A selection of Roger Soame Jenyns' private collection of Japanese porcelain is currently on long-term loan to and on display at the Fitzwilliam Museum, Cambridge.
14. Menno Fiski's transcription and translation into English are published in Oliver Impey's *The Early Porcelain Kilns of Japan* (1996), 132-9; see also Nagazumi Yôko, *Karabune yushutsunyûhin sûryô ichiran 1637-1833* [A In-depth Examination of Imported Items from Chinese Ships Entering Japan, 1637-1833] (1987). Dr Leonard Blussé and his colleagues including Cynthia Viallé based in the University of Leiden have republished the original VOC records in the series *Intercontinenta*. Cynthia Viallé, 'The records on the VOC concerning the trade in Chinese and Japanese porcelain between 1634 and 1661', *Aziatische Kunst* 1992, no. 3 (September 1992), 7. Another approach to examining VOC trade registers has been pursued by Bennet Bronson in 'Export Porcelain in Economic Perspective: the Asian ceramic trade in the 17th century', *Centre of Asian Studies Occasional Papers and Monographs*, no. 90 (1990), 126-51.

2. Chinese Ceramics in Japan during the Medieval Period, and their Significance in Tea Gatherings

1. The publication *Chanoyu Quarterly* was an example of the high quality of research published by the Urasenke Foundation.
2. The two compilations are entitled *Ronshû* and the *Bunka shûreishû*.
3. The tea was probably a type of brick tea (*dancha*). To make brick tea, newly picked tea was pounded into a paste and moulded into a small square and dried. The drink was prepared by breaking a piece of dried tea from the brick and boiling it in water seasoned with salt, raw ginger and arrowroot.
4. Steeped tea is traditionally called *tencha* and whipped tea is named *matcha*.
5. *Matcha* is prepared by placing a portion of dry, powdered tea into a bowl, adding hot water and whipping the mixture with a bamboo whisk into a froth.
6. The Japanese word *tenmoku* is a generalised term for Chinese or Japanese brown and black glazed ceramics with a specific shape. *Karamono tenmoku* refers to Chinese wares, and *wamono tenmoku* is its Japanese equivalent. The term refers to a mountain (Tian-Mu,

163

west of Hangzhou) in China where Japanese priests would visit to study Buddhist doctrine. The Japanese travellers bought Chinese brown ware bowls as souvenirs and probably assumed that they were produced in the vicinity. In fact, Jian ware was made in the Southern Chinese kilns of Fujian Province.

7. The 1476 version is reprinted in the *Gunsho ruiji*. The 1511 version is in the Tohoku Library and is published in its basic form in *Bijutsushi kenkyû* 30 (May 1933).

8. In most versions the *Kundaikan sôchôki* is divided into three sections, with the first focusing on Chinese painters of note, the second on the display of objects, and the third on ceramics, lacquer and scholarly implements.

9. Only three recognised examples of *yôhen tenmoku* ('iridescent' Jian ware tea bowls) are generally accepted, all of which are currently in Japan: in the Seikadô Foundation Art Museum, Tokyo (called *inaba tenmoku*); in Ryûkô-in, Kyoto; and in the Fujita Museum, Osaka. Ten superior *yuteki tenmoku* bowls are recognised ('oil spot' Jian ware), and again all are located in Japan.

10. There is a second Chinese Longquan celadon named *Bakôhan* in the Tokugawa Art Museum. This example also sports metal staples on a repair but is of much smaller size and is not registered.

11. Tea related vessels or ceramics with pedigrees have entered Western collections for over a century. However, too often boxes, documents and textiles that accompanied these pieces were separated or discarded. Occasionally tea wares would be sold knowingly to Europeans without their boxes. Certain wares, such as heirloom tea caddies, lose much or all of their identity as well as value when separated from their recorded pedigree. The loss of documentation in effect strips these objects of their histories and shifts the emphasis back to the origin of the ceramic rather than its pedigree, i.e. the production site (kiln) or country of origin.

12. Korean teabowls in the sixteenth century were often categorised by the Japanese tea aficionados using such term as *kôrai, mishima* and *ido,* among other appellations. The earliest documented use in a tea gathering of a Korean bowl is in 1537 (*kôrai chawan*); the earliest use of a *mishima* style bowl is in 1565, and of an *ido* style bowl is thought to be 1580.

13. Jian ware sherds have been excavated from most daimyô households in Edo (Tokyo), including the Date, Maeda and their vassals the Daishôji.

14. Some medieval workshops, like the old Seto kilns, produced copies of Chinese glazed wares and not domestic-style high-fire unglazed wares (*yakishime*). These Chinese-style ceramics were distributed mostly throughout eastern Japan, where access to trade ceramics was limited.

Notes to pages 98-100

15. Zang Yingxuan was commissioned by the Qing court to reorganize the Jingdezhen kilns between 1682 and 1700, and he is generally credited with their rehabilitation.

16. Similar sets of Chinese porcelain found at Osaka Castle and the Maeda lord's mansion in Edo are recorded in the following excavation reports: Osakashi bunkazai kyôkai (ed.), *Osakajô ato* (1988), and Tokyo daigaku iseki chôsashitsu (ed.), *Tokyo daigaku Hongo kônai no iseki, Yamaue kaikan, Goten-shita kinenkan chiten* (1990).

17. Horiuchi focuses on archaeological sites located on the Hongo campus of Tokyo University, but he also lists fourteen other Edo sites that have produced significant amounts of Chinese porcelain.

18. It is most likely that trade wares entered Japan (or the Satsuma domain) through the newly annexed Ryukyu islands, which were incorporated by the Satsuma domain in 1607.

19. The term Swatow comes from a historical name of a port to the north of Guangdong province between the border of Guangdong and Fujian where ceramics were exported (but not fired). What has been referred to as Swatow ware is now known as Zhangzhou ware.

20. Tokyo daigaku iseki chôsashitsu (ed.), *Tokyo daigaku Hongo kônai no iseki, Yamaue kaikan, Goten-shita kinenkan chiten* (1990) and Kyotoshi maizô bunkazai kenkyûjo (ed.), *Kyotoshi maizobunkazai kenkyûjo chôsa hôkoku dai 22 satsu* [Kyoto City Buried Cultural Properties Research Centre Report, no. 22]. Kyoto: Kyotoshi maizo bunkazai kenkyûjô, 2004, 3 vols. The latter report is a fascinating and rare excavation that took place with in the Gosho, the Imperial Palace area in Kyoto.

21. See Daisy Lion-Goldschmidt, *Ming Porcelain* (New York: Rizzoli, 1978), and Margaret Medley, 'Trade, Craftsmanship and Decoration', in Sir Michael Butler et al. (eds), *Seventeenth-century Chinese Porcelain from the Butler Family Collection* (1990), 11-20. Jessica Harrison Hall, *Ming Ceramics in the British Museum* (2001).

22. For example, Oliver Impey and Hiroko Nishida have both written that there was not a domestic market for Kraak ware: Impey (1996), 26-8, and Nishida (1974), section 1.

23. The ship *San Jago* was captured outside Zeelandia (Taiwan) and the contents sold at auction in Amsterdam in 1602; the *Santa Catharina* was captured in the Straits of Malacca and contents sold at auction the following year in 1603: C.L. Pijl-ketel (ed.), *The Ceramic Load of the Witte Leeuw* (1982). The auctions made Chinese porcelain both available and affordable to a large segment of the population that had little previous access to it.

24. Two examples are *The Vision*, by Jan Breughal the Elder (dated 1617) in the Museo del Prado, Madrid, and an oil painting attributed to Osias Beert (dated to before 1624), in the Rijksmuseum, Amster-

165

dam. See Sam Segal, *A Prosperous Past: the sumptuous still-life in the Netherlands* (1988).

25. See Stephen Little, *Chinese Ceramics of the Transitional Period: 1620-1683* (1983), and Richard Kilburn, *Transitional Wares and their Forerunners* (1981). For a preliminary exploration into Japanese ordered pieces and the connection between Oribe and Kosometsuke see: Okayamaken kyôiku iinkai (ed.), *Oribe to Kosometsuke: Mino to Keitokuchin no deai* (1991).

26. This type of porcelain is generally termed Transitional by Western ceramic specialists.

27. For an example of Kosometsuke excavated from Nagasaki, see Ogiura Masayoshi, *Edo hakkutsu* (1993) illustrated in fig. 3, no. 12; for Kosometsuke ware excavated in Tokyo, see the Shiodome Site excavation report, Tamaguchi Tokio et al. (eds), *Shiodome iseki*, 3 vols (1996).

28. The term 'shonzui' is of Japanese origin. Western academics often include this ware under the larger category of Chinese 'transitional' wares, which refers to porcelain produced from the end of the Ming to the beginning of the Qing period during the seventeenth century.

29. One example can be found in the Tekisui Museum, Ashiya, Hyogo Prefecture.

30. For further examples and Japanese classifications of specific Chinese wares see Kyoto National Musem (ed.), *Nihonjin ga kononda Chûgoku tôji* [Chinese Ceramics coveted by the Japanese] (1991).

3. The Genesis of Japanese Porcelain

1. Tanaka Takeo argues that the term *sakoku* derives from the book *Sakokuron*, the 1801 translation by Shizuki Tadao of Engelbert Kaempfer's *The History of Japan Together with a Description of the Kingdom of Siam, 1690-92*. Shizuki is thought to have translated the first chapter of a Dutch language version of the book. The original two-volume English publication was based on a translation from a German manuscript by the Swiss national Johan Casper Scheuchzer (1727). See Tanaka (1975), 272-3, referenced in Katô (1994), 18.

2. Katô Eiichi (1994), 17-25, discusses the merits and problems of the 'maritime prohibition' theory as opposed to the term Sakoku. He feels that the terminology applies to Chinese border defence in the Ming and Qing periods especially in reference to *wakô* (pirate) activity. Therefore, he argues if the term is to be adopted, there needs to be a consensus among Chinese and Korean historians. He cautions about replacing the term *sakoku* with 'maritime prohibitions' noting: 'assuming that it [maritime prohibitions] signifies the monopolization by state authorities of the functions for conducting foreign trade relations, then one must carefully examine and compare the structural

characteristics of state power in the countries that introduced policies of maritime prohibitions as well as the ethnic composition of the regions under the control of each country, the conditions obtaining in domestic trading spheres, the stages of development of production capacity, the organization of production resources, and the characteristics of landlordism' (24-5). See also Iwao (1966) and Toby (1984).

3. See Conrad Totman (1995), 5-8. Totman argues for a more fully articulated ecological approach to economic history, and 'broadening the field of inquiry to encompass more of the variables that determined the costs and benefits of material production and to look more closely at how those costs and benefits came to be distributed as time passed' (5). This is particularly relevant to the ceramic industry, which was dependent on access to natural resources such as wood, clay, and water. Kiln sites were strategically chosen for these resources, and once these resources began to be over-utilised they were regulated by the clan, as in the case of Arita-cho in Saga domain with the 1637 decree. With the Saga domain, it was most likely the rapid deforestation that was the impetus for exerting complete control over the inner *uchiyama* porcelain kilns.

4. Nagahara and Yamamura (1988), 77-109, and Totman (1995), 7.

5. Kamiki and Yamamura (1977), 24, quoted in Atwell (1982), 71.

6. Ryley (1899), 179, quoted in Atwell (1982), 71.

7. Kobata (1970), 8, quoted in Atwell (1982), 71-2. Atwell goes on to state: 'Although trading restrictions imposed by the Ming government meant that much of the silver first had to go to Macao, Taiwan, the Ryukyu (Liu-ch'iu) Islands, Korea and South East Asia, most of it ultimately reached China where it was used to purchase goods for the Japanese market. Moreover, this trade was so lucrative that the great Japanese merchant houses vied for shogunal permission to send their ships overseas, and sizable Japanese trading communities were established in most of the above locations.'

8. Hauser (1977-1978), 23-36. The documents regarding Hizen domain's shipping routes via the inland sea to Osaka, and the slip they used along with merchant arrangements are recorded in Maeyama Hiroshi, 'Sagahanzô yashiki monsho' [Document on the Saga Domain Residence].

9. Emura Senzai, *Rôjin zatsuwa* (Miscellaneous Talk of an Old Man), in Kondô Heijô (ed.), *Kaitei shiseki shûran,* vol. 10, no. 39 (Tokyo, 1900-1903), quoted in Crawcour (1961), 14.

10. For an example of these types of projects and expenditure involved see B. Hauser (1985), 153-72.

11. The Matsura daimyo of the Hirado domain were among the first lords to travel to Edo to congratulate Tokugawa Ieyasu soon after his victory at Sekigahara in 1600. The Matsura had originally backed Toyotomi Hideyori in the battle. This informal practice of travelling to

Edo show loyalty to the Tokugawa became mandatory in 1635 for *tozama* (Outside lords who had originally backed the Toyotomi). Many daimyo also had residences and trading facilities in Kyoto, Osaka and other cities outside their domain. See Tsukahira (1966).

12. Ishida Ichirô, *Chônin bunka* (1961), 64, quoted in Donald Shively (1964-65), 153.

13. See Ravina (1995), 1001, and Toby (1984), 242.

14. A groundbreaking symposium addressed this issue and was published by the Aoyama Archaeological Society. It is entitled *Bôeki tôji ni miru Ni-Chû kankei to kokunai ryûtsû* [Japanese Chinese Relations as seen through Tradewares and Domestic Trade Routes] and edited by Tamura kenkyûshitsu, Aoyama Gakuin University (1995).

15. The *Tôban kamotsuchô* has been republished in Nagazumi Yôko, *Karabune yushutsunyûhin sûryô ichiran 1637-1833* (1987), and has proved to be a corrective in understanding the differences between the *Tôban kamotsuchô* and the VOC records as they pertain to trade between China, South East Asia and Japan. Nagazumi helpfully lists exports and imports in the different documents showing discrepancies, but she does not attempt to explain their differences.

16. An excellent summary of Japanese trade records can be found with Nakamura Tadashi, *Kinsei Nagasaki bôekishi kenkyû* [A Study of Early Modern Nagasaki Trade] (1988). English and Dutch record and language studies include: Derek Massarella, *A World Elsewhere: Europe's Encounter with Japan in the Sixteenth and Seventeenth Centuries* (1990), and Grant Goodman, *Japan: The Dutch Experience* (1986). See Impey (1996), 132-9 for an abbreviated record of certain Dutch bills of landing in English for the years 1650-1660.

17. The main archives of the VOC are held in the Rijkarchief, den Haag, Holland. The VOC archives that were recorded and stored in Batavia [*Dagregister gehouden int Kasteel Batavia vant passerende daer ter plaetse als over geheel Nederlandts-India*] are translated into Japanese in three volumes starting with 1 January 1624 and ending with 1668, Nakamura Tadashi (1970). The VOC records that were kept at Castel Zeelandia (Taiwan) are republished in Dutch in J.L. Blussé, M.E. van Opstall and Ts'ao Yung-ho (eds), *De Dagregisters van het Kasteel Zeelandia, Taiwan, 1629-1662*, 2 vols (1986). An English-language index to all years recorded of the Dutch *Dagregister* at Deshima is published in Paul van der Velde, *The Deshima Dagregisters: Their Original Table of Contents* (1991).

18. Engelbert Kaempfer, *The History of Japan Together with a Description of the Kingdom of Siam, 1690-92* (1727). The Cleveland brother's records are held in the Peabody Essex Museum, Salem MA and were originally published by the Essex Museum, see Rousmaniere (1997), 23-9. See also Philipp Franz von Siebold's, 'Riese nach

dem Hofe des Siogun im Jahre 1826' (1826), and *Manners and Customs of the Japanese in the Nineteenth Century* (reprinted 1973).

19. Nakamura, *Kinsei Nagasaki bôeki kenkyû* (1988). See also Nagazumi (1987) for a complete record translated into Japanese, and Ôhashi (1989), 28-31.

20. There were three types of Chinese trade vessels entering Japan in the Edo period, *Kuchibune* or short distance vessels, came from the Chinese provinces of Jiangsu and Zhejiang. *Nakabune* or middle distance ships, travelled from Fujian and Guangdong Provinces and the adjacent islands. The *Okubune*, or long distance ships, where the ones that travelled from Southeast Asia and Japan. See Ishii Yoneo (1998), 1-3.

21. Tokugawa bijutsukan (ed.), *Ieyasu no isan* (1992), 186-202, 208-11.

22. Hagiwara Mitsuo, 'Zaisan mokuroku kara mita tôjiki no shoyû – Kôshû Hattake kazai mokuroku o chushin ni' [Examining Ceramics from Inventory Records, with a Focus on the Kôshû based Hatta Family], *Bôeki tôji kenkyû*, no. 15 (1995), 94-105.

23. For a comprehensive background to Korean and Japanese trade relations from a Japanese perspective see Nakamura Hidetaka, *Nissen kankei shi no kenkyû* (1965-69).

24. Among the earliest recorded examples of Korean ceramic ware excavated in Japan are sherds from the Koshidaka site on the island of Tsushima dating to around 6,000 BC. See Sasaki (1994, 36).

25. Two important Karatsu ware exhibitions have been held at the Idemitsu Museum of Arts and the Kyushu Ceramic Museum. Arakawa Masa'aki (ed.), *Kokaratsu* (Tokyo: Idemitsu Museum of Arts, 2004) and *Tsuchi to bi: Kokaratsu* [Beauty and Earth, Old Karatsu] (Arita: Kyushu Ceramic Museum, 2008). See also Johanna Becker, *Karatsu Ware* (New York: Kôdansha International, 1986).

26. There were at least 119 Karatsu ware kilns dating from the 1570s to 1590s in a 23 x 20 mile area: Nakazato, *Karatsu, Nihon tôji taikei*, vol. 13, 85-7.

27. Nagoya Castle, a ruin up until a few years ago, has recently been excavated and reconstructed in ferro-concrete with a museum devoted in part to Hideyoshi's invasions of Korea. Karatsu wares are now known to have begun to be produced a decade before Hideyoshi's invasions and the construction of Nagoya Castle.

28. Karatsu area potters, the Nakazato family, trace their ancestry back to Korean routes, as does the Imaizumi (Imaemon) family of Arita-cho. The heads of both families, once they reach a certain age, are often designated as 'Living National Treasures'.

29. Louise Allison Cort, 'Korean Influences in Japanese Ceramics: The Impact of the Teabowl Wars of 1592-1598', in W.D. Kingery (ed.), *Technology and Style*, vol. II, 331-62.

Notes to pages 125-135

30. Fukui Prefecture Ichijôdani Asakura Clan Archaeological Museum [Fukui kenritsu Ichijôdani Asakuashi iseki shiryôkan] (1994). There has been debate about the stratigraphic accuracy of the Karatsu sherds recovered from this site.
31. The inscription reads: 'Dedicated to the Seibo Daibutsu of Kazumoto Shrine, Iki Island, Japan. Tea storage jar for offerings signed Sokaku of Mojiro village. 20th year of Tensho (1592).' This is the same year in which Hideyoshi launched the invasions, rendering it highly unlikely that a fully completed Karatsu kiln producing fine wares was the result of his invasion. Nagatake Takeshi (ed.), *Kyushu I, Nihon yakimono shûsei*, vol. 11 (Tokyo: Heibonsha, 1981), plate 1.
32. Horiuchi Akihiro, 'Momoyama no hakkutsu chatô', *Tankô*, no. 108 (August 1988), 46.
33. Karatsu ware kilns started to cover the countryside in post 1600s, especially in Hizen province. The number of kilns in Hizen created a deforestation problem. In 1637 an edict was issued (*Saga honpon*) regulating the number of kilns, partially to prevent deforestation.
34. The slow-turning potter's wheel was introduced into Kyushu from the Korean Peninsula during the Yayoi period. A kick wheel appears to have been introduced from the Continent into Kyushu during the early sixteenth century.
35. Nagatake, *Kyushu I, Nihon yakimono shûsei*, vol. 11.
36. An early kiln that has a continuous roof and no stepped chamber differentiation is the Kishidake saraya kiln. It is thought that similar kilns were being used in Guangdong and Fujian and that the origins of the early *noborigama* may lie in southern China, or in a mixing of the technologies of southern China and Korea. See Ho Chuimei, 'Preface', in *Ancient Ceramic Kiln Technology in Asia*, iii-x.
37. Ôhashi Kôji, *Hizen jiki no akebono, Hyakunenkan tôji ronsô, dai ichi gô* (Arita: Fukagawa seiji kabushiki gaisha geijutsushitsu, 1988), 3-9.
38. See Hayashiya Seizô, 'The Korean Teabowl' (1977), 28-46, and Louise Allison Cort, 'Korean Influences in Japanese Ceramics: The Impact of the Teabowl Wars, 1592-98', 331-62.
39. See Morgan Pitelka (2005) for an alternate view on Raku ware origins.
40. 1616 or 1614, depending on which legend or document that is being used. In the *Kanegaeke monjo* (documents of the Kanegae house) written in 1807 (Bunka 4) two hundred years after the incident, a date of 1614 is recorded (*Arita-choshi tôgyôron I*, 12-18, 564-72), though the date is frequently referred to as 1616 in other secondary reference materials. See for example, Pope (1970), 3.
41. Mikami Tsugio, *Arita Tengudani koyô* (Tokyo: Chûô kôronsha shuppan, 1972).

42. Kyushu tôji bunkakan (ed.), *Tsuchi to honô* (Arita-cho: Kyushu tôji bunkakan, 1996). The English version entitled is *Earth and Fire* published the same year by The Kyushu Ceramic Museum for the World Ceramic Exposition (Saga Prefecture 1996).

43. The Ri Sampei legend is vital to the current economy in Arita-cho. See Ôhashi Kôji, *Hizen jiki no akebono, Hyakunenkan tôji ronsô, dai ichi go* [The Beginnings of Hizen Porcelain, 100 years of the porcelain debate, vol. 1], 1-7.

44. World Ceramic Exposition 2001 Organizing Committee, *Masterpieces of the Choson Potters' Descendants in Japan.* Seoul: World Ceramic Exposition 2001 Korea, 2001, includes both an exhibition catalogue and conference proceedings.

45. Ôhashi, 'Imarijiki sôseiki ni okeru karatsuyaki tono kanren ni tsuite', 520-31. This information was partially taken from Ôhashi (1987), 71- 6. Some of this information listed here is based on conversations with Ôhashi Kôji and Murakami Nobuyuki in Arita-cho, from 1993 to 1995.

46. Some of the earliest porcelain and stoneware producing kilns in the 1610s-20s were located in the less mountainous areas around Arita-cho, and in particular to the west in Nishi Arita-cho. Early kilns include Benzaiten, Haraake, Komizo, Komonnari, Komoridani, Mukaenohara, Seirokunotsuji, Tanigama, Tenjinmori, Tatara, and Yanbeta, no. 4.

47. Uchigawa Ryûshi, *Hachijôjima kyû Chôdamura ni shozai suru 'ishiba' ni kansuru yosatsu, Kôkogakuin daigaku kôkogaku shiryôkan kiyô, dai 7 shû* [Regarding Stone offerings at the former village of Chôdamura in Hachijôjima, vol. 7] (1990). The dishes were most probably fired at the Tengudani or Kamanotsuji kilns in Arita-cho.

48. The Jade Hare motif is originally a Chinese design that enjoyed a revitalised popularity in the late sixteenth and seventeenth centuries in Japan.

49. Sister Johanna Becker mentions this early on in her 'The Karatsu Style and Korean Influences' (1979), 71-6. See Kyushu Ceramic Museum's definitive exhibition on Karatsu ware (2008). Japanese merchants created a trading centre in Korea in 1616 called the Punsan wakan (Punwon). Recently Korean excavations have uncovered further kilns in southern area of the Korean Peninsula that supplied stoneware teabowls for the Japanese market. Katayama Mabi from Tokyo University of the Arts is currently working on this topic.

50. Izumiyama stone is of volcanic origin and made up of sericite and quartz that naturally contains kaolinite. See J. Allen Howe, *A Handbook to the Collection of Kaolin, China-clay, and China Stone in the Museum of Practical Geology, Jermyn Street London SW* (1914), 12; quoted in Impey (1996), 33.

51. The original document is located in the Taku Library in Taku, Saga Prefecture. It is known as the *Yamamoto Jin'emon Shigezumi gonenpu* and dated to 1647. Informally it is generally called the *Saga honpon*. It was first published in the *Arita Sarayama sôgyô shirabe* edited by Kume Kunitake in 1873. The 1873 text also mentions that in 1634 the Nabeshima domain took control over the Arita-cho district. See Ôhashi 1989, 23-7.

52. The closure of the non-porcelain firing kilns was enacted to protect scarce resources in the area such as wood, and was most likely enacted to streamline the industry. It was probably related to the 'non Korean' potter eviction edict. Currently scholars interpret the 'non-Korean' potter eviction notice at face value, meaning those not of Korean blood were prohibited from firing ceramics. But as is demonstrated terms for Korean and Chinese were fluid and applied not only to race and origin of product but also to style. If the domain was building up a new industry of Chinese style porcelain, then the edict could just as well apply to potters who were not producing Korean or Chinese style porcelain. The association of this fledgling industry with foreign craftsmen lent an air of authenticity to the new brand of porcelain.

53. Ôhashi Kôji (1987), 72. The seven initial kilns in the Arita-cho area were Tenjinmori, Komizo kami (upper), naka (middle), and shita (lower), Komonnari, Seirokunotsuji, Haraake, Mukaenohara, and Benzaiten.

54. There is also mention in records of a third district called *ôsoto yama*, meaning far outer mountain (area), presumably referring to the Hasami kilns in neighbouring territory. See Ôhashi (1989), 21-3.

55. The Magistrate Office was called the Sarayama Daikansho. It was composed of the *Daikan* (the magistrate), the *Gun metsuke* (area superintendent), the *Shunyôyaku* (fiscal manager), the *Shita metsuke* (lieutenant superintendent), and the *Shita yaku* (junior official).

56. The four Ming reign dates of Xuande (1425-1436), Chenghua (1465-1488), Jiajing (1521-1566) and Wanli (1572-1620) were often copied on Hizen porcelain bases throughout the Edo period.

57. A smaller percentage of marks fall outside the spurious Chinese reign dates and often refer to other styles of Chinese marks such as *chiku seki kyo* [house of bamboo and stone].

Bibliography

Akamatsu Toshihide, 'Okazarisho', *Chadô koten zenshû* [Compendium of Tea Classic], vol. 2. Kyoto: Tankôsha, 1958, 405-501.

Akanuma Taka, 'Kensan to tenmoku' [Jian Ware and Tenmoku], in *Karamono tenmoku – Fukken shô Kenyô shutsudo tenmoku to Nihon densei no tenmoku: Tokubetsuten* [A Special Exhibition on Chinese Jian Wares, Excavated Examples from Fujian and Heirloom Items from Japan], Chadô shiryôkan and Fukkenshô hakubutsukan (eds). Kyoto: Chadô shiryôkan, 1994, 177-86.

Akanuma Taka (ed.), *Chatô no bi* [The Beauty of Tea Vessels], vol. 1. Kyoto: Tankôsha, 2005.

Appadurai, Arjun (ed.), *The Social Life of Things: commodities in cultural perspective*. Cambridge: Cambridge University Press, 1986.

Arakawa Masa'aki, (ed.), *Ôzara no jidaiten* [The Age of Oversized Dishes]. Tokyo: Idemitsu Museum of Arts, 1998.

Arakawa Masa'aki (ed.), *Kokutani* [Kokutani Style]. Tokyo: Idemitsu Museum of Arts, 2004.

Arakawa Masa'aki (ed.), *Kokutani roman kareinaru Yoshidayaten* [The Romance of Old Kutani and the Brilliance of the Yoshidaya Style: the beauty of Kaga that transcends 180 years]. Tokyo: Asahi Shimbun, 2005.

Arita-cho kyôiku iinkai (ed.), *Hirosemukai*. Arita-cho kyôiku iinkai, 2009.

Arita-cho shi hensan iinkai [Arita-cho editorial committee] (ed.), *Arita-cho shi, tôgyôhen I* [A Compendium of the History of Arita-cho, the Ceramic Industry I] Fukuoka: Gyôsei, 1985, 1-46, 475-608.

Asahi Shimbun (ed.), *Harukanaru tôji no michiten* [Exhibition of the Distant Ceramic Road]. Tokyo: Asahi Shimbun, 1993, 64-74.

Atwell, William, 'International Bullion Flows and the Chinese Economy circa 1530-1650', *Past and Present* 95 (1982), 68-90.

Audsley, George Ashdown and James Lord Bowes, *Keramic Art of Japan*. London: Henry Sotheran & Co, 1879.

Baird, Christina, 'Japan and Liverpool: James Lord Bowes and his legacy', *Journal of the History of Collection* 12, no. 1 (2000), 127-37.

Becker, Sister Johanna, 'The Karatsu Style and Korean Influences', *Keramos* 85 (July 1979), 71-6.

Becker, Johanna, *Karatsu Ware*. New York: Kôdansha International, 1986.

Blussé, J. Leonard, M.E. van Opstall and Ts'ao Yung-ho (eds), *De Dagregisters van het Kasteel Zeelandia, Taiwan, 1629-62*, 2 vols. 's-Gravenhage: Verkrijgbaar bij Martinus Nijhoff, 1986.

Borgen, Richard, *Sugawara no Michizane*. Cambridge, MA: Harvard University Press, 1988.

Bowes, James Lord, *Japanese Pottery*. London: Edward Howell, 1890.

Bowes, James Lord, *A Vindication of Japanese Porcelain*. Liverpool: Private Printing, 1891.

Boxer, Charles, *Jan Compaigne in Japan*. Den Haag: Martinus Nijhoff, 1950.

Bibliography

Bronson, Bennet, 'Export Porcelain in Economic Perspective: the Asian ceramic trade in the 17th century', *Centre of Asian Studies Occasional Papers and Monographs*, no. 90. Hong Kong: University of Hong Kong, 1990, 126-51.

Carson, Barbara G., *Ambitious Appetites: dining, behavior, and patterns of consumption in federal Washington*. Washington, DC: The American Institute of Architects Press, 1990.

Caygill, Marjorie, and John Cherry (eds), *A.W. Franks: 19th-century collecting and the British Museum*. London: British Museum Press, 1997.

Chadô shiryôkan (ed.), *Iseki shutsudo no Chôsen ôchô tôji* [Excavated Korean Joseon Dynasty Ceramics: famous bowls and archaeology]. Kyoto: Chadô shiryôkan, 1990.

Chadô shiryôkan and Fukken shô hakubutsukan (eds), *Karamono tenmoku – Fukken shô Kenyô shutsudo tenmoku to Nihon densei no tenmoku: Tokubetsuten* [A Special Exhibition of Chinese Jian Wares: excavated examples from Fujian and heirloom works from Japan]. Kyoto: Chadô shiryôkan, 1994.

Clunas, Craig, 'The Cost of Ceramics and the Cost of Collecting in the Ming Period', *Bulletin of the Oriental Ceramic Society of Hong Kong*, no. 8 (1986-88), 47-53.

Clunas, Craig, *Superfluous Things: material culture and social status in Early Modern China*. New York: Polity Press, 1991.

Cort, Louise Allison, 'Medieval Japanese Ceramics and the Tea Ceremony', *Keramos* 85 (July 1979), 49-58.

Cort, Louise Allison, 'Korean Influences in Japanese Ceramics: the impact of the Teabowl Wars of 1592-1598', in *Technology and Style*, vol. II, W.D. Kingery (ed.). Columbus, Ohio: The American Ceramic Circle, 1985, 331-62.

Cort, Louise Allison, *Seto and Mino Ceramics*. Washington, DC: Freer Gallery of Art, Smithsonian Institution, 1992.

Cort, Louise Allison, 'Buried and Treasured in Japan: another source for Thai ceramic history', *Thai Ceramics, The James and Elaine Connell Collection*. Oxford: Oxford University Press, 1993, 27-44.

Crawcour, E.S., 'Some Observations on Merchants: a translation of Mitsui Takafusa's *Chônin kôken roku*', *Transactions of the Asiatic Society of Japan*, third series, vol. 8 (December 1961).

Faulkner, Rupert F.J., 'Seto and Mino Kiln Sites: an archaeological survey of the Japanese medieval tradition and its early transformation', unpublished PhD dissertation, Oxford University, 1987.

Foster, Sir William (ed.), *A New Account of the East Indies by Alexander Hamilton*, vol. 11. London: Argonaut Press Empire House, 1930.

Franks, Augustus Wollaston, *Catalogue of a Collection of Oriental Porcelain and Pottery, Lent and Described by A.W. Franks*, 1st edn. London: The Science and Art Department of the Committee of the Council of Education, South Kensington, 1876.

Franks, Augustus Wollaston, *Catalogue of a Collection of Oriental Porcelain and Pottery, Lent and Described by A.W. Franks*, 2nd edn. London: privately printed, 1879, vii-viii. Considerable revisions were made after the 1st edn.

Franks, Augustus Wollaston, *Japanese Pottery at the Victoria and Albert Museum*. London: Victoria and Albert Museum, 1880.

Bibliography

Franks, Augustus W. 1880 *Japanese Pottery: being a native report with an introduction and catalogue.* London: Chapman and Hall Ltd.

Franks, A.W. 1906 *Japanese Pottery: being a native report with an introduction and catalogue.* London: Wyman and Sons for H.M.S.O.

Fujino Tamotsu (ed.), *Sagahan no sôgô kenkyû, hansei no seiritsu to kôzô* [Research on Saga Domain's Industries: establishment and structure]. Tokyo: Yoshikawa kôbunkan, 1981.

Fujiwara Tomoko, 'Hizen Wares Abroad: part II, the Dutch story', *The Voyage of Old-Imari Porcelain.* Arita: Kyushu Ceramic Museum, 2000, 156-65.

Fukui Prefecture Ichijôdani Asakura Clan Archaeological Museum, *Umi o koete kita yakimono* [Ceramics that Arrived from over the Seas]. Asakura: Fukui kenritsu Ichijôdani Asakurashi iseki shiryôkan, 1994.

Fukui Prefecture Ichijôdani Asakura Clan Archaeological Museum (ed.), *Echizen Asakurashi, Ichijôdani* [The Asakura of Echizen, Ichijôdani Site]. Fukui City, Fukuikenritsu Ichijôdani Asakurashi iseki shiryôkan, 2002.

Fukui Kikusaburo, *Japanese Ceramic Art and National Characteristics, Nihon tôjiki to sono kokuminsei.* Tokyo Ôzarasha, 1927, 59-60.

Gen'e, '*Kissa ôrai*' [Letter on Tea Drinking], *Chadô koten zenshû* [Compendium of Classics of the Way of Tea], vol. 2, Sen Sôshitsu (ed.). Kyoto: Tankôsha, 1958, 163-213.

Gifu Municipal Museum (ed.), *Sanjô kaiwai no yakimonoten* [Exhibition of Ceramics from Kyoto's Sanjô District]. Gifu City: Gifu Municipal Museum, 2001.

Goodman, Grant, *Japan: The Dutch Experience.* London: The Athlone Press, 1986.

Guth, Christine, *Art, Tea and Industry, Masuda Takashi and the Mitsui Circle.* Princeton: Princeton University Press, 1993.

Hagiwara Mitsuo, 'Zaisan mokuroku kara mita tôjiki no shoyû – Kôshû Hattake kazai mokuroku o chushin ni' [Examining Ceramics from Inventory Records, with a focus on the Kôshû-based Hatta family]. *Bôeki tôji kenkyû*, no. 15 (1995), 94-105.

Harrison-Hall, Jessica, *Ming Ceramics in the British Museum.* London: British Museum Press, 2001.

Hasebe Gakuji, 'Chinese Ceramics Historically Passed down through the Ages in Japan', *The International Symposium on Chinese Ceramics.* Seattle: Seattle Art Museum, 1977, 16-23.

Hasebe Gakuji and Imai Atsushi, *Nihon shutsudo no Chûgoku tôji, Chûgoku no tôji*, vol. 12 [Chinese Ceramics, vol. 12: Chinese ceramics excavated in Japan]. Tokyo: Heibonsha, 1995.

Hauser, William B., 'Osaka: A Commercial City in Tokugawa Japan', *Urbanism Past and Present* 5 (Winter 1977-1978), 23-36.

Hauser, William B., 'Osaka Castle and Tokugawa Authority in Western Japan', in *The Bakufu in Japanese History,* Jeffrey P. Mass and William B. Hauser (eds). Stanford: Stanford University Press, 1985, 153-72.

Hayashiya Tatsusaburô (ed.), *Nihon shisô taikei* [The History of Japanese Thought], vol. 23: *Kodai chûsei geijutsuron* [Ancient and Medieval Aesthetic Theory]. Tokyo: Iwanami shoten, 1973.

Hayashiya Seizô, 'The Korean Teabowl', *Chanoyu Quarterly* 18 (1977), 28-46.

Hayashiya Tatsusaburô, Nakamura Masao and Hayashiya Seizô, *Japanese Arts and the Tea Ceremony.* New York: Weatherhill, 1974.

Bibliography

Hickman, Money and Peter Fetchko, *Japan Day by Day*. Salem, MA: Peabody Museum of Salem, 1977.

Horiuchi Hideki, 'Tokyo-to Edo iseki shutsudo no Minmatsu Shinsho no tôjiki' [End of Ming and Early Qing Ceramics Excavated from Tokyo Area Edo Period Sites]. *Bôeki tôji kenkyû*, no. 11 (1991), 185-200.

Horiuchi Hideki, 'Edo iseki shutsudo no Shin tôji' [Qing Ceramics Excavated from Edo Sites], *Bôeki tôji kenkyû* [Trade Ceramic Studies], no. 19 (1999), 1-22.

Horiuchi Hideki, 'Toshi Edo ni okeru bôeki tôjiki no shôhi: Edo no juyô to sono haikei [The Consumption of Trade Ceramics in the City of Edo: the supply in Edo and its background], in *Edo no yakimono* [Edo Ceramics]. Tokyo: Edo iseki kenkyûkai, 2010, 7-42.

Howe, J. Allen, *A Handbook to the Collection of Kaolin, China-clay, and China Stone in the Museum of Practical Geology, Jermyn Street London SW*. London: Museum of Practical Geology, 1914.

Hsieh Ming-liang, 'Fifteenth and Sixteenth Century Japanese Connoisseurship of Chinese Ceramics' [in Chinese], *Taida Journal of Art History*, no. 17 (September 2004), 161-90.

Idemitsu Museum of Arts (ed.), *Koyama Fujio no me to waza, tô no shijin* [Koyama Fujio, a potter's dream]. Tokyo: Idemitsu Museum of Arts, 2003.

Idemitsu Museum of Arts (ed.), *Ko-garatsu* [Old Karatsu]. Tokyo: Idemitsu Museum of Arts, 2004.

Impey, Oliver, 'Collecting Oriental Porcelains in Britain in the Seventeenth and Eighteenth Centuries', in *The Burghley Porcelains*, Alexandra Munroe and Naomi Richards (eds). New York: Japan Society Galleries, 1986.

Impey, Oliver, 'A Tentative Classification of the Arita Kilns', *International Symposium on Japanese Ceramics*, Seattle, 1972, 85-90.

Impey, Oliver, 'The Earliest Japanese Porcelains: Styles and Techniques', in *Decorative Techniques and Styles in Asian Ceramics, Colloquies on Art and Archaeology in Asia*, no. 8. London: Percival David Foundation of Chinese Art, University of London, 1978, 126-48.

Impey, Oliver, *The Early Porcelain Kilns of Japan*. Oxford: Clarendon Press, 1996.

Impey, Oliver, 'Japanese Export Porcelain at Burghley House: The 1688 Inventory and the 1888 Sale', *Journal of the Metropolitan Museum of Art*, 37 (2002), 117-31.

Impey, Oliver, *Porcelains in the Ashmolean Collection*. Amsterdam: Hotei Press, 2005.

Impey, Oliver and Mary Tregear, 'An Investigation into the Origin, Provenance and Nature of Tianqi Porcelain', *Bôeki tôji kenkyû* [Trade Ceramic Studies], no. 3 (1983), 103-18.

Ishida Ichirô, *Chônin bunka, Genroku bunka, Bunsei jidai no bunka ni tsuite* [Concerning Merchant Culture, Genroku Culture and Bunsei Culture]. Tokyo: Shibundô, 1961.

Ishige Naomichi, *The History and Culture of Japanese Food*. New York: Kegan Paul Limited, 2001.

Ishii Yoneo (ed.), *The Junk Trade from Southeast Asia, Translations for the Tôsen fûsetsu gaki 1674-1723*. Singapore: Institute for Southeast Asian Studies, 1998.

Ishikawa Prefectural Museum of Art and the Kyushu Ceramic Museum (eds),

Bibliography

Imari kokutani meihinten [An Exhibition of Masterpieces of Kokutani and Imari]. Saga: Seibundô, 1987.

Ishikawa Prefecture, Enuma-gun Yamanaka-cho kyôiku iinkai (ed.), *Kutani*. Yamanaka-cho: Ishikawa Prefecture, Enuma-gun Yamanaka-cho kyôiku iinkai, 2004.

Itô Yoshiaki, 'Wamono tenmoku' [Japanese Tenmoku], in *Karamono tenmoku* [Chinese Tenmoku], Chadô shiryôkan and Fukken shô hakubutsukan (eds). Kyoto: Chadô Shiryôkan, 1994.

Itoh Ikutarô, *Chôsen no tôji* [Korean Ceramics] *(Yakimono meikan*, vol. 5). Tokyo: Kôdansha, 2000.

Iwao Seiichi, *Sakoku* [Closed Country]. Tokyo: Chûô kôronsha shuppan, 1966.

Japan Society for Southeast Asian Archaeology (ed.), *Tôjiki ga kataru kôryû, Kyushu, Okinawa kara shutsudoshita Tônan Ajiasan tôjiki* [Interrelations between Kyushu and Southeast Asia through Southeast Asian Ceramics found in Kyushu and Okinawa]. Kagoshima: Tônan Ajia kôkogaku kaigi jimukyoku, 2004.

Japanese National Museum of History (ed.), *Tôjiki no bunkashi* [Cultural History of Ceramics]. Sakura: Kokuritsu rekishi minzoku hakubutsukan, 1998.

Jenyns, Soame, *Japanese Porcelain*. London: Faber and Faber, 1965.

Kaempfer, Engelbert, *The History of Japan Together with a Description of the Kingdom of Siam, 1690-92*, Johan Casper Scheuchzer (tr.). London: The Royal Society, 1727, 2 vols.

Kakiemon chôsa iinkai (ed.), *Kakiemon*. Saga: Kakiemon chôsa iinkai, 1957.

Kamei Meitoku, 'Nihon ni okeru bôeki tôji kenkyû no hôhôron' [Methodology in the Study of Trade Ceramics in Japan], in *Karamono tenmoku – Fukken shô Kenyô shutsudo tenmoku to Nihon densei no tenmoku: Tokubetsuten* [A Special Exhibition of Chinese Jian Wares: excavated examples from Fujian and heirloom works from Japan], Chadô shiryôkan and Fukken shô hakubutsukan (eds). Kyoto: Chadô Shiryôkan, 1994.

Kamiki Tetsuo and Yamamura Kozo, 'Silver Mines and Sung Coins: a monetary history of medieval and modern Japan in international perspective', in *Precious Metals in the Late Medieval and Early Modern Worlds*, John F. Richards (ed.). Durham: Carolina Academic Press, 1983, 336-46.

Kaner, Simon, 'The Oldest Pottery in the World', *Current World Archaeology* 1, 44-9.

Kansai Early Modern Archaeological Society (*Kankinken*) (ed.), *Kinsei shotô no kaigai bôeki to tôjiki* [Ceramics and Overseas Trade in the Early Part of the Early Modern Period], Kansai kinsei kôkogaku kenkyû 17, 2009.

Katayama Mabi, '16seiki kôhan – 17seiki no Chôsen tôki no seisan, ryûtsu, juyô' [Second half of 16th century to 17th century Korean ceramics, origin, routes and demand], *Kinsei shotô no kaigai bôeki to tôjiki* [Ceramics and Overseas Trade in the Early Part of the Early Modern Period], Kansai kinsei kôkogaku kenkyû 17, 2009, 141-52.

Katô Eiichi, 'On the Reexamination of "National Seclusion"', *Acta Asiatica*, no. 67 (August 1994), 17-25.

Kawai Masatomo, 'Reception Room Display in Medieval Japan', in *Kazari: Decoration and Display in Japan, 15th-19th Centuries*, Nicole Rousmaniere (ed.). London: The British Museum, 2002, 32-41.

Kawashima Tatsurô and Ogi Ichirô, *Kokutani no jisshôteki mikata* [The Way of

Bibliography

Viewing Kokutani Ceramics from a Scientific Perspective]. Tokyo: Sôjusha bijutsu shuppan, 1991.

Kawazoe Shôji, *Umi ni hirakareta toshi, kodai chûsei no Hakata* [Ancient and Medieval Hakata, a city connected by the sea], *Yomigaeru chûsei 1, Higashi Ajia no kokusai toshi Hakata* [Rereading the Medieval Period 1, Hakata, an International City in East Asia]. Tokyo: Heibonsha, 1988.

Kerlen, Henri, 'Imari Marks and their Origin', *Andon* 76 (Leiden, 2004), 15-17.

Kerr, George H., *Okinawa, The History of an Island People*. Boston: Tuttle Publishing, 2000.

Kerr, Rose and Wood, Nigel, *Ceramic Technology*. Cambridge: Cambridge University Press, 2004.

Kilburn, Richard, *Transitional Wares and their Forerunners*. Hong Kong: The Oriental Ceramic Society of Hong Kong, 1981.

Kim Wondong, 'Chinese Ceramics from the Wreck of a Yuan Ship in Sinan-with Particular Reference to Celadon Wares', unpublished PhD dissertation, University of Kansas, 1986.

Kobata Atsushi, 'Jûroku, jûnana seiki ni okeru Kyokutô no gin no ryûtsû' [Routes for Silver in the 16th and 17th centuries], in *Kobata Atsushi kyôju taikan kinen kokushi ronshû*. Kyoto: Kyoto University, 1970.

Kobayashi Tatsuo, *Jômon Reflections*, Simon Kaner (ed.) with Nakamura Oki. Oxford: Oxford Books, 2004.

Ko-Imari chôsa iinkai (ed.), *Ko-Imari* [Old Imari]. Saga: Ko-Imari chôsa iinkai, 1959.

Kondô Heijô (ed.), *Kaitei shiseki shûran* [Collection of Historical Writings], vol. 10, no. 39. Tokyo, 1900-1903.

Kono Motoaki, 'The Workshop System of the Kano School of Painting', in *Fenway Court*, John M. Rosenfield (ed.). Boston: Isabella Stewart Gardner Museum, 1993, 19-29.

Koreana (ed.), 'Apex of Korea's Cultural Heritage Glorified by Nameless Ceramists, Special Edition on Korean Ceramics', *Koreana*, vol. 5, no. 3, 1991.

Kumakura Isao, 'Honzen kara kaiseki e' [From Honzen Dining to Kaiseki Dining], *Bessatsu Taiyô* 14. Tokyo: Heibonsha, 1976, 85-92.

Kumakura Isao, *Bunka to shite no manaa* [Manner as Culture]. Tokyo: Iwanami shoten, 2000.

Kume Kunitake (ed.), Arita Sarayama *sôgyô shirabe* [A Survey of Porcelain Production at Sarayama, Arita-cho], 1873.

Kutani koyô chôsa iinkai [Kutani Kiln Research Group] (ed.), *Kutani dai 1 chosa hôkoku* and *Kutani dai 2 chosa hôkoku* [Archaeological Report on the Survey of the Kutani no. 1 and no. 2 Kiln Sites]. Ishikawa: Ishikawaken kyôiku iinkai, 1971, 1972.

Kyoto National Museum (ed.), *Nihonjin ga Kononda Chûgoku tôji* [Chinese Ceramics: the most popular works among Japanese nationals]. Kyoto: Kyoto National Museum, 1991.

Kyotoshi maezo bunkazai kenkyûjô (ed.), *Kyotoshi maizôbunkazai kenkyûjo chosa hôkoku dai 22satsu* [Kyoto City Buried Cultural Properties Research Centre Report, no. 22]. Kyoto: Kyotoshi maizô bunkazai kenkyûjô, 2004, 3 vols.

Kyushu Ceramic Museum (ed.), *Tsuchi no bi kokaratsu: Hizen tôji no subete* [Karatsu – The Beauty of Clay: a compendium of all Hizen ceramics]. Kyushu Ceramic Museum, 2008.

Bibliography

Kyushu kinsei tôji gakkai (ed.), *Jûroku, jûnana-seiki ni okeru Kyûshû tôji o meguru gijutsu kôryû* [16th- to 17th-century Kyushu Porcelain: the transfer of techniques]. Arita-cho: Kyûshû kinsei tôji gakkai, 2005.

Kyushu Kinsei tôji gakkai (ed.), *Sekai ni yushutsu sareta Hizen tôji* [Hizen Ceramics Exported Throughout the World]. Arita: Kyushu Kinsei tôji gakkai, 2010.

Li Jian An, 'Nihon chadôgu no naka no Fukkentôshi' [Fujian Ceramics among Japanese Tea Utensils], *Nomura bijutsukan kenkyû kiyô*, vol. 6 (1997), 26-32.

Little, Stephen, *Chinese Ceramics of the Transitional Period: 1620-1683*. New York: China Institute of America, 1983.

Maeyama Hiroshi, *Sagahan no ryûtsû* [Saga Domain Distribution Routes]. Arita-cho: Kyushu Ceramic Museum, 1989.

Maeyama Hiroshi, *Imariyaki ryûtsûshi no kenkyû* [Research on Imari ware Routes]. Saga: Seibundô, 1990.

Maeyama Hiroshi, 'Sagahan karayashiki bunsho' [Document on the Saga Domain Residence]. Osaka shôgyô daigaku shôgyôshi kenkyûjo shozo, n.d. [undated, held in Osaka Universities of Commerce Research Institute].

Massarella, Derek, *A World Elsewhere: Europe's encounter with Japan in the sixteenth and seventeenth centuries*. New Haven: Yale University Press, 1990.

Matsumoto Satarô, *Teihon kokutani* [Handbook for Kokutani]. Tokyo: Hôunsha, 1940.

Matsushima Sôei (ed.), *Kundaikan sôchôki kenkyû* [Research on the Document entitled Kundaikan Sôchôki]. Tokyo: Chûô bijutsusha, 1931.

Medley, Margaret, 'Trade, Craftsmanship and Decoration', in *Seventeenth-century Chinese Porcelain from the Butler Family Collection,* Sir Michael Butler et al. (eds). Alexandria, VA: Art Services International, 1990, 11-20.

Mikami Tsugio, *Tôji bôekishi kenkyû* vols 1-3 [Research on Trade Ceramics]. Tokyo: Chûôkôransha, 1987.

Mikami Tsugio and the Arita-cho Educational Board [Aritacho kyôiku iinkai] (eds), *Arita tengudani koyô* [The Arita-cho Tengudani Kiln Archaeological Report] Tokyo: Chûôkôransha shuppan, 1972.

Mikami Tsugio and Youn Moo-byong (eds), *Shinan kaitei hikiage bunbutsu* [Cultural Relics Recovered from the Sinan Shipwreck]. Tokyo: the Tokyo National Museum and the National Museum of Korea, 1983.

Mikasa, Princess Akiko of, 'Collecting and Displaying "Japan" in Victorian Britain: The Case of the British Museum', unpublished PhD dissertation, Oxford University, 2010.

Mori Hitoshi, '1867-nen Pari bankoku hakurankai ni okeru Nihon, Nihon shuppin o megutte' [Japan in the Universal Exhibition on Paris in 1867, on the Japanese exhibit], *Tojô ronsô*, vol. 3 (1993), 1-28.

Morimura Ken'ichi, 'Funsei sagi kara kameyamakei e tenkai' [Changes from Buncheong to Kameyama style Ceramics], *Kôkorekishi gakushi*, vol. 8, bessatsu (1992.8), 355-75.

Morse, Edward Sylvester, *Shell Mounds of Omori. Memoirs of the Science Department University of Tokio, Japan*, vol. 1, pt. 1, 1879.

Morse, Edward Sylvester, *The Studio*, 10 January 1891.

Morse, Edward Sylvester, *Catalogue of the Morse Collection of Japanese Ceramics in the Museum of Fine Arts*. Boston: Trustees of the Museum of Fine Arts, Boston, 1901.

179

Bibliography

Mowry, Robert D., *Hare's Fur, Tortoiseshell, and Partridge Feathers, Chinese Brown and Black-glazed Ceramics, 400-1400.* Cambridge, MA: Harvard University Art Museums, 1996.

Mowry, Robert D., 'Song Ceramics: an overview', introductory essay in Lisa Rotondo-McCord (ed.), *Heaven and Earth Seen Within: Song ceramics from the Robert Barron Collection,* exhibition catalogue, New Orleans Museum of Art, 2000, 10-30.

Munhwa Kongbobu (ed.), *Sinanhaejo yumul* [On the Sinan Shipwreck]. Seoul: Munhwa kongbobu munhwajae kwalliguk, 1983.

Murai Yasuhiko, 'The Development of Chanoyu before Rikyû', in *Tea in Japan: essays on the history of Chanoyu,* Paul Varley and Kumakura Isao (eds). Honolulu: University of Hawai'i Press, 1989, 3-32.

Murakami Nobuyuki, 'Hizen jiki no tamashii tonatta Richô no jiki' [Korean Joseon ceramics and their Soulmates Hizen porcelain], *Fukuoka Style, Hizen no jiki,* vol. 15 (1996), 28-34.

Murakami Nobuyuki, 'Hizen ni okeru shoki no noborigama ni tsuite' [Concerning Early Linked Chamber Climbing Kilns in Hizen], *Tôyô Tôji,* no. 27 (1997), 33-48.

Murakami Nobuyuki, 'Hizen tôji no genryû' [The Origins of Hizen Porcelain], *Tôjiki ga kotonaru Ajia to Nihon, Kokuritsu Rekishi Hakubutsukan Kiyô,* vol. 94 (March 2002), 441-68.

Murakami Nobuyuki, 'Hizen jiki no gijutsu' [Techinques in Hizen Porcelain], *Jûroku, jûnana-seiki ni okeru Kyûshû tôji o meguru gijutsu kôryû* [16th- to 17th-century Kyushu Porcelain, the transfer of techniques], Kyûshû kinsei tôji gakkai (ed.). Arita-cho: Kyûshû kinsei tôji gakkai, 2005.

Nabeshima hanyô chôsa iinkai (ed.), *Nabeshima hanyô no kenkyû* [Research on the Nabeshima Official Domain Kiln]. Saga: Nabeshima hanyô chôsa iinkai, 1954.

Nagahara Keiji and Yamamura Kozo, 'Shaping the Process of Unification: technological progress in 16th- and 17th-century Japan', *Journal of Japanese Studies* 14, no. 1 (Winter 1988), 77-109.

Nagatake Takeshi, *Hizen tôji no keifu* [Lineage of Hizen Porcelain]. Tokyo: Heibonsha, 1975.

Nagatake Takeshi (ed.), *Kyushu I, Nihon yakimono shûsei,* vol. 11 [Compendium of Japanese Ceramics]. Tokyo: Heibonsha, 1981.

Nagazumi Yôko, *Karabune yushutsu nyûhin sûryô ichiran 1637-1833* [An In-depth Examination of Imported Items from Chinese Ships Entering Japan, 1637-1833]. Tokyo: Sôbunsha, 1987.

Nakajima Hiroki, *Hizen tôjishikô* [The History of Hizen Ceramics]. Arita: 1936.

Nakamura Hidetaka, *Nissen kankei shi no kenkyû* [Research on Asian Tradeshipping], 3 vols. Tokyo: Yoshikawa Kôbunkan, 1965-69.

Nakamura Tadashi, *Kinsei Nagasaki bôekishi kenkyû* [A Study of Early Modern Nagasaki Trade]. Tokyo: Yoshikawa kôbunkan, 1988.

Nakamura Tadashi (ed.), *Batabuia jônisshi* [Batavia Journal of Trade]. *Tôyô bunko,* no. 170. Tokyo: Heibonsha, 1970.

Nakazato Tarôemon (ed.), *Karatsu, Nihon yakimono shûsei* [Japanese Ceramic Compendium], vol. 11. Tokyo: Heibonsha, 1981.

Narasaki Shôichi, 'Investigation at the Kutani Kiln Site', *Tôyô tôji* [Oriental Ceramics] 1990, 91-3, vols 20-1, Japan Society of Oriental Ceramic Studies, 1993, 95-112.

Bibliography

Narasaki Shôichi, *Koseto, Nihon no bijutsu 133* [Old Seto, Japanese Art 133]. Tokyo: Shibundo, 1977.

National Museum of Japanese History (ed.), *Cultural History of Ceramic Ware*. Sakura, Chiba Prefecture: National Museum of Japanese History, 1998.

National Museum of Japanese History, *The Interaction in Medieval East Asian Sea*. Sakura, Chiba Prefecture: The National Museum of History, 2005.

Nezu Art Museum (ed.), *Shirarazaru Karatsu* [The Little-known Karatsu Wares of the Edo Period]. Tokyo: Nezu Art Museum, 2002.

Nishida Hiroko, 'Japanese Export Porcelain in the 17th and 18th Centuries', unpublished PhD thesis, Oxford University, 1974.

Nishida Hiroko, 'Chinese Ceramics Imported to Japan in the Momoyama and Early Edo Periods', *International Symposium on Chinese Ceramics*. Seattle: Seattle Art Museum, 1977, 149-57.

Nishida Hiroko, *Nanban shimamono* [Namban Ceramics]. Tokyo: Nezu Art Museum, 1993.

Nishida Hiroko, *One Hundred Teabowls from the Nezu Collection*. Tokyo: Nezu Art Museum, 1994.

Noba Yoshiko, 'Boki ekotoba no tôjiki' [Ceramics in the *Boki ekotoba* handscroll], *Annual Bulletin of the Nagoya City Museum*, vol. 13 (1990), 24-44.

Nogami Takenori, 'Hizen Porcelain Exported to Asia, Africa and America', *The East Asian Mediterranean: Maritime Crossroads of Culture, Commerce and Human Migration*. Wiedbaden: Harrassowitz Verlag, 2008, 203-18.

Nogami Takenori, 'Mechanism of the Production of Early Modern Hizen Porcelain – A Study on the Formation of the Foundation of a Modern Local Industry' [in Japanese with English Abstract], unpublished PhD dissertation, Kanazawa University, 2008.

Ogiura Masayoshi, *Edo hakkutsu* [Excavating Edo]. Tokyo: Meicho shuppankai, 1993.

Ôhashi Kôji, '17 seiki ni okeru Hizen jiki ni tsuite' [17th-century Hizen Porcelain] in Ishikawa Prefectural Art Museum and the Kyushu Ceramic Museum (eds), *Imari kokutani meihin ten* [Masterworks of Imari and Kokutani]. Saga: Seibundo, 1987, 7-13.

Ôhashi Kôji, 'Hizen tôjiki no hensen' [Changes in Hizen Ceramics], *Bôeki tôji kenkyû*, no. 7 (1987), 71-6.

Ôhashi Kôji, '17 seiki kôhan ni okeru Hizen tôjiki no meikan ni tsuite' [Characteristics of Second Half of 17th-century Hizen Porcelain], *Tôyô tôji*, vol. 17 (1987-89), 25-31.

Ôhashi Kôji, *Hizen jiki no akebono, Hyakunenan tôji ronshû, dai ichi go*. [The Beginnings of Hizen Porcelain: 100 years of the porcelain debate, vol. 1]. Arita: Fukagawa seiji kabushiki gaisha geijutsushitsu, 1988.

Ôhashi Koji, *Hizen toji* [Hizen Ceramics]. Tokyo: Nyuu saiensusha, 1989.

Ôhashi Koji, 'Oriental Ceramics and the Vicissitudes of the Ottoman Turkish Empire', *Treasures from the Tokapi Palace*. Arita: Kyushu Ceramic Museum, 1995, 123-33.

Ôhashi Kôji, 'Kyushu ni okeru Minmatsu – Shin jidai no Chûgoku jiki no shutsudo bunpu to sono naiyô ni tsuite' [A Chronology and Explanation of the End of Ming and Qing Ceramics Excavated in Kyushu]. *Bôeki tôji ni miru Ni-Chû kankei to kokunai ryûtsu, Aoyama kôko*, vol. 12 (May 1995), 55-68.

Ôhashi Kôji (ed.), *Tsuchi to honô* [Fire and Earth]. Arita-cho: Kyushu Ceramic Museum, 1996.

Bibliography

Ôhashi Kôji, *Umi o wattata tôjiki* [Ceramics that Crossed the Seas]. Tokyo: Yoshikawa kobunko, 2004.

Ôhashi Kôji, *Shogun to Nabeshima, Kakiemon* [The Shogunate and Nabeshima and Kakiemon]. Tokyo: Yuzankaku, 2007.

Ôhashi Kôji, 'An Overview of Export Hizen Porcelain', in *Sekai ni yushutsu sareta Hizen tôji* [Hizen Ceramics Exported Throughout the World], Society of Kyushu Early Modern Ceramic Study (ed.). Arita: Kyushu Kinsei tôji gakkai, 2010, 15-29.

Ôhashi Kôji and Arakawa Masa'aki (eds), *Shoki Imariten* [Early Imari Exhibition]. Tokyo: NHK Promotion, 2004.

Okayamaken kyôiku iinkai (ed.), *Oribe to Kosometsuke: Mino to Keitokuchin no deai* [Oribe and Kosometsuke: The Meeting of Mino and Jingdezhen]. Okayama: Hayashibara Art Museum, 1991.

Ôkôchi Masatoshi, *Kakiemon to iro-nabeshima* [Kakiemon and Overglaze Decorated Nabeshima]. Tokyo, 1916.

Ono Masatoshi, 'Shutsudo tôji yori mita 15, 16 seiki ni okeru gakki no sobyô' [An Overview of the 15th to 16th Centuries through Excavated Ceramics], *Museum*, no. 416 (1985), 20-8.

Osakashi bunkazai kyôkai (ed.), *Osakajô ato* [The Ruins of Osaka Castle]. Osaka: Osaka bunkazai kyôkai, 1988.

Pearson, Richard (ed.), *Okinawa, The Rise of an Island Kingdom*, BAR International Series 1898. London: Archaeo Press, 2009.

Pijl-ketel, C.L. (ed.), *The Ceramic Load of the Witte Leeuw*. Amsterdam: Rijksmuseum, 1982.

Pitelka, Morgan (ed.), *Japanese Tea Culture, Art, History, and Practice*. London: Routledge Curzon, 2003.

Pitelka, Morgan, *Handmade Culture: Raku Potters, Patrons, and Tea Practitioners in Japan*. Honolulu: University of Hawai'i Press, 2005.

Plutschow, Herbert, *Rediscovering Rikyû, and the Beginnings of the Tea Ceremony*. Folkestone, Kent: Global Oriental, 2003.

Pollard, Clare, *Master Potter of Meiji Japan*. Oxford: Oxford University Press, 2002.

Pope, Alexander, 'The Beginnings of Porcelain in Japan', in *200 Years of Japanese Porcelain*, Richard Cleveland (ed.). St Louis: City Art Museum of Saint Louis, 1970, 1-3.

Ravina, Mark, 'State-building and Political Economy in Early-Modern Japan', *The Journal of Asian Studies* (November 1995), vol. 54, no. 4, 997-1022.

Rosenfield, John, 'Japanese Painting Workshops and the Gardner Museum Collections', in *Fenway Court*, Boston: Isabella Stewart Gardner Museum, 1993, 8-11.

Rousmaniere, Nicole, 'Defining Temmoku: Jian Ware Teabowls Imported into Japan', in *Hare's Fur, Tortoiseshell, and Partridge Feathers, Chinese Brown and Black-Glazed Ceramics, 400-1400*, Robert D. Mowry (ed.). Cambridge, MA: Harvard University Art Museums, 1996, 42-58.

Rousmaniere, Nicole, 'The Accessioning of Japanese Art in Early Nineteenth-century America: *Ukiyo-e* Prints in the Peabody Essex Museum, Salem', *Apollo* (March 1997), 23-9.

Rousmaniere, Nicole, 'Japanese Art and the World in the 17th Century', *Japan Society Proceedings*, no. 135 (Summer 2000), 26-38.

Bibliography

Rousmaniere, Nicole, 'Porcelains in the British Museum', *Transactions of the Oriental Ceramic Society*, vol. 65 (2000-2001), 83-92.

Rousmaniere, Nicole (ed.), *Kazari, Decoration and Display in Japan 15th-19th Centuries*. London: British Museum Press, 2002, 94-5.

Rousmaniere, Nicole (ed.), *Crafting Beauty in Modern Japan*. London: British Museum Press, 2007.

Ryley, J. Horton (ed.), *Ralph Fitch: England's Pioneer to India*. London, 1899.

Sakai Municipal Museum (ed.), *Sakaishû chanoyu o hajimeta hitobito* [Tea Connoisseurs from Sakai: the people who started the tea ceremony] Sakai City: Sakai Municipal Museum, 1989.

Sanders, Herbert H., *The World of Japanese Ceramics*. Tokyo: Kodansha International, 1982.

Sasaki Tatsuo, *Tôji* [Ceramics]. Tokyo: Tokyodo shuppan, 1994.

Schaap, Robert (ed.), *Meiji Japanese Art in Transition*. Leiden: The Society for Japanese Arts and Crafts, 1987.

Segal, Sam. *A Prosperous Past: the sumptuous still-life in the Netherlands*. The Hague: SDU Publishers, 1988.

Seino, Takayuki, 'Maizô bunkazai kankei toukei shiryô no Kaisetsu to bunseki: Heisei 20 nendo ban [Statistical Data on Buried Cultural Properties in 2008: commentary and analysis]. *Gekkan Bunkazai* [*Cultural Properties Monthly*] 548 (2009): 41-6

Sekiguchi Hirotsugu, 'Products and Potters of Himetani Kiln in Hiroshima Prefecture', *Tôyô tôji* [Oriental Ceramics], 1990, 91-3, vols 20-1, Japan Society of Oriental Ceramic Studies, 1993, 69-78.

Seto City Museum (2004) *Finest Ceramics in Seto: in commemoration of the 2005 World Exposition, Aichi, Japan*. Nagoya: NHK Nagoya, 2004.

Shimizu Yoshiaki, 'A Chinese Album Leaf from the Former Ashikaga Collection in the Freer Gallery of Art', *Archives of Asian Art* 37 (1984), 101.

Shively, Donald, 'Sumptuary Regulations and Status in Early Tokugawa Japan', *Harvard Journal of Asiatic Studies* 25 (1964-65), 123-64.

Takeuchi Jun'ichi, 'Nihon tôji kenkyûshi jôsetsu (7), soto kara no shiten' [A View from Outside: the history of the study of Japanese ceramics 7], *Tôsetsu* 576 (March 2001), 60-3.

Tamaguchi Tokio et al. (eds), *Shiodome iseki* [The Shiodome Site], 3 vols. Tokyo: Shiodome-chiku iseki chôsa kai, 1996.

Tamamushi Satoko, 'Chûgoku bunjin shumi juyô-sô to shite no daimyo kaikyû' [Daimyo Status Seen Through Chinese Scholar Literati Taste], Paper given at the Eastern Section of the Japanese Art History Association, 28 July 2000.

Tamura kenkyûshitsu, Aoyama Gakuin University (ed.), *Bôeki tôji ni miru Ni-Chû kankei to kokunai ryûtsu* [Japanese Chinese Relations as Seen Through Tradewares and Domestic Trade Routes], *Aoyama kôkô*, no. 12 (Tokyo, 1995).

Tanaka Takeo, *Chûsei taigai kankeishi* [A History of Foreign Relations in Medieval Japan]. Tokyo: University of Tokyo Press, 1975.

Tankôsha (ed.) *Tenmoku: Shôgan sare tsuzsukeru shihô no chawan* [Treasured Teabowls that Continue to be Admired] (*Tankô bessatsu*, no. 56). Kyoto: Tankôsha, 2009.

Taoci (ed.), 'Grès et raku du Japon', *Taoci, revue annualle de la Société française d'Étude de la Céramique orientale*, no. 3, 2004.

Bibliography

Toby, Ronald, *State and Diplomacy in Early Modern Japan*. Princeton: Princeton University Press, 1984.

Tokugawa Art Museum (ed.), *Ieyasu no isan* [Ieyasu's Last Will and Testiment]. Nagoya: Tokugawa Art Museum, 1992.

Tokyotonai iseki chôsakai (ed.), *Komagome unaginawate, Osakite kamiyashiki* [The Daimyo Household Osakite in Komagome]. Tokyo: Tokyotonai iseki chôsakai, 1997.

Totman, Conrad, *The Lumber Industry in Early Modern Japan*. Honolulu: University of Hawai'i Press, 1995.

Tôyô tôji [Oriental Ceramics], 91-3, Japan Society of Oriental Ceramic Studies, vols 20-1, 1993.

Trollope, Anthony, *The New Zealanders*. Oxford: Clarendon Press, 1972.

Tsukahira Toshio George, *Feudal Control in Tokugawa Japan: The Sankin Kôtai System*. Cambridge, MA: The East Asian Research Center, Harvard University, 1966.

Tsutsui Hiroichi, 'Chahô no inyû to sono tenkai' [The Way of Tea and its Development], in Chadô shiryôkan and Fukken shô hakubutsukan (eds), *Karamono tenmoku – Fukken shô Kenyô shutsudo tenmoku to Nihon densei no tenmoku: Tokubetsuten* [Chinese Tenmoku Bowls: tenmoku bowls excavated from Fujian and heirloom examples in Japanese collections]. Kyoto: Chadô shiryôkan, 1994.

Uchigawa Ryûshi, *Hachijôjima kyû Chôdamura ni shozai suru 'ishiba' ni kansuru kôsatsu* [Regarding Stone Offerings at the Former Village of Chôdamura in Hachijôshima]. *Kokugakuin daigaku kôkogaku shiryôkan kiyô*, dai 7 shû (1990).

Ueda Hideo et al. (eds), *Higashi Ajia no umi to shirukurôdo no kyôten, Fuken* [Fujian, the Base of the East Asian Sea and Silk Route]. Seto City: Kai no shiruku rôdo no shuppatsuten Fukken ten kaisai jikô iinkai 2008.

University of Tokyo Early Modern Archaeological Research Institute [Tokyo daigaku iseki chôsa shitsu] (ed.), *Rigakubu 7 go kan chiten, Tokyo daigaku iseki chôsa shitsu hakkutsu chôsa hôkokusho 1* [The Science Building, no. 7, Archaeological Report for the Tokyo University Archaeological Resources Study Center, no. 1]. Tokyo: Tokyo University iseki chôsa shitsu, 1989.

University of Tokyo Archaeological Resources Study Center (ed.), *Tokyo daigaku Hongo kônai no iseki, Yamaue kaikan, Goten-shita kinenkan chiten* [University of Tokyo Hongo Campus Yamaue Memorial Building, the Memorial Go-ten Sports Facility]. Tokyo: Tokyo University, 1990.

van der Velde, Paul, *The Deshima Dagregisters: their original Table of Contents*. Leiden: The Leiden Centre for the History of European Expansion, 1991.

Viallé, Cynthia, 'The Records on the VOC Concerning the Trade in Chinese and Japanese Porcelain between 1634 and 1661', *Aziatische Kunst* 1992, no. 3 (September 1992).

Viallé, Cynthia, 'Japanese Porcelain for the Netherlands: the records of the Dutch East India Company', *The Voyage of Old-Imari Porcelain*. Arita: Kyushu Ceramic Museum, 2000.

Volker, Paul, 'Porcelain and the Dutch East India Company', *Mededelingen van het Rijksmuseum voor Volkenkunde*, no. 11, Leiden, 1954.

Volker, Paul, *Porcelain and the Dutch East India Company, 1602-1682*. Leiden: E.J. Brill, 1954.

Bibliography

von Siebold, Philipp Franz, 'Riese nach dem Hofe des Siogun im Jahre 1826', *Nippon*, 19 February 1826.

von Siebold, Philipp Franz, *Manners and Customs of the Japanese in the Nineteenth Century*. Reprinted in Tokyo: Charles Tuttle Company, 1973.

Wakita Osamu, 'The Social and Economic Consequences of Unification', *Early Modern Japan, The Cambridge History of Japan*, vol. 4. Cambridge: Cambridge University Press, 1991, 105-21.

Watanabe T., 'Maizô bunkazai kankei tôkei shiryô no kaisetsu to buneki: Heisei 19 nendo ban' [Statistical Data on Buried Cultural Property in 2007: commentary and anaysis], *Gekkan bunkazai* [Cultural Properties Monthly], no. 535 (Tokyo, 2008), 36-42.

Wayman, Dorothy G., *Edward Sylvester Morse, A Biography*. Cambridge, MA: Harvard University Press, 1942.

Wilson, David, *The Forgotten Collector*. London: Thames and Hudson, 1984.

Wilson, David M., 'Introduction: Augustus Wollaston Franks – Towards a Portrait', in *A.W. Franks, Nineteenth-Century Collecting and the British Museum*, Marjorie Caygill and John Cherry (eds). London: The British Museum Press, 1997, 1-5.

Wilson, Richard, 'Tea Taste in the Era of Japonisme', *Chanoyu Quarterly*, no. 50 (1987), 23-39.

Wilson, Richard, *Inside Japanese Ceramics: a primer of materials, techniques, and traditions*. Boston: Weatherhill, 1995, 2nd edn 2004, 41-4.

Yabe Yoshiaki, 'Chûgoku no tôji' [Chinese Ceramics], in *Kadokawa Nihon tôji daijiten* [Kadokawa Large Dictionary of Japanese Ceramics]. Tokyo: Kadokawa shoten, 2002, 896-7.

Youn Moo-byong, 'Recovery of Seabed Relics at Sinan and its Results from the Viewpoint of Underwater Archaeology', in Mikami Tsugio and Youn Moo-byong (eds), *Shinan kaitei hikiage bunbutsu* [Cultural Relics Recovered from the Sinan Shipwreck]. Tokyo: Tokyo National Museum and National Museum of Korea, 1983.

Website

What's Up Around the Prime Minister, 20-21 May 2006, accessed 15 March 2010. http://www.kantei.go.jp/foreign/koizumiphoto/2006/05/20hokuriku_e.html.

Index

Index

60, 77, 97, 98, 101, 102, 103, 115,
118, 119, 136, 138, 142, 143, 145,
147, 161
copper glaze 122
Corfu Museum of Asian Art 54
Cort, Louise Allison 26, 89, 91, 169,
170
Crawcour, E.S. 109, 167
Cuba 42, 152

death inventories 77, 114, 115
Defoe, Daniel 67
Deshima 68, 113, 119, 168
Devonshire schedule 68
Dresden 64, 68
Dutch East India Company 67, 74,
112

Early Modern Archaeological
Research Institute, Tokyo
University 61, 65
earthenware 26, 32, 35, 52, 53, 54,
70, 71, 151
Echizen 117
Edo period 35, 41, 43, 46, 48, 50, 53,
56, 59, 65, 69, 78, 84, 92, 96, 98,
99, 100, 102, 106, 107, 109, 111,
113, 114, 122, 128, 132, 133, 145,
162, 166, 172
Eichû 79
Eisai 79, 80
Emura Senzai 110, 167
English Trade Company 112
Enpô era 148

Faulkner, Rupert F.J. 94
feldspar 25, 36
Fillimore, President 68
Fitch, Ralph 108
Fitski, Menno 74, 163
Foster, Sir William 144
Franks, Augustus Wollaston 15, 53,
54, 55, 68, 70, 71, 72, 73
Freer Gallery 73, 131
Frois, Lois 111
Fujino Tamotsu 130, 161
Fujita Museum 164
Fukui Kikusaburo 163
Fukui Prefecture Ichijôdani
Asakura Clan; Archaeological

Museum 77, 98; Museum of
Ceramics 50
Fukuyama, 36, 84

Gei'ami 83
Genna era 110, 114
Gesso Joshin 133
Gifu Prefectural Ceramic Museum
50, 66
gold 25, 84, 108, 110, 116
Goodman, Grant 168
Gorodaiyu go shonzui 102, 131, 132
Gotô Yûjô 86
Guan ware 49, 83
guest hall companions (dôbôshu) 82,
83
Guimet Museum 53
Guth, Christine 85, 86, 92

Hachijôjima Island 137
Hachiôji Castle 6, 117, 118
Hagiwara Mitsuo 169
Hakata 80, 88, 90, 91, 94, 96, 98, 99,
107, 109
Hall, Jessica Harrison 165
Hamilton, Alexander 144
Handscroll of Kundaikan sôchôki 71
Harper's New Monthly Magazine 23,
155
Hasabe Gakuji 63
Hasebe 129, 131
Hata family 123, 124
Hatta family 115
Hayashiya Tatsusaburô 49, 63, 79,
83, 162, 170
Hebei province 25
Heian period 32, 79
heirloom objects (*denseihin*) 28, 31,
49, 60, 61, 67, 90, 106, 114, 115,
117, 164
Higashi Mariko 62
Hôjô family 93, 117, 118
Horiuchi Hideki 63, 65, 98, 100, 165

Ichijôdani site 77, 96, 98, 117, 118,
125, 170
Idemitsu Museum of Arts 15, 37, 43,
50, 51, 60, 61, 65, 103, 120, 121,
162, 169
Idemitsu Sazô 57

Index

Index

Index

Index